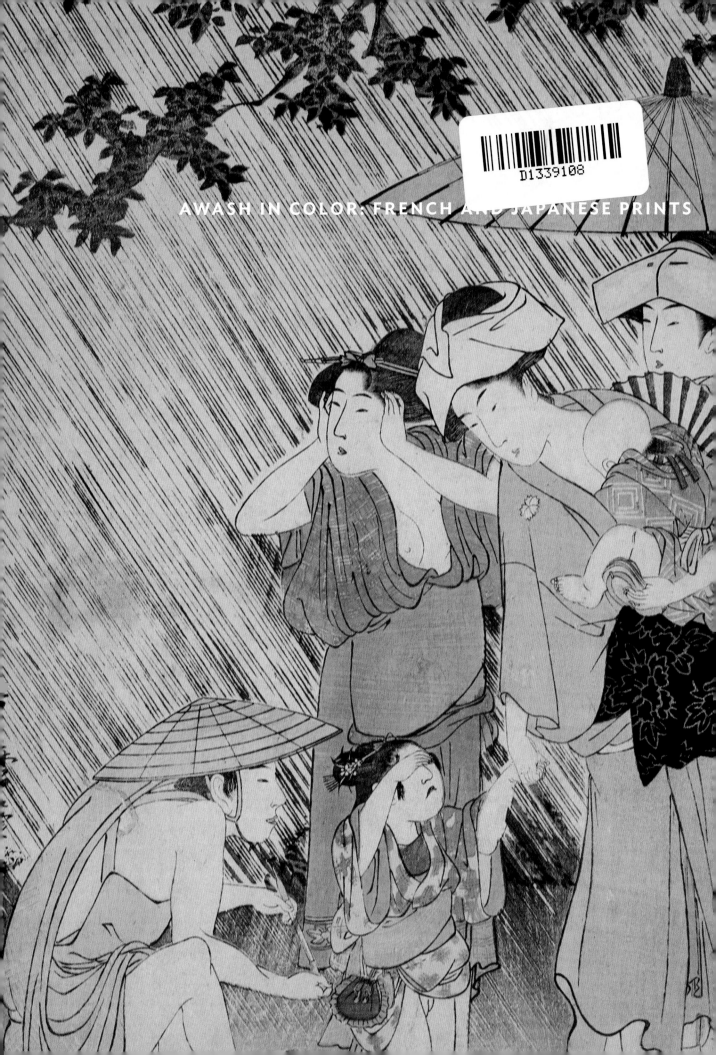

AWASH IN COLOR

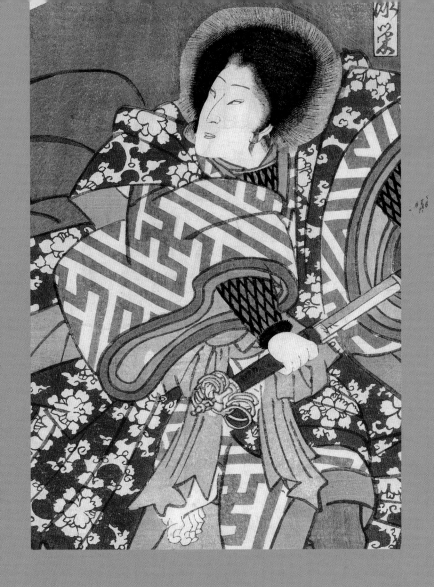

FRENCH AND JAPANESE PRINTS

CHELSEA FOXWELL AND ANNE LEONARD,
WITH DAVID ACTON, DAVID WATERHOUSE, DREW STEVENS,
ANDREAS MARKS, LAURA KALBA, AND STEPHANIE SU

SMART MUSEUM OF ART
UNIVERSITY OF CHICAGO

CONTENTS

PREFACE / ACKNOWLEDGMENTS

AWASH IN COLOR, when first slotted into the Smart Museum's exhibition calendar, was envisioned as a small- to medium-sized, collection-based presentation that would highlight a selection of color prints from France and Japan, many of which had been acquired in the previous five years. The convergence of several factors—the arrival of Japanese art specialist Chelsea Foxwell at the University of Chicago, the influx of new endowment funds into our already-thriving Mellon exhibition program, and the recognition of an area that was ripe for scholarly reappraisal—gave us every reason to vault *Awash in Color* to an entirely new level of scope and ambition, and to reassign it to our largest special exhibition gallery.

Thus the project documented in these pages, while originating in a core of Smart Museum collection strength, encompasses loans from well over a dozen U.S. museums and libraries, as well as several important private collections. Likewise, the catalogue essays reflect the expertise of leading print scholars across the country, even as the essential collaboration that launched the project remains grounded at the University of Chicago—between Chelsea Foxwell, Assistant Professor of Art History, and Anne Leonard, Curator and Associate Director of Academic Initiatives at the Smart Museum of Art. This distinguished tradition of partnership with academic departments of the University has been fundamental to the Smart Museum's exhibition program since the 1990s, thanks to the vision and ongoing support of the Andrew W. Mellon Foundation. We are very pleased at the central role that Professor Foxwell and her research assistants, art history students Stephanie Su and Mai Yamaguchi, were able to play in this project, and we thank them for their industry, dedication, and exemplary collegiality.

It is a pleasure also to thank the contributors to this publication, which is the eleventh in our series of Mellon exhibition catalogues. In addition to Chelsea Foxwell, Anne Leonard, and Stephanie Su, they include David Acton, Curator of Prints, Drawings, and Photographs at the Worcester Art Museum in Massachusetts; Laura Anne Kalba, Assistant Professor in the Art Department at Smith College, Northampton, Massachusetts; Andreas Marks, Director and Chief Curator of the Clark Center for Japanese Art in Culture in Hanford, California; Drew Stevens, Curator of Prints, Drawings, and Photographs at the Chazen Museum of Art at the University of Wisconsin in Madison; and David Waterhouse, Professor Emeritus of East Asian Studies at the University of Toronto. We greatly appreciate their illuminating essays and their sharing of advice and expertise.

Awash in Color would not have been possible without the many generous institutions and individuals who lent works to the exhibition. We thank the Art Institute of Chicago, Douglas

Druick, President and Eloise W. Martin Director, James Cuno, former President and Eloise W. Martin Director, Suzanne Folds McCullagh, Anne Vogt Fuller and Marion Titus Searle Chair and Curator of Prints and Drawings, and Martha Tedeschi, Prince Trust Curator in Prints and Drawings; the Ryerson and Burnham Libraries at the Art Institute of Chicago, Jack Perry Brown, Director, and Christine Fabian, Library Collections Conservator; the Boston Public Library, Amy E. Ryan, President, Karen S. Shafts, Assistant Keeper of Prints, and Susan Glover, Manager of Special Collections; the Brooklyn Museum, Arnold L. Lehman, Director, Joan Cummins, Lisa and Bernard Selz Curator of Asian Art, and Marguerite Vigliante, Works on Paper Study Room Coordinator; the Trammell and Margaret Crow Collection of Asian Art, Amy Lewis Hofland, Director, Caron Smith, Curator, and Katie Womack, Collections Manager; the Field Museum, Alan Francisco, Head Registrar, Department of Anthropology; the Minneapolis Institute of Arts, Kaywin Feldman, Director and President, Matthew Welch, Deputy Director and Chief Curator, and Thomas Rassieur, John E. Andrus III Curator of Prints and Drawings; the Museum of Fine Arts, Boston, Malcolm Rogers, Ann and Graham Gund Director, Helen Burnham, Pamela and Peter Voss Curator of Prints and Drawings, and Patrick Murphy, Study Room Supervisor; the National Gallery of Art, Washington, Earl A. Powell III, Director, Andrew Robison, Andrew W. Mellon Senior Curator of Prints and Drawings, Margaret Morgan Grasselli, Curator of Old Master Drawings, Carlotta J. Owens, Associate Curator, Department of Modern Prints and Drawings, and Ginger Hammer, Assistant Curator of Old Master Prints and Drawings; the National Museum of American History at the Smithsonian Institution, Margaret Grandine, Outgoing Loan Officer, and Helena Wright and Joan Boudreau, Curators in the Department of Graphic Arts; the New York Public Library, Deborah Straussman, Assistant Registrar for Outgoing Loans and Temporary Exhibitions, and David Christie, Print Collection Specialist; the Regenstein Library at the University of Chicago, David Larsen, Head of Access Services; the Spencer Museum of Art at the University of Kansas, Saralyn Reece Hardy, Director, Stephen Goddard, Associate Director and Senior Curator of Prints and Drawings, Kris Ercums, Curator of Asian Art, and Kate Meyer, Assistant Curator of Works on Paper; and the private collectors Harlow and Susan Higinbotham, George and Roberta Mann, and Charles Mottier.

For their professional services, we are indebted as ever to Katherine Reilly, who expertly edited the catalogue, and to Joan Sommers, who beautifully designed it. We also thank all those who furnished images for the catalogue, with special thanks in particular to Ann Sinfield at the Chazen Museum.

As always, we are grateful to the Mellon Foundation for its transformative support of this exhibition series and of our other initiatives to continue to make the Museum and its collections integral to the academic life of the University. In addition, thanks for major funding are due the Women's Board of the University of Chicago; the Samuel H. Kress Foundation; Ariel Investments; the Elizabeth F. Cheney Foundation; the International Fine Print Dealers Association (IFPDA) Foundation; and Thomas McCormick and Janis Kanter. For their generous support of related exhibition programming, we thank the University of Chicago's France Chicago Center, Department of Music, and Department of Art History, as well as Mrs. Betty Guttman. Additional support for the exhibition catalogue was provided by Furthermore: a program of the J. M. Kaplan Fund.

Projects such as this one can come to fruition only through the dedicated efforts of the entire Museum staff. We recognize in particular Richard Born, Senior Curator; Stephanie Smith, Deputy Director and Chief Curator; Warren Davis, Director of Development and External Relations; Katherine Nardin, Manager of Development Communications; C. J. Lind, Associate Director of Communications; Angela Steinmetz, Head Registrar; Sara Hindmarch, Associate Registrar; and Sara Patrello, Assistant Registrar. We also thank the gifted Smart Museum curatorial interns who contributed in different ways to this project: Eric Huntington, Kate Hadley Williams, and Hui Min Chang.

Most of all, grateful thanks are owed to the project's two organizers. Chelsea Foxwell has been an ideal partner, giving unstintingly of her time, knowledge, and enthusiasm ever since she arrived in Chicago. Anne Leonard has once again shepherded a complex project to a successful conclusion with the intelligence, sensitivity, and utter professionalism that have characterized all of her work. Her clear vision of the potential of this exhibition and, more broadly, her commitment to the possibilities for important collaborations with scholars and students across the University of Chicago have been responsible for much of the remarkable vitality and stimulating content of the Smart Museum's exhibition program. This catalogue provides ample evidence of those qualities. We are proud to offer the exhibition to the public.

Anthony Hirschel
Dana Feitler Director

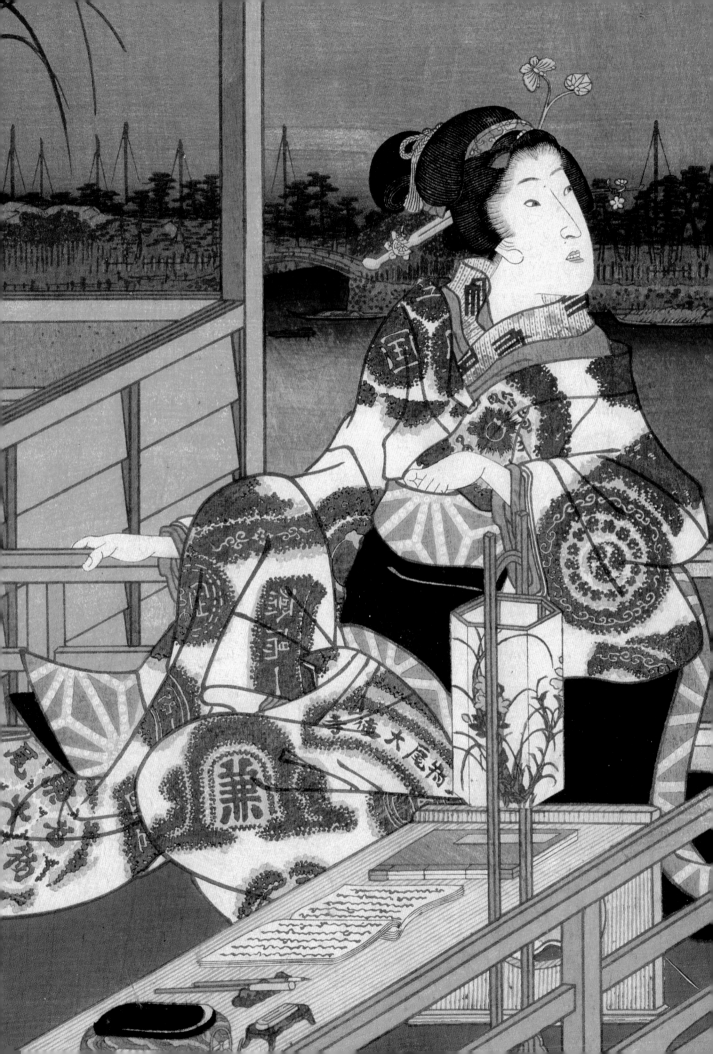

ONE OF OUR STRONGEST DESIRES at the outset of this exhibition project was that it not revalorize the one-sided *Japonisme* narrative of nineteenth-century Europeans' fascination with art coming from the East. Accordingly, we opted for a longer historical arc and a broader scope, offering a dual overview of color printing in Japan and France from the eighteenth through early twentieth centuries. Those usually considered the major figures in French *Japonisme*, such as Manet and Toulouse-Lautrec, have indeed been included here, along with examples of the Japanese artists they admired. But rather than being given outsized prominence, they find themselves woven into a larger narrative incorporating earlier color print examples as well as more commercially oriented chromolithography. Likewise, the contributions of Hiroshige and Hokusai, ordinarily put front and center in studies of *Japonisme*, have been contextualized with regard to other print developments occurring not just in Japan but also further afield, in China as well as Europe.

It seemed essential, even if we could not presume to trace an exhaustive history of Japanese and French color printmaking, to give at least some hint of its capaciousness and complexity. The argument of the exhibition is that color printmaking flourished independently in both France and Japan before the two cultures ever came into extensive contact; and that printmaking developments predating the normalization of trade and diplomatic relations between the two countries in the 1850s are what allowed the two traditions to engage with each other so productively in later years.

This comparative approach invites attention to individual techniques such as woodcut and mezzotint, along with other details of the printing process: embossing, color superimposition, the technical and economic challenges of multi-block registration, and the quest for satisfying colorants. But it also invites a comparative study of the broader patterns of production, patronage, reception, valuation, and the changing status of the artist and printmaker in each culture. Above all, by bringing together a selection of color prints from each culture over the course of over two centuries, we hope to demonstrate how viewers in each locale became accustomed to a certain range of techniques and palettes—and also to a series of functions and connotations for the color print—that would then be challenged by the rapid influx of prints from the other side of the world in the latter half of the nineteenth century. At the same moment that French artists were seeking to emulate the pale, lucid colors of Japanese single-sheet prints and books, the Japanese government was sponsoring efforts to improve facility in burin engraving, mechanized printing, color lithography, and forms of photographic reproduction, all of which would transform the potential

of images to circulate within society even as it triggered further self-reflection and innovation on the part of woodblock print producers. In each culture, then, changes in the world of color printing challenged and redefined assumptions about the creative and reproductive print, art and commerce, naturalism and stylization, citation and process-based experimentation. While this history has generally been seen as the tale of Japan's increased industrialization and national integration and of France's harkening toward a simpler time of handmade prints, it is hoped that the works themselves attest to the diverse artistic and social possibilities for the color print in history.

We are grateful to the many individuals who lent their time, support, and expertise to the exhibition and catalogue. David Waterhouse, Andreas Marks, Drew Stevens, Satoko Shimazaki, Xu Peng, Katō Hiroko, Tsunoda Takurō, Janice Katz, Aki Ishigami, Timothy Clark, Helena Wright, Joan Boudreau, Ann Yonemura, Henry Smith, Ling-en Lu, and Ryoko Matsuba provided indispensable assistance in studying and identifying Japanese prints from the Smart and from our many lenders. David Acton, James A. Bergquist, Bernard Derroitte, Gloria Groom, and Peter Parshall offered helpful advice on this catalogue, bibliographic sources, and identifications of certain Western prints. Stephanie Su and Mai Yamaguchi generously gave their time and passion to the project over the past two years, as did Hui Min Chang in the later stages of research. The Adachi Institute of Woodcut Prints contributed instructional materials about the Japanese woodblock printmaking process. May all of these, including any we have inadvertently neglected to mention, accept our sincere gratitude for their invaluable contributions.

Chelsea Foxwell and Anne Leonard

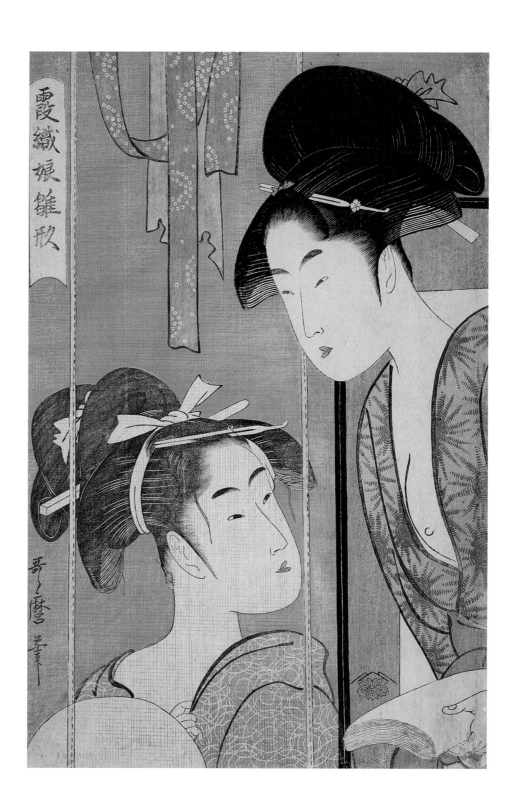

FIGURE 1
Kitagawa Utamaro,
Mosquito-net, c. 1794–95,
color woodblock print,
The Art Institute of
Chicago, Cat. 73

CHELSEA FOXWELL

ONE
THE SOCIAL LANDSCAPE OF COLOR PRINTMAKING: JAPAN AND BEYOND

WHEN WESTERN VIEWERS FIRST BEGAN their sustained engagement with Japanese art in the 1860s through 1890s, they hailed the unexpected uses and combinations of color that they encountered in textiles, ceramics, and especially woodblock prints. Edmond de Goncourt proclaimed that Kitagawa Utamaro's beauties were dressed in "the luminous colors of the anemone... the most distinguished colors of nature, the most *artistic*, and the farthest away from the European taste for frank, straightforward colors."[1] Goncourt implied that Utamaro's sense of color was derived from the study of nature, but in a way that had little in common with mid-nineteenth-century European art.

The Japanese print's alternately bold and subtle approach toward color was epitomized by Utamaro's beauties [FIG. 1], with their range of vivid greens and "unspeakable grays."[2] It also announced itself in Katsushika Hokusai's *Large Flowers* (c. 1833–34), a series that Claude Monet devoted himself to collecting around 1896 [FIGS. 2–4].[3] In this series, individual plant specimens accompanied by a bird, insect, or other small creature are depicted at eye level against a solid background devoid of titles, poetic inscriptions, or other details. The saturated yellow, peach, or blue backgrounds have now faded, but originally the surface was animated by the optical effects produced by their vivid color contrasts. Hokusai's prints were filled with the coarse, slightly alien energy of nature in a way that evoked foreign botanical prints as much as the delicacy of ordinary bird-and-flower prints.[4] The latter were customarily accompanied by poems, as in the bird-and-flower compositions presented in *The Mustard Seed Garden Manual* (see fig. 10).[5] The prints of Hokusai and Utamaro were part of a larger corpus of Japanese works that stimulated late-nineteenth-century European artists and viewers, who were engaged in exploring new possibilities for color and pictorial framing.

In the process of establishing their own break from existing European approaches to color and composition, many French writers emphasized what they saw as the startling differences of Japanese color prints, which were plentiful, sensual, and relatively unconcerned with the reproduction of polychrome paintings. Japanese prints also attended to birds, insects, vegetables, sea life, and other subject matter that could easily be seen as beneath serious consideration from the perspective of standard European genre hierarchies.

Yet for all the traditional emphasis on the differences between eighteenth- and early-nineteenth-century Japanese prints and their French counterparts, the two bear notable similarities. The comparison can also be extended to the rise and flourishing of color printmaking in parts of China in the final decades of the Ming dynasty (1368–1644). In each case, urban growth, socioeconomic mobility, and a thriving publishing industry fostered the color print as a desirable commodity; not coincidentally, in each place color prints also visualized contemporary class and gender identities and bore frank associations with commerce, fashion, sex, and women.

While color printing in each place was remarkably similar, Western commentators tended to ennoble Japanese prints as art objects even while calling attention to their humble status in Japan.[6] Meanwhile, French color prints were less highly esteemed in many cases. This disparity was aided by the fact that Western admirers were culturally removed from Japanese prints and could appreciate their visual qualities—along with their irreverence and eroticism—without themselves being implicated. Until the 1890s, when color printmaking in France had begun to flourish in elite artistic circles, it was easier for many French collectors to indulge in color prints from abroad than to champion them at home.

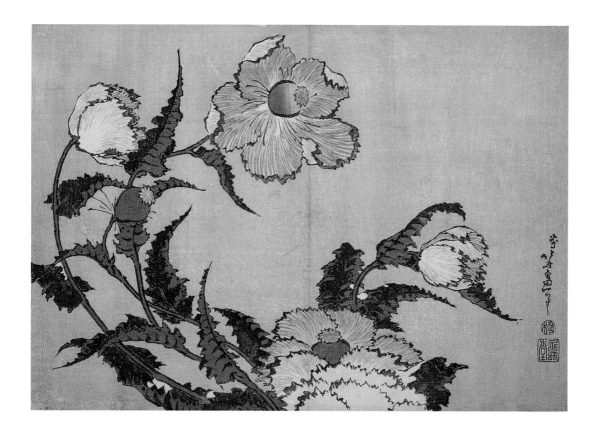

FIGURE 2
Katsushika Hokusai, *Poppies*, c. 1833–34, color woodblock print, The Art Institute of Chicago, Cat. 70

FIGURE 3
Katsushika Hokusai, *Morning Glories and Tree Frog*, c. 1833–34, color woodblock print, The Art Institute of Chicago, Cat. 69

FIGURE 4
Katsushika Hokusai, *Hydrangea and Swallow*, c. 1833–34, color woodblock print, The Art Institute of Chicago, Cat. 68

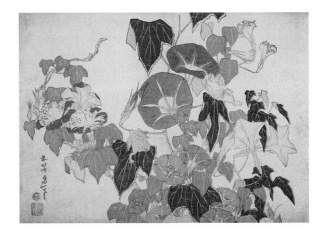

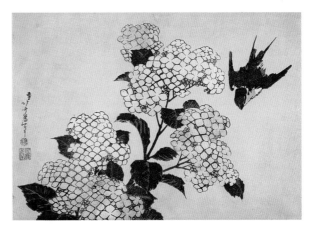

Desire and the Color Print

THROUGHOUT THE SEVENTEENTH CENTURY in China and the eighteenth century in Japan and Europe, technological innovations led from simple hand-coloring to increasingly meticulous and labor-intensive printing with one, two, or more colors. That said, the embrace of color was never simply a question of technical knowledge; it flourished when and where the market supported it. Whether in copper plate or woodblock, color printing was so tedious and expensive that it required steady overall demand as well as persistent commitments from individual patrons and innovators. Single-tone prints, by contrast, could be produced in quick succession.

Nor was the need for printed colors acute, especially given the longstanding prevalence of hand-colored prints in both Europe and Asia. In China and France, court printmaking studios experimented with color printing when funding and patronage allowed; in each place, as in Japan, private publishers in wealthy, densely settled areas used marketing to incite desire for new products.[7] In Edo Japan, Okumura Masanobu, an important early designer of *ukiyo-e* prints and guides to the pleasure quarters, also ran a publishing business and claimed to be the originator of several print innovations including *benizuri-e* ("pink-printed pictures," early color printing in two to five colors). By attaching a name and a founder to ideas and processes as they were being developed, Masanobu helped provoke and crystallize demand while directing attention away from his competitors.[8]

Marketing savvy paved the way for technological innovation, for the latter was rarely sufficient on its own. In early-eighteenth-century Europe, for example, J. C. Le Blon revolutionized the field of color printing with his three- and four-plate color mezzotints, but his ventures ended in bankruptcy. Malcolm Charles Salaman once proposed that "Le Blon's failure in London. . . was due chiefly to injudicious selections of subjects for his prints.[. . .] He chose Italian subjects which were faddishly and 'indiscriminately' collected among the British aristocracy, without realizing how small could have been the appeal to a public that had cultivated no pictorial taste whatever." Had Le Blon been conscious of the need to cultivate a broader audience base and the support of art dealers, adjured Salaman, "the history of colour-printing in France, and possibly in England too, would have been different."[9]

In Japan, the patronage of the well-to-do members of poetry groups provided the critical funds needed to effect the rapid transition from *benizuri-e* to the full-color printing of *nishiki-e* (brocade pictures).[10] Here, it is no coincidence that the single-sheet color prints that took Edo society by storm in the Meiwa era (1764–72) were privately distributed calendar prints (*egoyomi*), images that evaded the official government monopoly on calendar production by embedding the numbers of the long and short months within a witty, elegant, or auspicious picture. The prints were exchanged at parties where samurai officials mingled with wealthy merchants and elite artisans. The images were frequently tinged with eroticism and determined by notions of time-sensitivity, transgression, and the literal need to be up to date; it is therefore not surprising that pictorial calendars were among the earliest *benizuri-e*.[11] These objects must have circulated intensively during a short period of time before becoming practically obsolete. Once the deadline-oriented initial outpouring of money and effort had culminated in a successful design, certain calendar prints were later reissued without the calendar marks and sold on the open market, as in the case of Suzuki Harunobu's *Couple beside a Well* [FIG. 5], whose figures are dressed in patterned robes that showcase the delicate registration of the new multi-block printing (see Waterhouse essay in this volume).[12]

In China as in Japan, color woodblock printing first flourished in a growing urban region: in this case, seventeenth-century Suzhou and nearby cities in the wealthy Jiangnan delta. Color printing became far more widespread in Japan than in China, and while *ukiyo-e* prints streamed into the European market in the late nineteenth century, relatively few Chinese color prints reached the West prior to the 1900s. Nor did these works come to occupy a significant place within narratives of the history of East Asian art. In 1907, Laurence Binyon marveled at the discovery of twenty-nine vividly colored images of birds, flowers, fruits, and antiquities among the British Museum's Sloane drawings [FIG. 6]. These are now recognized as eighteenth-century products of the Ding family workshop in Suzhou.[13] Binyon noted with amazement that "besides black. . . no less than twenty-two colors have been employed," twelve individually discernible, and ten by superimposed printing.[14] In 1929, upon studying the British Museum's early Qing-dynasty color prints of elegant beauties and children, he emphasized, "among these newly discovered woodcuts we find for the first time some which hint at the existence of a Chinese 'Ukiyo-ye' occupied in making cheap prints of girls, mothers and children, and such-like subjects."[15] Drawing a contrast with Japanese prints, the British curator implied that China's sophisticated color printmaking tradition had nearly disappeared from the record: "no doubt considered as totally beneath the consideration of a Chinese connoisseur," he wrote, "[t]hese prints were obviously very cheap and common

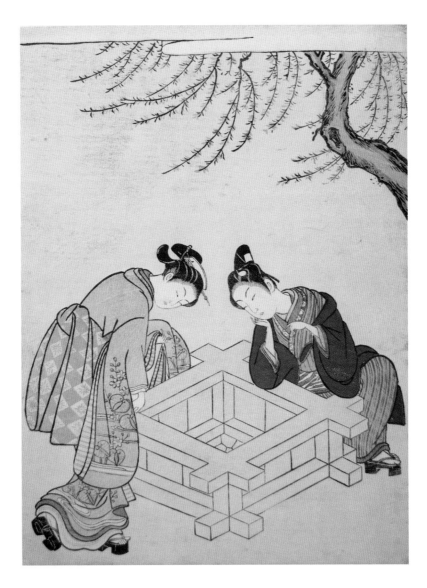

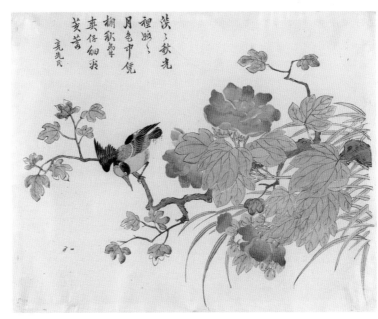

FIGURE 7

Number 19, from *The Romance of the Western Chamber*, 1977 facsimile of 1640 original, University of Chicago Library, Cat. 125

FIGURE 8

Bowl, China, late Qing dynasty, 19th century, porcelain with overglaze enamels, Smart Museum of Art, Cat. 137

productions; hence their extreme scarcity, since no one deigned or troubled to collect them." Binyon further noted that the eighteenth-century southern Chinese prints "have all the appearance of having been, like the Japanese colour-prints, designed for engraving" rather than being reproductions of existing paintings.[16] The utter refinement of the printing technology, combined with the prosaic nature of the auspicious subjects and compositions, immediately suggested "a mass of popular prints, long perished," and with it areas of early modern Chinese cultural history that had yet to be reevaluated by scholars and collectors.

Even earlier, in the first half of the seventeenth century in China, the labor-intensive technology of color printmaking was used to illustrate theatrical texts such as *The Romance of the Western Chamber (Xixiang ji)*, erotica, painting manuals, and stationery for letters and poetry, in ways that often approximated certain effects of painting without directly copying them. The remarkable 1640 Zhejiang edition of the *Romance* published by Min Qiji, for example, depicted scenes of the

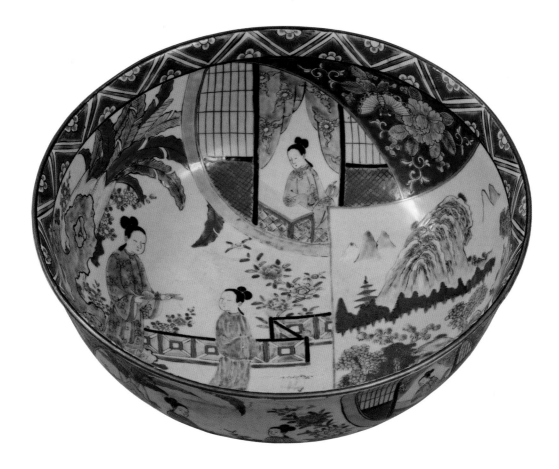

romance as portrayed on the surface of a different object or re-staged in other media [FIG. 7]. This delicate metapictorial approach to the text suggested a reader-viewer who was highly attuned to the circulation of the romance's images in painting, print, theater, and on the surface of ordinary objects such as cups or fans.[17] It also points to the lively relationship between prints and new developments in the polychrome ornamentation of Chinese ceramics. The late Ming and early Qing dynasties saw the depiction of colorful scenes from plays and novels on the surfaces of large porcelain vases and other objects: "five colors" (wucai) wares decorated with underglaze cobalt blue and overglaze enamels show scenes that bear a compositional relationship to the monochrome woodblock-printed book illustrations as well as single-sheet prints: while some attempt at modulation has been made, the nature of the overglaze enamels led to the production of surfaces with unmodulated zones of color for the clothing, furniture, and other details, which appear like props or roundels floating on the white surface of the vessel [FIG. 8].

Access to new chemical compounds for coloring via trade with the West further expanded the palette of overglaze enamel-decorated porcelains; in certain carefully painted works on porcelain or metal, enamels were mixed with white to achieve a high degree of delicate tonal modulation [FIG. 9].[18] Heavily exported to the West in the eighteenth century, the finished products came to provide an important foundation for the fanciful images of China seen in European *Chinoiserie*: Delicate scenes rendered in opaque and translucent pastel colors against a solid background with limited spatial elaboration, flat areas of pooled glaze, and lighthearted motifs suggested a fantasy world to delight the eye with little grounding in reality. Yet as shown by the Crow Collection piece,

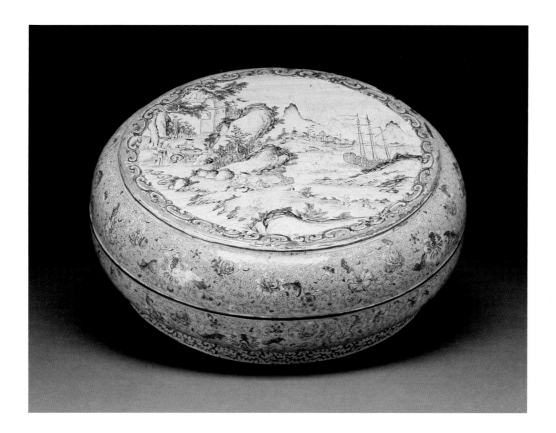

FIGURE 9
Lidded Box Painted with Scenes of Europeans in China, China, Qing dynasty, late 18th century, Guangdong ware, enamel colors on tin, Trammell and Margaret Crow Collection of Asian Art, Cat. 136

which presents an imagined Chinese vision of Europeans relaxing in a landscape, the colorful, dreamlike effect of late Ming and Qing Chinese porcelains and related arts developed as the result of an East–West technological exchange (in terms of both colors and enameling techniques) and in response to consumer demand from both regions.

Chinese color printing was used for a limited number of painting manuals and poetic letter papers [FIG. 10] and for amorous or openly erotic images, some of which appear to have found their way to Edo Japan.[19] A print in the British Museum shows a night scene from a printed or performed romance in which a young gentleman dallies with a lady who attempts to conceal him from a maid [FIG. 11]. Her skirt lifts to show her calf, and an elaborately curtained bed stands behind

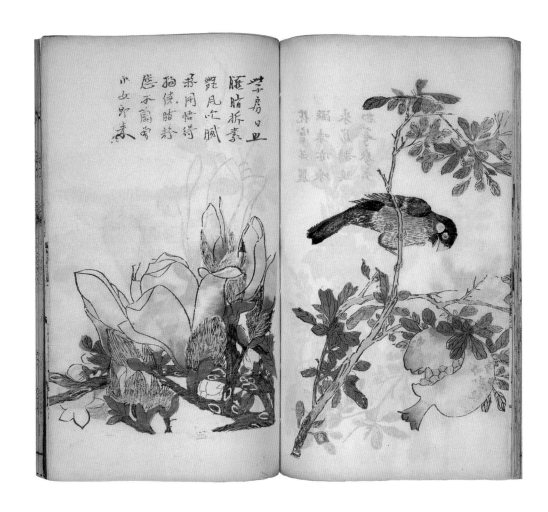

FIGURE 10
Wang Gai, page from *The Mustard Seed Garden Manual*, 1818 edition, University of Chicago Library, Cat. 128

FIGURE 11
Artist unknown, *Cui Hu Stealing the Slipper*, early Qing dynasty, color woodblock print

them. It is easy to imagine this image as the lead-in to a collection of more explicitly erotic scenes; indeed, erotica are among the earliest known full-color Chinese woodblock-printed images. The famous *Pictures at the Height of Sophistication (Fengliu juechang tu)*, for example, has a preface dated to 1606 and was long known in Japan, where it was likely emulated by Moronobu.[20] The late Ming books, with their alternating pages of poetry and images, show delicate, effete couples engaged in loveplay in finely appointed interiors stocked with screens, flowers, furniture, and decorative arts. The color-printed erotic book with its embossing and unusual color effects thus appears to have been part of a larger cult of finely made things that was well represented in erotic painted albums and especially associated with the luxury craft studios of the Jiangnan region, where the prints were made.[21] In this sense, Chinese color prints related to other forms of sensual pleasures sought by the well-to-do.[22]

Here, the eroticism of eighteenth-century French color prints is a significant point of comparison. In *Indiscretion*, a color aquatint by Philibert Louis Debucourt, two young women are shown by a silk canopied bed in an aristocratic interior. With certain key differences, such as the location of the male lover "offstage," outside the frame of the image, the print with its elaborately framed bed and dishabille strikingly resembles the roughly contemporaneous Chinese color woodblock print. The seated woman, in a peignoir, has her left hand behind the corseted waist of the visiting lady and reaches in front of her in an attempt to grasp the love-letter or note that the elegant caller has snatched from her hand. Feminine intimacy centers on the retelling of a romantic encounter with a male lover who is absent the scene but also constitutes it. In Debucourt's *The Ascent, or The Morning Farewell*, an amorous country couple parts in the midst of an idyllic landscape whose colors resemble the rich, dark tones of oil painting (see fig. 74). A 1949 account of Debucourt, Jean-François Janinet, and their contemporaries notes that some of Janinet's works "unfortunately had already been destroyed as being unseemly," suggesting a tradition of French color-printed erotica that is today perhaps less prominent than erotica by Japanese *ukiyo-e* masters.[23]

Like their Chinese and Japanese counterparts, the French *estampes galantes* of the ancien régime provided an imaginative glimpse into interiors finely appointed with paintings, furniture, robes, and books.[24] In all these works, the appreciation of finely made things, with their sensuous surfaces, as Jonathan Hay has termed them, appealed to the sense of touch and "involved the beholder in erotic possibilities of self-realization and connectedness that dissolved the internal and external boundaries of the social."[25] The success of color printing rested on forms of desire that circulated among the image-conscious, upwardly mobile inhabitants of the rapidly growing urban centers of China, Japan, and France.

The Blue Revolution and Beyond

FULL-COLOR "BROCADE PRINTS" IN JAPAN developed around 1765, just as the Kyoto painters Itō Jakuchū and Maruyama Ōkyo were separately experimenting with new forms of color application, life sketching, and modes of seeing stimulated by images from Qing-dynasty China and the West.[26] Within the Edo bookshops and vending stalls of illustrated fiction and other light reading (*kusazōshiya*, "booklet shops") where woodblock prints were sold, prints vied for the viewer's attention: the fact that they were displayed side by side with dozens of similar works meant that they sold based on their ability to lure the viewer by the novelty of their design, palette, and subject matter.[27]

Even a limited number of color combinations could create a striking surface. Recent analysis has demonstrated that Kiyonaga's color prints achieved the effects of full-color printing with just four different colors plus ink, which could be both blended and superimposed to yield a range of composite hues.[28] Meanwhile, the idea of deliberately restricting a print's color palette appears throughout the history of "full-color" printing in Japan. While the fugitive nature of certain colors, especially blue, has limited our appreciation of the initial range and intensity of colors, many printmakers seemed to exercise restraint to create a striking composition: In Utamaro's print, for example, the green of the bamboo blinds is counterpoised with the pink sash hanging at upper left, while the summer robe is delicately printed in superimposed blue and pink (see fig. 1).

In the 1830s, Berlin blue (bero), available through Dutch and Chinese importers, began to be widely used in woodblock prints, effecting what Henry Smith has memorably called a "blue revolution" in printmaking. Far more vivid and permanent than the blue dyes previously available, it transformed the color palette of Japanese prints and helped ukiyo-e printmaking expand its themes beyond actors and beauties to cover landscapes and other subjects. Hokusai's Thirty-six Views of Mt. Fuji was not the first series to print the landscape in blue instead of black, but it brilliantly demonstrated the color's potential for landscape: the famous Great Wave off Kanagawa, Mishima Pass in Kai Province [FIG. 12], Fuji from beneath Mannen Bridge at Fukugawa [FIG. 13], and others made exclusive use of the color for the water, sky, and distant views. Other prints in the series continued to use a blue key block to print outlines customarily printed in black, but blue was combined with other hues to create the effects of a lyrical landscape tinged with atmospheric perspective.[29]

The idea of using blue to suggest the cool of evening or a bath predated the introduction of bero. Even in Kiyonaga's time, blue connoted cool, refreshing qualities; it also evoked the ubiquitous indigo-dyed blue cotton robes worn in summer and at the bathhouse.[30] In a Kiyonaga pillar print, an elongated beauty appears to have emerged from the bath, wrapping a thin blue robe loosely around her figure as she exchanges words with a man outside her window [FIG. 14]. In a similarly relaxed image, In a Public Bathhouse, three beauties wear variously patterned blue-and-white cotton robes; the center figure is fully dressed, while the one on the right tends to her pedicure and the one on the left wraps a rose-colored undergarment around her waist [FIG. 15]. Both reddish pink and peach serve as foils to the pale, translucent blues, with a limited number of colors conveying the cool sensation of stepping out of an evening bath.

Prints produced in blue in the nineteenth century continued the association with evening cool—in blue landscape scenes on the surface of paper fans, for example—even as they used the new pigment to create unprecedented renderings of the deep evening sky.[31] The mid-nineteenth century saw the emergence of dark colors in ukiyo-e as never before: when Utagawa Kuniyoshi's famous print The Earth Spider Generates Monsters at the Mansion of Minamoto Raikō appeared in 1843, viewers perceived the work as a political satire, with one contemporary diarist adding that the triptych's dark coloration and eerie theme immediately set it apart from ordinary ukiyo-e prints [FIG. 16].[32] Once introduced, the dark palette enhanced by deep blue remained popular, buoyed by the visibility of occult or macabre themes in the kabuki theater, where viewers crowded into dimly lit theater spaces to share moments of suspense and dramatic irony. In a mid-nineteenth-century print, the actor Onoe Kikujirō II appears in the role of Funadama Osai, Kawatake Mokuami's sword-wielding female character who wears the guise of a Kumano bikuni, or itinerant nun.[33] At one

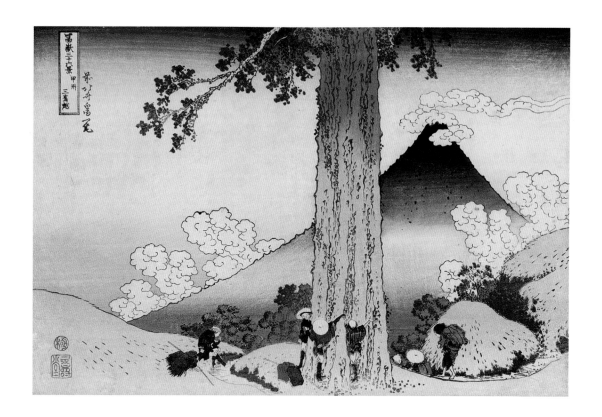

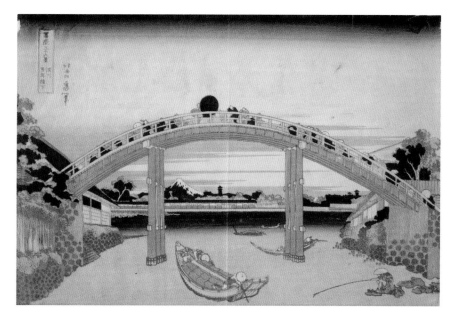

FIGURE 12
Katsushika Hokusai, *Mishima Pass in Kai Province*, early 1830s, color woodblock print, Smart Museum of Art, Cat. 67

FIGURE 13
Katsushika Hokusai, *Fuji from beneath Mannen Bridge at Fukagawa*, early 1830s, color woodblock print, Spencer Museum of Art, Cat. 65

FIGURE 14
Torii Kiyonaga, *Girl in a Blue Robe Whispering to a Man outside through a Latticed Window*, 1784, color woodblock print, Collection of Mr. and Mrs. Harlow Niles Higinbotham, Cat. 96

FIGURE 15
Torii Kiyonaga, *In a Public Bathhouse*, c. 1783–84, color woodblock print, The Art Institute of Chicago, Cat. 97

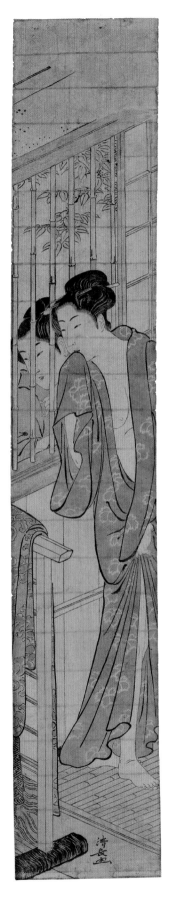

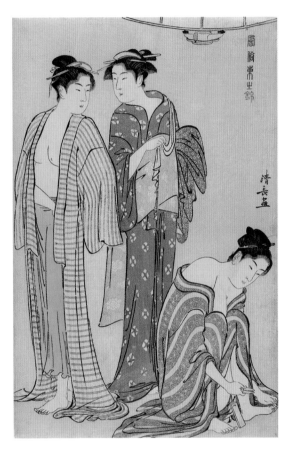

moment in the play, Osai removes her head covering, and the hair from her recently shorn head billows forth as she crouches in the grasses with the full moon above [FIG. 17]. In Utagawa (Andō) Hiroshige and Utagawa Kunisada's *An Elegant Genji: Tsukuda*, the horizon is accented by the shadowy profiles of ships in the harbor. The water and the moonlit sky are both a deep blue, and the woman's robe is white with an assortment of dark blue motifs [FIG. 18].[34] Finally, in Kunisada's image from *Thieves in Designs of the Times*, the actor Ichikawa Kodanji IV is portrayed as the ruffian Subashiri no Kumagorō. Midstride, with his right arm awkwardly outstretched and holding a bundle of money wrapped in a homely red-and-yellow cloth, Kodanji emerges from a deep blue background suggesting the darkness of night [FIG. 19]. As he leers at the viewer, he appears to shake off his robe, flamboyantly decorated with a raised-embroidery design of carp and waves, so that the design is literally animated by the wearer's body (a similar but unrelated robe is worn by Madame Monet in the painter's famous *Japonaiserie* of 1876). By placing the posed, extravagantly dressed figure against a stark background, Kunisada highlighted the movements of the actor's body that were so savored by fans.

 Bero made its most transformative impact on landscape prints. Some scholars speculate that Hokusai's *Thirty-six Views of Mt. Fuji* began as depictions of the immortal mountain in monochrome blue-printed sheets evoking the blue-and-white ceramic landscape tradition—essentially paying tribute to the mountain by phrasing it in terms of the ideal Chinese landscapes that appeared on the surface of porcelain vessels from China.[35] Gradually Hokusai added other colors to successive prints in the series. The most famous of these is the *Great Wave*, in which Mt. Fuji appears about to be consumed by an enormous cresting wave. The mouth-like wave was already a known motif when Hokusai cleverly appropriated it for his image, and subsequent to his Fuji series, "great waves" appeared with increasing frequency. Utagawa Yoshikazu uses undulating, clawlike waves printed in two shades of blue in his print of the legendary Minamoto no Yoshitsune confronted by the ghost of his enemy Taira no Tomomori at sea [FIG. 20]. Here the waves are tense and jagged, evoking the upsurge of the supernatural that threatens to engulf the living. Above the

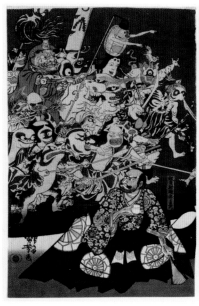

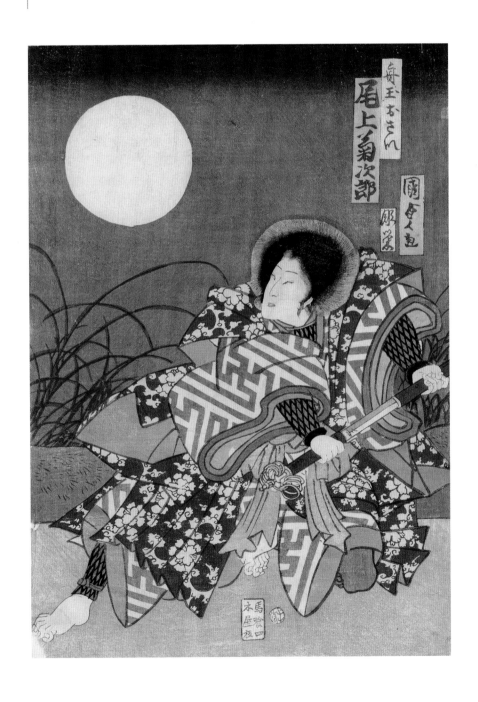

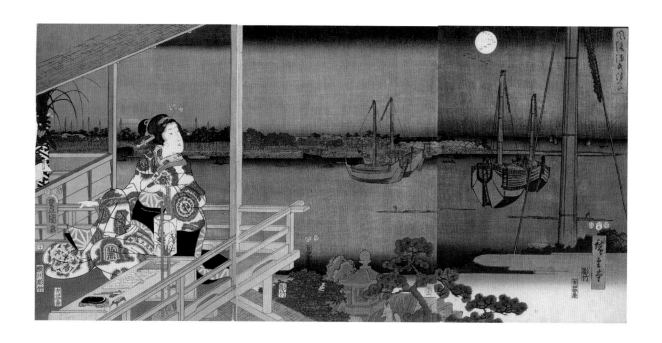

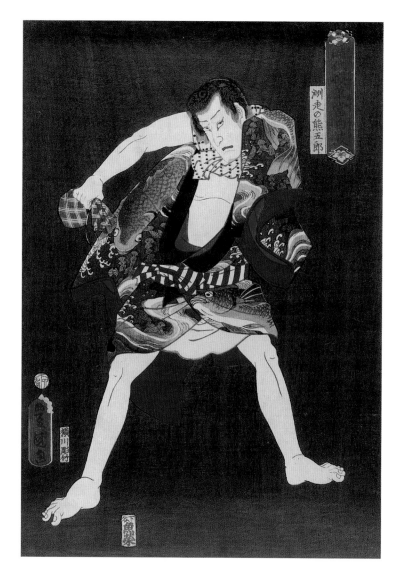

FIGURE 18
Utagawa (Andō)
Hiroshige and Utagawa
Kunisada, *An Elegant
Genji: Tsukuda*, 1853,
color woodblock print,
Brooklyn Museum,
Cat. 108

FIGURE 19
Utagawa Kunisada, *The
Actor Ichikawa Kodanji IV
as Subashiri no Kumagorō*,
1859, color woodblock
print, Brooklyn Museum,
Cat. 110

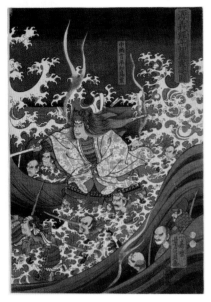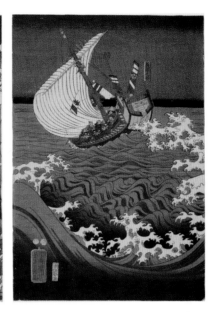

FIGURE 20
Utagawa Yoshikazu,
*Meeting of Minamoto no
Yoshitsune and the Ghost
of Taira no Tomomori*,
c. 1851–53, color wood-
block print, Spencer
Museum of Art, Cat. 117

FIGURE 21
Ochiai Yoshiiku, *Night
Parade of One Hundred
Demons at Sōma Palace*,
1893, color woodblock
print, Spencer Museum
of Art, Cat. 78

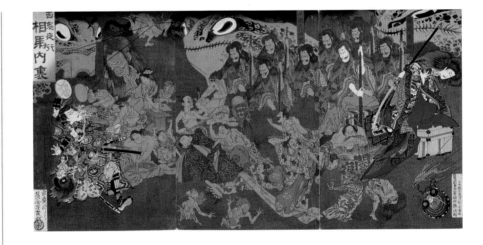

firmly delineated horizon line, the sky is printed in rich black with impressed and likely hand-wiped gradations, heightening the eerie mood.[36]

The blue revolution in *ukiyo-e* was followed by a move away from the watery, jewel-like tones of earlier prints toward deeper, more saturated colors. This trend continued into the Meiji era (1868–1912), when the popularity of performed tales of the supernatural was reflected in prints such as Ochiai Yoshiiku's *Night Parade of One Hundred Demons at Sōma Palace* [FIG. 21]. Black pigment had always been available in the form of ink, but only occasionally, and arguably only in the modern age, was it used to create such a sinister mood.[37] While the low horizons, saturated colors, and dramatically shaded skies of Western landscapes may have prompted increased attempts to print dark skies in *ukiyo-e* prints, that naturalism also opened up the possibility for new forms of expression.

Enlightenment and Longing: The Colors of the Meiji Era

THE DEVELOPMENT OF THE EUROPEAN organic chemical industry in the nineteenth century led to the synthesis of aniline dyes or "coal-tar colors," "the fashionable colors named Aniline purple, Tyrian purple or Mauve, Violine, Roseine, Fuchsine or Magenta . . . Aniline green or Emeraldine, Azuline, &c."[38] Beginning around midcentury, these water-soluble synthetic dyes were readily prepared on the commercial scale from benzene and other organic molecules extracted from the condensation of tar gas. As documented by a color fashion plate (itself possibly printed with red and purple aniline dyes) in the *Englishwoman's Domestic Magazine*, Queen Victoria wore a mauveine (purple) dress to the London International Exhibition of 1862.[39] Used to dye cloth, the affordable yet intense colors soon found their way into the studios of Japanese printmakers, where they were applied to all genres of print. With the coincident emergence and flourishing of so-called "Yokohama pictures" (*Yokohama-e*) in the 1860s and "enlightenment pictures" (*kaika-e*) in the early Meiji period, the new Western colors became synonymous with celebratory depictions of the new social and political landscape of Meiji Japan.

An album of early to mid-Meiji prints in the Smart Museum epitomizes the association of intense aniline dyes with the pageantry and building projects of the new regime. In *The Opening of the Exposition at Ueno Park* by Kobayashi Eisei, an aerial view of the new park is crowned by a deep red sky that contrasts with the deep green trees and pink cherry blossoms. Even the windows of the new Art Gallery bear rectangular panels of colored stained glass [FIGS. 22–23]. The text at upper right explains the nature of a public exhibition, noting that "the purpose is to promote competition among agriculture, manufacturing, and business, so that in striving to refine their techniques and refusing to cede their position to others they display their pride and allow Japan's manufactures to succeed and flourish."

Woodblock prints continued to be a fixture of life in Edo-Tokyo through the 1890s, but color woodblock prints began to decline in numbers and profitability as newspapers, photoengraving, lithography, and the printing press penetrated daily life. A writer in 1890 noted that there were two basic types of *ukiyo-e* print buyers: tourists who brought them home to people in the countryside and collectors who bought them "for their own reference" (*sankō no tame*).[40] Beginning with the Satsuma Rebellion of 1877, war or other political disturbances also became catalysts for print sales. When the great Meiji general Saigō Takamori was induced to lead the Satsuma Rebellion against the Meiji government in distant Western Japan, woodblock prints portraying him in a

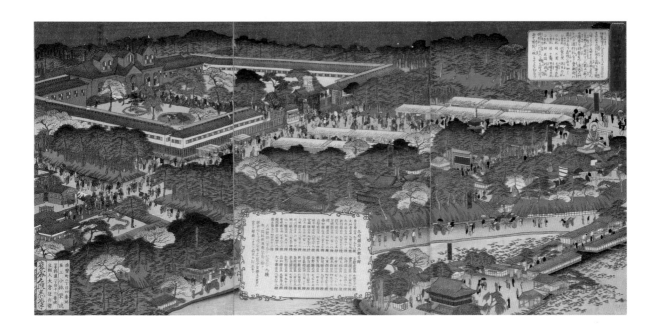

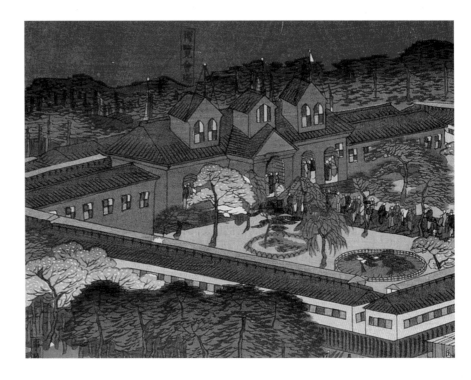

FIGURE 22
Kobayashi Eisei, *The Opening of the Exposition at Ueno Park*, 1877, color woodblock print bound in album, Smart Museum of Art, Cat. 118

FIGURE 23
Detail of fig. 22

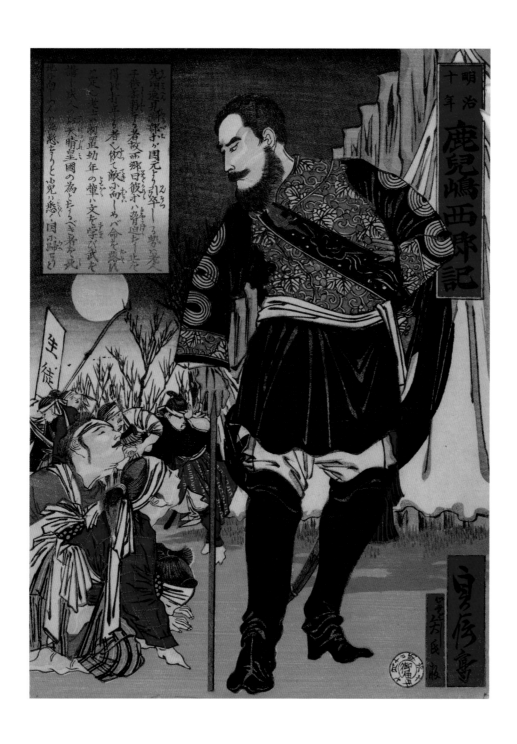

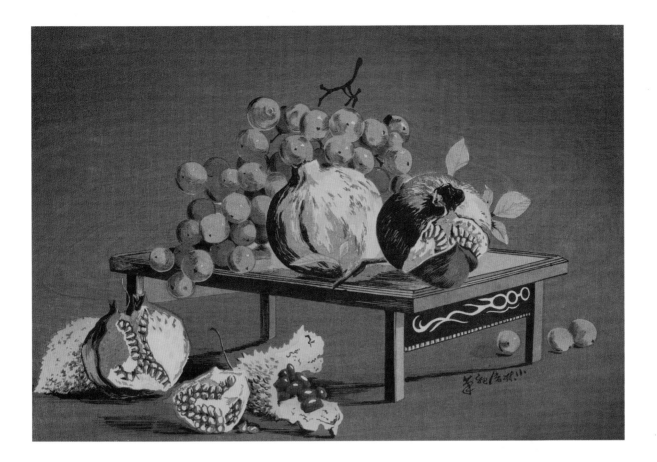

positive light circulated widely even as the government sought to discredit the rebels. An Osaka woodblock print designed by Hasegawa Sadanobu II portrays Saigō in profile and in mid-stride, his broad chest covered by the floral crest of the imperial family [FIG. 24]. The text states that when the rebel leader Fuchibe Gunpei brought a group of women, old men, and youths to fight against the new government's forces, Saigō chided them and sent them home, responding that it would be cruel to send young people to their deaths. The image and text together establish a delicate position between heralding Saigō's virtue and authority as a general while signaling his dedication to the imperial house.[41]

As an urban medium that could circulate and negotiate between different groups of people and between old and new, the color woodblock print offered opportunities to reflect on the changes of the new era and even on the capacity of the medium itself to withstand them. In the late 1870s and early 1880s, Kobayashi Kiyochika produced experimental prints with his publishers Matsuki Heikichi and Fukuda Kumajirō. The still life *Pomegranates and Grapes* uses woodblocks to re-create the effects of American wood engravings and lithographs, particularly their concern with lighting contrasts and the expression of volume [FIG. 25]. According to the notes of the *shin-hanga* (New Print) publisher Watanabe Shōsaburō, who reprinted some of Kiyochika's works from the original blocks, the artist's experimental still-life and genre prints of this period required as many as nineteen wood blocks, each carved front and back.[42] To complete the Western effect, Kiyochika signed his name horizontally beneath the table. A cast shadow and three fallen grapes suggest the immediacy of human presence; while such tropes were characteristic of the most mundane American book and magazine illustrations, they were new to most Japanese viewers in the 1870s.[43]

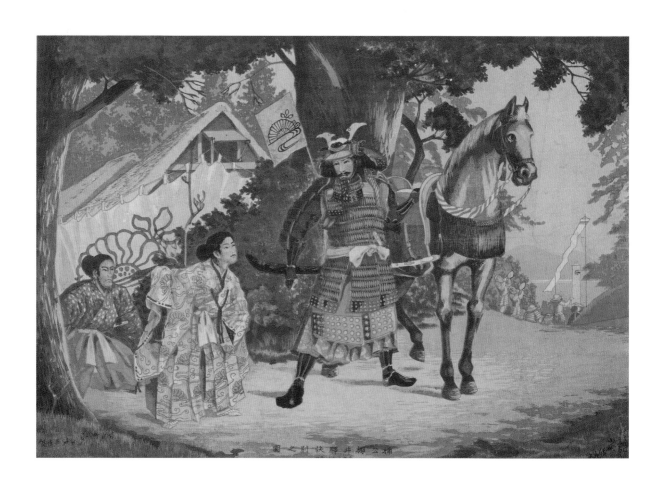

FIGURE 26
Kobayashi Kiyochika,
*Departure of the Warrior
Kusunoki Masashige
at Sakurai Station*,
c. 1880–99, color
woodblock print, The
Minneapolis Institute of
Arts, Cat. 76

Kiyochika continued to study Western images throughout his long career, but he favored watercolor and was quick to abandon the dark, hard-edged style of conventional Western engravings.[44] In his woodblock print *Departure of the Warrior Kusunoki Masashige at Sakurai Station,* colored cross-hatching lends the image a loosely brushed feel characteristic of lithography. The green foliage is printed with a minimum of black outlines, achieving the lush, moist effects of a watercolor sketch. The subject is Kusunoki Masashige, a medieval general who supported Emperor Go-Daigo's failed attempt to overthrow the Kamakura shogun, sending his young son to safety as shogunal forces pressed in and Masashige prepared for death [FIG. 26]. Because of its themes of imperial loyalism, family sentiment, and hope for the future, this episode was overwhelmingly popular in the early to mid-Meiji period, when artists, critics, and government officials first began to envision forms of history painting and historical drama that would be relevant to contemporaneous nation-building concerns. The work bears thematic resemblances to Sadanobu's image of Saigō Takamori dispatching the youth of Kagoshima so that they might grow up and "serve this great imperial nation" (*nochi appare kōkoku*) instead of dying on the battlefield (see fig. 24).

Late-nineteenth-century Japanese printmakers and viewers confronted a period of symbolic and technological flux as the practical possibilities of reproductive technology and color printing were undergoing rapid changes in the West. At the world's fairs of the 1860s through the 1880s, Japanese woodblock prints were ennobled by the universal-sounding term *chromoxylography* and appeared to match or surpass any forms of commercially viable full-color printing available in Europe.[45] In the first years of Meiji, many Japanese books and texts were still printed by individually carved wood blocks instead of by metal moveable type, ensuring an abundance of experienced block-cutters and printers who could easily combine word and image, and Japanese and Chinese scripts, on a single page. By the late 1880s, however, the transformation to moveable type and concurrent embrace of the printing press, lithography, and photogravure was well underway.

Individual masters were as brilliant as ever, but the rhetoric of decline had become prominent by the late 1880s. One contributor to the *Yomiuri* newspaper wrote, "This newspaper has carried many articles by those who lament the decline of Tokyo's famous Eastern brocade prints [*azuma nishiki-e*], and call for their reform and preservation [*kairyō hozon*]." The article then goes on to profile a new series of "reformed *ukiyo-e*" (*kairyō nisihiki-e*) by Kiyochika and his publisher Matsuki Heikichi.[46] In 1890, a contributor to the paper again called attention to the decline (*suisei*) of color woodblock prints. He claimed that within the past five years, the volume of *ukiyo-e* prints had decreased by almost half; moreover, by mixing traditionally available colors with Western dyes or poor-quality colorants, the prints reputedly changed color within a few months.[47] In Meiji, eighteen publishers had formed a new guild in order to stabilize the prices and quality of *ukiyo-e* prints, and the article closed with an appeal for "preservation and [quality] reform" within *ukiyo-e*. Meanwhile, there were reports in 1889 that "a Parisian company is publishing color lithograph reproductions" of Utamaro's famous prints, "even to the lengths of faithfully copying the shabby old colors [*furuboketa iro*], and it is said that they will send several samples of their work back to [Japan]."[48]

Woodblock printmakers and designers of the 1880s onward thus approached their work with a mixture of awareness of the Western appreciation for older Japanese woodblock prints and an ironic sense of the inevitability of technological change. Around this time, enterprising publishers began to explore the use of *ukiyo-e* prints as a color reproductive medium, although the print runs

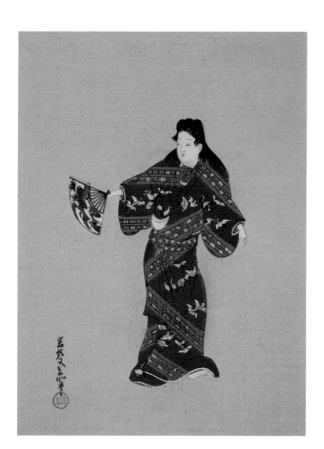

FIGURE 27

Iwasa Katsushige, 1887, color woodblock print, Spencer Museum of Art, Cat. 61

FIGURE 28

Yōshū (Hashimoto) Chikanobu, *The Illustrious Nobility of the Empire*, 1887, color woodblock print, Spencer Museum of Art, Cat. 122

of woodblock prints were necessarily much smaller and more time-consuming than those of color lithographs. While East Asian painting manuals, or *gafu* (see cat. nos. 126 and 127), sometimes reproduced specific works, reproductive prints prior to the late nineteenth century tended to be memory images synthesizing a painter's best-known compositions and subjects. One early example of such an approach appears in the print series *A Comparison of Beauties by Famous Masters of the Past* compiled by the publisher Aoki Tsunesaburō. His two sets of twelve color woodblock reproductions present beauties loosely based on the work of established Japanese painters throughout history, including Hishikawa Moronobu and Iwasa Katsushige [FIG. 27]. Each print produces an image that was iconographically similar to the artist's most famous works, although the individual features and clothing patterns differ, suggesting that the print artist and publisher probably had little access to treasured originals. It also points to general indistinctness regarding the identity of figures like Katsushige, whose names functioned like placeholders denoting the earliest period of *ukiyo-e* painting.

Why did Japanese print artists and publishers prior to the Meiji period not take greater advantage of color printing technologies to reproduce famous paintings as in the West? This may have been a question of demand or of the publishers' inclinations. Another answer lies in the Tokugawa status system, which established the ruling powers and their affairs as off-limits to print circulation and separated painters into two rough categories: those who bore samurai status and waited on members of the elite, and those whose status was closer to that of artisans. Until the dawn of the Meiji era, when the new government strove to create the image of a modern monarch [FIG. 28], living emperors were usually depicted indirectly.[49] While information concerning the lineages

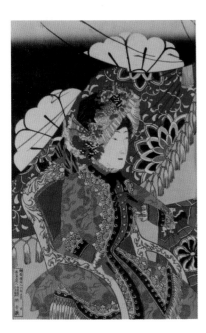 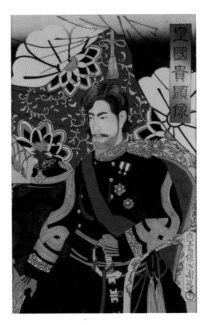

and personal affairs of the elite circulated in manuscript form among commoners, often without eliciting any protest from superiors, publicizing it in print was to be avoided.[50]

There is reason to believe that this approach held for objects as well. Instead of leaving treasures continually on view, late medieval and early modern Japanese collectors emphasized what Nicole Rousmaniere has called decoration as "a process. . . reflecting the transformation of the ordinary into the extraordinary." A cherished object's default position was in storage, while the act of unveiling or displaying it took on a variety of political and aesthetic meanings.[51] The ability to conceal and reveal one's possessions and thereby to admit or exclude others from seeing them helped reinforce established status hierarchies. The savoring of the moment of display or unveiling led to an environment in which few collectors would actively disseminate copies of works in their possession. Artists, too, kept art treasures and even copies of rare works carefully locked away in their storehouses: Maruyama Ōkyo's pupil and benefactor, for example, noted that the painter made sketches of rare objects for use in future works, squirreling them away in his storehouse and telling no one of his impressive holdings.[52]

This changed dramatically in the modern period. Just as medieval shoguns had once forced imperial princes and other subordinates to lend cherished hand-scrolls to their "painting matches," the Meiji government made temples, former daimyo (feudal lords), and other art amateurs lend a select number of possessions to exhibitions.[53] In 1884, the *Miracles of the Kasuga Shrine Deity* (*Kasuga gongen genki-e*), a work treated as a sacred object, was put on view at a government-sponsored exhibition and announced in the paper.

In 1889, the pioneering art journal *Kokka* was founded under the editorial direction of the young Okakura Kakuzō. In addition to black-and-white illustrations and large photographic images, each issue also offered at least one woodblock print illustration that reproduced a painting, textile, or other artifact, including the *Miracles of the Kasuga Shrine Deity*, which is hand-drawn and printed in thick, unoutlined pigments with metallic accents [FIG. 29]. These works showcase the woodblock medium as a color reproductive technology that could hold its own with color

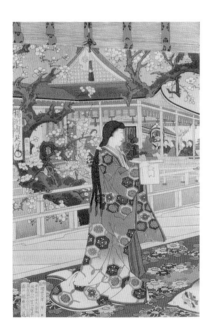

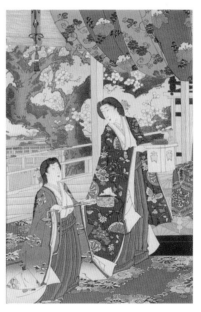

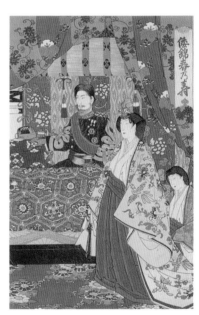

FIGURE 29
Reproduction of *Miracles of the Kasuga Shrine Deity*, 14th century, chromoxylograph in *Kokka*, no. 31 (April 1892), University of Chicago Library, Cat. 132

FIGURE 30
Yōshū (Hashimoto) Chikanobu, *Spring Felicitations in Japanese Brocade*, 1885, color woodblock print, Spencer Museum of Art, Cat. 121

lithography.[54] Labeled in both English and Japanese, *Kokka*'s plates were studied by amateurs and scholars in Japan and the West. Together with public exhibitions, they helped promote the "original" work of art as an object whose values were unique and non-transferrable. It is significant that in its final years, the woodblock print medium became almost transparent: in establishing its usefulness as a reproductive technique, it also relinquished much of its medium specificity and raised the possibility of its own dispensability.

In the latter half of the Meiji period, bright, celebratory colors gave way to a more muted palette meant to symbolically lift the woodblock print out of the realm of "vulgar" (*zoku; gehin*) urban popular culture and into respectability. This trend was inaugurated already in the age of brilliant aniline dyes, when Chikanobu and other artists attempted to "rewrite" *ukiyo-e* with upper-class subjects, in accordance with the general thrust of Meiji reform discourse combining technological improvement with up-classing. In works such as *Spring Felicitations in Japanese Brocade*, Chikanobu showcased members of the imperial couple's entourage; once off-limits to print representation, they now provided a model of "enlightened" nobility [FIG. 30]. Beginning in the 1890s, artists moved away from such brilliant colors and virtuoso printing effects, favoring a palette that resembled the delicate coloration of ancient artworks as represented in the reproductive *ukiyo-e* in *Kokka* and elsewhere. The movement to savor the historicity of *ukiyo-e*, to use it as a reproductive medium, and to "reform" the chemically unstable color palette (which, it was pointed out, blended traditional [*denrai*] and imported colors) took place roughly simultaneously, so that the genteel activities of the upper-class subjects would now be reinforced by a subdued palette that evoked both elite works and the faded colors of eighteenth-century prints [FIG. 31].[55] New *ukiyo-e* prints, in other words, came to reinscribe their own historicity: like Mary Cassatt, artists such as Miyagawa Shuntei appear to have openly emulated the pale, narrow color range of faded prints even as they portrayed well-to-do women and children engaged in activities that appeared timeless. This was a full decade or more before the inception of the New Print Movement of Watanabe Shōsaburō, which itself began as an attempt to faithfully reproduce early *ukiyo-e*. Subsidized by scholars and collectors and deliberately described in terms of acts of preservation (*hozon*), Japanese color woodblock prints began their lives as modern museum pieces and art objects, but only after their connection to the more explicit economies of money, social identity, and sexual desire in the floating world had begun to fade.

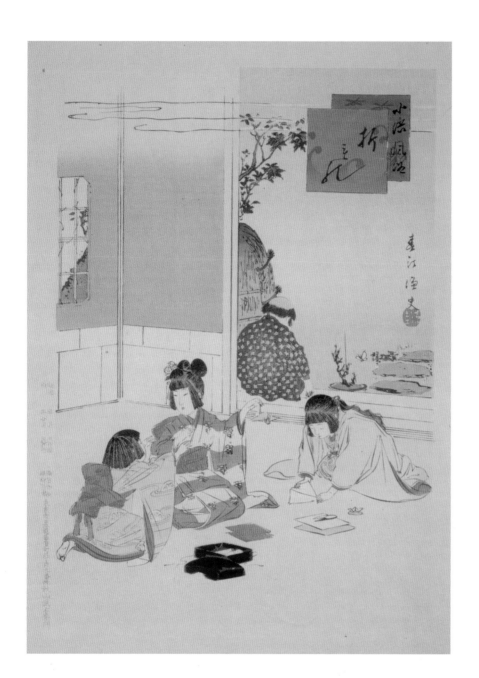

FIGURE 31
Miyagawa Shuntei,
Origami (Paper folding),
1896, color woodblock
print, Spencer Museum
of Art, Cat. 77

NOTES

1. Edmond de Goncourt, *Outamaro: Le peintre des maisons vertes* (Paris: Charpentier, 1891), 40–41.

2. Ibid., 40. "une série de gris indicibles, des gris qui semblent teintés de reflets lointains, tout à fait lointains, de couleurs voyantes."

3. John House, *Monet: Nature into Art* (New Haven: Yale University Press, 1988), 43.

4. Matthi Forrer, *Hokusai* (New York: Prestel, 2010), 186; Imahashi Riko, *Edo no kachōga: Hakubutsugaku o meguru bunka to sono hyōshō* (Tokyo: Sukaidoa, 1996), 350–88. Forrer and Imahashi emphasize that Hokusai's choice of subjects in the *Large Flowers* carried poetic associations even as they echoed the scale and vantage point of natural history depictions. While Hokusai's close-up views and omission of poetic inscriptions have been described as constituting an iconographic revolution, one important precedent is the remarkable privately produced color woodblock-printed book *Kaihaku raikin zui* (A Compendium of Pictures of Birds Imported from Overseas, 1789 and 1791) by Hokusai's contemporary Kuwagata Keisai (Kitao Masayoshi, 1764–1824), which similarly bridges the terrain between natural history and poetic images and between Japanese, Qing, and Western styles, having been drawn and printed based on images that the Nagasaki painter Watanabe Shūsen (1736–1824) had originally produced on behalf of the shogun. See Cynthea Bogel, "Introduction: Hiroshige and the Bird and Flower Tradition in Japan," in *Hiroshige: Birds and Flowers* (New York: G. Braziller, 1988), 18–19; and Atsumi Kuniyasu, *Edo no kufūsha Kuwagata Keisai: Hokusai ni kesareta otoko* (Tokyo: Geijutsu Shinbunsha, 1996).

5. Thomas G. Ebrey, "Printing to Perfection: The Colour-Picture Album," in Clarissa von Spee, ed., *The Printed Image in China: From the 8th to the 21st Centuries*, exh. cat. (London: British Museum Press, 2010), 26–35. *The Mustard Seed Garden Manual* was copied in Japan and published in 1748 in color by Kawanami Shiroemon of Kyoto. See Ebrey, 33–35.

6. For details, see Inaga Shigemi, "The Making of Hokusai's Reputation in the Context of Japonisme," *Japan Review* 15 (2003): 77–100; and Foxwell, "*Dekadansu*: Ukiyo-e and the Codification of Aesthetic Values in Modern Japan, 1880–1930," *Octopus: A Visual Studies Journal* 3 (2007): 21–41. On the price and circulation of woodblock prints in the Edo period, see Julie Nelson Davis, *Utamaro and the Spectacle of Beauty* (Honolulu: University of Hawaii Press, 2007), 10–17.

7. Gugong bowuguan, ed., *Qing dai gong ting ban hua* (Beijing: Zijincheng Chubanshe, 2006); von Spee, ed., *The Printed Image in China*, 111–31; Margaret Morgan Grasselli, *Colorful Impressions: The Printmaking Revolution in Eighteenth-Century France*, exh. cat. (Washington: National Gallery of Art, 2003); Pierre Joseph Redouté, *The Roses: The Complete Plates* (Cologne: Taschen, 2007).

8. Sarah E. Thompson, "The Original Source (Accept No Substitutes!): Okumura Masanobu," in Julia Meech and Jane Oliver, eds., *Designed for Pleasure: The World of Edo Japan in Prints and Paintings, 1680–1860*, exh. cat. (New York: Asia Society and Japanese Art Society of America, 2008), 57. Timothy Clark, "Image and Style in the Floating World: The Origins and Early Development of *Ukiyo-e*," in Clark et al., *The Dawn of the Floating World, 1650–1765: Early Ukiyo-e Treasures from the Museum of Fine Arts, Boston* (London: Thames & Hudson, 2001), 28–29.

9. Malcolm C. Salaman, *French Colour-prints of the XVIII Century* (Philadelphia, J. B. Lippincott Co.; London: W. Heinemann, 1913), 19–20.

10. Clark, "Image and Style," 30. On the term *nishiki-e* see Allen Hockley, "Suzuki Harunobu: The Cult and Culture of Color," in Meech and Oliver, eds., *Designed for Pleasure*, 85–86.

11. A print by Okumura Masanobu is among the earliest known examples of a multi-block, multi-color Japanese woodblock print (*benizuri-e*). It is a picture calendar (*egoyomi*) from 1744 in the collection of the Royal Museum of Ontario. Picture calendars themselves emerged in the early days of *ukiyo-e* prints. See Okada Yoshirō, *Edo no egoyomi* (Tokyo: Taishūkan Shoten, 2006); Clark, "Image and Style," 29.

12. This print was originally issued as a calendar print for the year 1766 and has been interpreted as alluding to the well-curb episode (episode 23) in the *Tales of Ise*. Helen Craig McCullough, *Tales of Ise: Lyrical Episodes from Tenth-Century Japan* (Stanford: Stanford University Press, 1968), 87–88.

13. This series of twenty-nine prints was known in the past as the Kaempfer series, but the association with Kaempfer has been disproven. See von Spee, ed., *The Printed Image in China*, 79–82.

14. Laurence Binyon, "A Note on Colour-Printing in China and Japan," *Burlington Magazine* 11 (1907): 31; idem, "A Note on Some Chinese Colour Prints," *Eastern Art: A Quarterly* 1, no. 3 (January 1929): 131–33.

15. Binyon, "A Note on Some Chinese Colour Prints," 131.

16. Ibid., 131.

17. Wu Hung, *The Double Screen: Medium and Representation in Chinese Painting* (London: Reaktion, 1996), 245–51; Jennifer Purtle, "Scopic Frames: Devices for Seeing China, c. 1640," *Art History* 33, no. 1 (February 2010): 55–73; and Kobayashi Hiromitsu, "Min dai hanga no seika: Kerun Shiritsu Tōa Bijutukan shozō Sūtei jūsannen (1640) Kan Min seikyūbon Seishoki hanga ni tsuite," *Kobijutsu*, no. 85 (1988): 32–50.

18. Rose Kerr, "What Were the Origins of Chinese Famille Rose?" *Orientations* 31, no. 5 (May 2000): 53–59. Hokusai, too, mixed white with translucent colors to produce shading in his late paintings. See Carolina Retta, "Hokusai's Treatise on Coloring: *Ehon saishiki tsū*," in Gian Carlo Calza, ed., *Hokusai Paintings: Selected Essays* (Venice: International Hokusai Research Center, University of Venice, 1994), 237–46.

19. On Chinese color-printed letter papers, see Suzanne E. Wright, " 'Luoxuan Biangu Jianpu' and 'Shizhuzhai Jianpu': Two Late-Ming Catalogues of Letter Paper Designs," *Artibus Asiae* 63, no. 1 (2003): 69–122.

20. Kobayashi Hiromitsu, "In Search of the Cutting Edge: Did Ukiyo-e Artists Borrow from the Erotic Illustrations of the Chinese Fengliu Juechang Tu?" *Orientations* 40, no. 3 (2009): 62–67; J. S. Edgren, "Late-Ming Erotic Book Illustrations and the Origins of *Ukiyo-e* Prints," *Arts Asiatiques* 63 (2011): 117–34.

21. See Jonathan Hay, *Sensuous Surfaces: The Decorative Object in Early Modern China* (Honolulu: University of Hawaii Press, 2010), 21–52, 271–309.

22. Edgren, "Late-Ming Erotic Book Illustrations."

23. Charles E. Russell, *French Colour-prints of the XVIIIth Century: The Art of Debucourt, Janinet & Descourtis* (London and New York: Halton, 1949), v.

24. Russell notes that Debucourt and his contemporaries captured "the fine *objets d'art* made by the craftsmen of the period, whose work is so sought after today [by collectors of antiques]." Ibid., iii.

25. Hay, *Sensuous Surfaces*, 396.

26. See, for example, Timon Screech, *The Shogun's Painted Culture: Fear and Creativity in the Japanese States, 1760–1829* (London: Reaktion Books, 2000); and Imahashi Riko, *Edo no kachōga*.

27. Asano Shūgō, "Ukiyoe no sankeitai: ichimaie, surimono, hanpon," *Nihon bijutsu zenshū*, vol. 20 (Tokyo: Kōdansha, 1990), 170–71.

28. Shimoyama Susumu, "Torii Kiyonaga sakuhin ni shiyō sareta chakushokuryō no hihakan bunseki chōsa," in *Torii Kiyonaga: Edo no Binasu tanjō* (Chiba: Chiba-shi Bijutsukan, 2007), 12–23; Shimoyama Susumu, "Colors of the Floating World," *Highlighting Japan* 2, no. 10 (February 2009): 31–33.

29. Henry D. Smith II, "Hokusai and the Blue Revolution in Edo Prints," in John Carpenter, ed., *Hokusai and His Age: Ukiyo-e Painting, Printmaking, and Book Illustration in Late Edo Japan* (Amsterdam: Hotei, 2005), 235–69. Berlin or Prussian blue had already been used by painters; most recently, it was shown to be present in small quantities in Itō Jakuchū's *Colorful Realm of Living Beings* (c. 1757–66). Hayakawa Yasuhiro, "On the Colorants," in Yukio Lippit et al., *Colorful Realm: Japanese Bird-and-Flower Paintings by Itō Jakuchū*, exh. cat. (Chicago: University of Chicago Press, 2012), 207–21.

30. Smith, "Hokusai," 247–48.

31. For one important example of a blue fan print, see ibid., fig. 2, p. 238. Fan prints sometimes contained images of snowy landscapes that "psychologically tempered the summer heat" (Minneapolis Institute of Arts, *Fan Prints by Ukiyo-e Artists* [2009]. http://www.artsmia.org/index.php?section_id=2&exh_id=3493)

32. Maeda Ai, "Tenpo kaikaku ni okeru saku-sha to shoshi," in *Kindai dokusha no seiritsu, Maeda Ai Chosakushū* (Tokyo: Chikuma Shobo, 1989), 2: 32–33. See also Melinda Takeuchi, "Kuniyoshi's *Minamoto Raikō and the Earth Spider*: Demons and Protest in Late Tokugawa Japan," *Ars Orientalis* 17 (1987): 5–38; Minami Kazuo, "Kuniyoshi ga 'Minamoto Raikō kō kan tsuchigumo saku yōkai zu' to minshū," *Nihon rekishi* 302 (July 1973): 119–23.

33. Funadama Osai is a character in Mokuami's *Koharu nagi okitsu shiranami*, which was performed at the Ichimura-za in Edo in the intercalary eleventh month of Genji 1 (1864). The play is reproduced in Kawatake Shigetoshi, ed., *Mokuami zenshū* (Tokyo: Shun'yōdō, 1935), 21: 165–366. This print was likely part of a triptych.

34. The harbor view of moored ships resembles Hiroshige's nighttime image of Tsukuda from Eitai Bridge (1857) in *One Hundred Views of Famous Places in Edo*. See Henry D. Smith II, *Hiroshige: One Hundred Famous Views of Edo* (New York: Braziller, 1986), no. 4.

35. Smith, "Hokusai."

36. Christine Guth, "Hokusai's Great Waves in Nineteenth-Century Japanese Visual Culture," *Art Bulletin* 93, no. 4 (December 2011): 468–85.

37. Anita Cheng, *Chinese Art in an Age of Revolution: Fu Baoshi (1904–65)* (New Haven: Yale University Press, 2011), 210; Julia Andrews, *Painters and Politics in the People's Republic of China* (Berkeley: Univeristy of California Press, 1994), 368–76; Jerome Silbergeld with Gong Jisui, *Contradictions: Artistic Life, the Socialist State, and the Chinese Painter Li Huasheng* (Seattle: University of Washington Press, 1993), 14, 125–30.

38. "Dye-stuffs," *Chambers's Encyclopaedia: A Dictionary of Universal Knowledge for the People, with Maps and Numerous Wood Engravings* (New York: Collier, 1887), 3: 226.

39. Peter Taylor and Michael Gagan, eds., *Alkenes and Aromatics* (Milton Keynes: The Open University, 2002), 68–69. See also *Perkin Centenary, London: 100 Years of Synthetic Dyestuffs* (London: Pergamon Press, 1958).

40. "Azuma nishiki-e no suitai," *Yomiuri shinbun*, August 18, 1890.

41. Mark Ravina, "The Apocryphal Suicide of Saigō Takamori: Samurai, *Seppuku*, and the Politics of Legend," *Journal of Asian Studies* 69 (2010): 691–721.

42. Narazaki Muneshige, "Kenkyū shiryō: Kobayashi Kiyochika *Neko to chōchin*: Kōsenga teishō no

chorei to shite," *Kokka* 1150 (September 1991): 67–70.

43. Yamanashi Emiko, "Kobayashi Kiyochika *Takanawa Ushimachi rōgetsu* kei o megutte: Meiji ki ni okeru Amerika bijutsu no eikyō, jō," *Bijutsu kenkyū*, no. 338 (March 1987): 147–56.

44. Henry D. Smith II, *Kiyochika: Artist of Meiji Japan*, exh. cat. (Santa Barbara: Santa Barbara Museum of Art, 1988).

45. See, for example, William Anderson, *Descriptive and Historical Catalogue of a Collection of Chinese and Japanese Paintings in the British Museum* (London: Longmans & Company, 1886). Anderson (p. 330) described the works of the late eighteenth-century masters Kiyonaga and Shunchō as "the most beautiful colour-prints . . . perhaps in the world."

46. "Kairyō nishikie," *Yomiuri shinbun*, September 26, 1885.

47. "Azuma nishiki-e no suitai," *Yomiuri shinbun*, August 18, 1890.

48. "Utamaro no nishiki-e," *Yomiuri shinbun*, December 31, 1889, 3.

49. There is a significant literature on the portrayal of the Meiji emperor. See, for example, T. Fujitani, *Splendid Monarchy: Power and Pageantry in Modern Japan* (Berkeley and Los Angeles: University of California Press, 1996); Donald Keene, "Portraits of the Emperor Meiji," *Impressions* 21 (1999): 17–30; Mikiko Hirayama, "The Emperor's New Clothes: Japanese Visuality and Imperial Portrait Photography," *History of Photography* 33 (2009): 165–84; and Bruce A. Coats, ed., *Chikanobu: Modernity and Nostalgia in Japanese Prints*, exh. cat. (Leiden: Hotei, 2006), 18–19, 30–31.

50. Peter F. Kornicki, "Manuscript, not Print: Scribal Culture in the Edo Period," *Journal of Japanese Studies* 32, no. 1 (2006): 23–52.

51. Nicole Coolidge Rousmaniere, ed., *Kazari: Decoration and Display in Japan, 15th–19th Centuries* (New York: Harry N. Abrams, 2002).

52. Hiroko Katō, "Nude or Naked? The Life Sketches of Maruyama Ōkyo," lecture delivered at the Association of Asian Studies Annual Meeting, April 2011.

53. Takagishi Akira, "Muromachi dono emaki korekushon no keisei," *Bijutsushi* 53, no. 1 (October 2003): 16–29; Karen Brock, "The Shōgun's 'Painting Match'," *Monumenta Nipponica* 50, no. 4 (1995): 433–84.

54. The Meiji government printing bureau began producing lithographs with the aid of European and American equipment and technicians in the early 1870s and by the late 1870s had already produced an album of color lithographed reproductions of Japanese artworks and temple treasures, *Kokka yōhō* (The lingering fragrance of our nation). On Meiji lithography see Ono Tadashige, *Nihon no sekihanga* (Tokyo: Bijutsu Shuppansha, 1967); Kawasaki-shi Shimin Myūjiamu, *Meiji no hanga: Oka Korekushon o chūshin ni* (Kawasaki: Kawasaki-shi Shimin Myūjiamu, 2002).

55. For an overview, see Honda Yasuo, *Shinbun shōsetsu no tanjō* (Tokyo: Heibonsha, 1998); Tawara-shi Hakubutsukan, ed., *Sashie gaka Miyagawa Shuntei* (Tawara, Aichi: Tawara-shi Hakubutsukan, 2010).

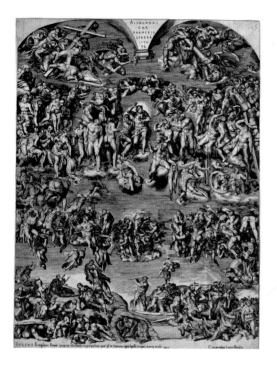

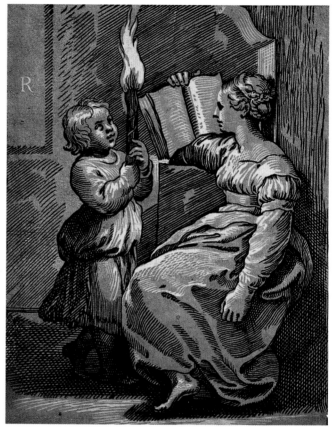

ANNE LEONARD

TWO
CRYPTO/
CHROMO:
COLOR
AND THE
REPRODUCTION
OF IMAGES

THE UNDERSTANDING OF PRINTS as an art of black and white is deeply ingrained, if unsupported by the facts. Color prints, despite a history dating back to the earliest days of printmaking (if one counts hand-coloring), tend to be considered less characteristic, normative—in short, less print-like—than those that hold to black and white.[1] Perhaps this can be explained by the long association of printed color with a desire to imitate some other medium. This was indeed the impetus for many of the technical innovations in the realm of color printmaking. Black-and-white prints, when called upon to reproduce or disseminate designs for other art forms, did so without masquerading as something other than what they were (see fig. 32);[2] that may have caused them to be perceived as more "honest" reproductions than the much later chromolithograph, for example, which actively sought to deceive with extra features like surface varnish and a mimicked canvas weave.

John Evelyn, whose seventeenth-century *Sculptura* is an important early treatise on the art of the print, believed that an effect of *trompe l'oeil*, or successful imitation, was "the consummate triumph of graphic art"—a belief shared by most of his contemporaries. As C. F. Bell wrote in his introduction to the modern edition of *Sculptura*, "[for Evelyn] every artistic effort was worthy of admiration as it approached or failed to approach the deceptive imitation of natural appearances." Further, Evelyn considered the best black-and-white prints fully capable of evoking color.[3] He praised the Sadeler family of engravers for their mastery of color—meaning not literal changes of hue, but effects of contrast, volume, and relief. Taking as model the ancient Greeks, who he believed had used "no other Colours but those eminent *Contraries*," Evelyn wrote: "the lights and the shades, in the true managing whereof, so many wonders are to be produced by this *Art*, and even a certain splendour, and beauty in the touches of the *Burin*, so as the very *Union* and colouring it self may be conceiv'd without any force upon the imagination." All the same, Evelyn bestowed high praise on Ugo da Carpi's decision, following the success of his two-color *Sibyl Reading* after Raphael [FIG. 33], to "improv[e] the curiosity to three colours."[4] What Evelyn would have thought of Anne Allen's *à la poupée* prints after Jean Baptiste Pillement, to say

45

nothing of Louis Prang's chromolithographic reproductions a century later, is hard to fathom (see figs. 37, 61).

The chiaroscuro woodcut, which Ugo da Carpi claimed to have pioneered, was actually a German invention. A later German printmaker, Ludolph Büsing, helped stimulate French interest in chiaroscuro woodcut with elaborate works like *The Flute Player*, after a drawing by Georges Lallemand [FIG. 34]. In the eighteenth century, the techniques of chiaroscuro woodcut and etching began to be used in combination to reproduce wash drawings, as in several examples from the celebrated *Recueil Crozat* (see Acton essay, p. 74).[5] The etched lines, printed in black ink, help give sense and shape to flat areas of woodblock-printed color. By the early 1760s, the first experiments in aquatint provided the trigger for a second edition of the *Recueil*, in which this new tonal medium—executed on copperplate and thus compatible with etching—took the place of the more laborious multiple-block woodcut.[6] A comparison of the first and second editions of the same print, after Giovanni Bonatti's *Abbot Saint Restores a Blind Man's Sight*, suggests that although aquatint had the distinct virtue of creating a wash effect with a single plate, it could not always do justice to the intricacies of an expertly carved woodblock [FIGS. 35, 36]; note in particular the hatching on the stairs in the lower left corner, and the total abandonment of this effect under the arch at upper left.

Chiaroscuro woodcut enjoyed favor over a long period as a method of reproducing drawings.[7] But it had grievous limitations when it came to reproducing paintings, and no one was more aware of this than J. C. Le Blon, a Frankfurt native who brought his newly invented color printing method to France in 1738. As Le Blon wrote:

> With chiaroscuro woodcut comes a dryness that makes you think, at first glance, that it would have been better to stick with lines. No progressive tone, no lightness; everything is harsh. [With my technique] the print bears comparison with painting, it approaches nature itself; and if the work has been executed with all the refinements of which art is capable, very careful examination is required to determine that it is not the work of the paintbrush.[8]

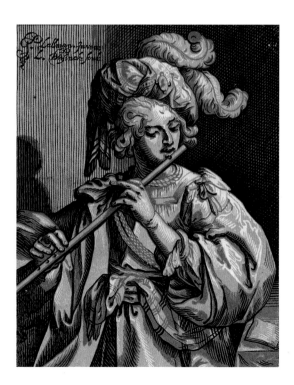

FIGURE 34
Ludolph Büsing after Georges Lallemand, *The Flute Player*, 1630, three-color chiaroscuro woodcut, Smart Museum of Art, 1967.116.99

FIGURE 35
Anne-Claude-Philippe, comte de Caylus, and Nicolas Le Sueur, after Giovanni Bonatti, *Abbot Saint Restores a Blind Man's Sight*, 1729–42, etching and chiaroscuro woodcut, Smart Museum of Art, Cat. 8

FIGURE 36
François-Philippe Charpentier after Giovanni Bonatti, *Abbot Saint Restores a Blind Man's Sight*, 1763, etching and aquatint, Smart Museum of Art, Cat. 10

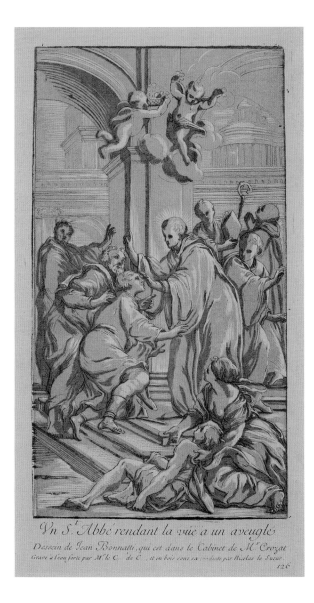

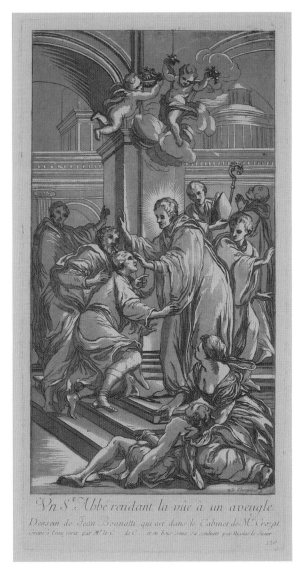

Le Blon's technique derived from the principle that "all visible objects" could be represented with a combination of just three colors: yellow, red, and blue.[9] His comments imply, within this economy of means, a continuing adherence to Evelyn's ideal of faultless—even deceptive—imitation.

Anne Allen's color intaglio prints after *Chinoiserie* designs by her husband, Jean Baptiste Pillement, were most likely intended to circulate as models for works in other media, such as textiles and ceramics [FIG. 37].[10] In this generative as much as reproductive role, they are less yoked to the notion of absolute imitation, a factor that contributes to their lively charm (see Acton essay, pp. 80–81). *Chinoiserie*, in any event, was a flexible category that admitted a wide range of motifs, color palettes, and potential sources. The *Cahiers chinois* were printed *à la poupée*—that is, using a dauber tool (called a *poupée*) to apply all colors to a single etched copperplate. Because the plate was passed just once through the press, the different inks blended slightly while still wet, yielding more gradual and sinuous color transitions in the printed impressions than in Le Blon's process. Drying times for each color are built into the multiple-plate process, meaning that inks may be superposed on the paper but never physically blend. Still, this small element of chance in the *à la*

FIGURE 37
Anne Allen after Jean
Baptiste Pillement,
title-sheet and plates 2
and 4 from *Nouvelle suite
de cahiers chinois no. 2*,
c. 1796–98, color etch-
ings, Smart Museum of
Art, Cat. 1

poupée process—and its aesthetic result—was surely not the primary reason for choosing it in the 1790s. Quite simply, it was less costly than multiple-plate color printing.

From its earliest days, the print's primary virtues were reproducibility, portability, multiplicity—and, for a long time, fungibility. Just as any impression of a print could stand in for another, so the print itself was often expected to stand in for some less portable, less tractable object.[11] Thus it would seem natural to assume that printed color progressed with ever-increasing sophistication, following a desire for ever-more-faithful replication of other artworks. But the story of color printmaking in the West by no means sails along in a straight line. Two key moments, mentioned above, are the early sixteenth century—with the flowering of multiple-block chiaroscuro woodcut printing—and the latter half of the eighteenth century, which saw a surge in color intaglio printing (in France and England especially). But color was not seen as *inherent* to the print until an even later stage in this progression, the late nineteenth century in France, when color exploded across all print media. And in between these three peaks, color had very little role at all in printmaking.[12] This is puzzling because, at any moment, various media and techniques were potentially available: why did some come into vogue at certain times, and not others? The preference for (and mad pursuit of) images in color waxes and wanes dramatically, following anything but a smooth, continuous trajectory. Although these variations are due to a complex mix of economic, technological, social, and cultural conditions, they also may reflect attitudes that are specific to printed color itself.

The debate over color in art, usually expressed in terms of color vs. line or *colore* vs. *disegno,* is very old.[13] So is the debate over the reproduction of images—though not quite as old, because not as problematic for the early modern period. This anxiety over original vs. copy depends on an understanding of art as the creative expression of an individual, which therefore must be distinguished from a mere mechanical operation. In color printing, both debates become closely intertwined.

Insofar as the goal of most reproductive imagery was fidelity to the source, color print technology could seem an unequivocal boon to the possibility of the faithful reproduction of images. But each step toward more accurate rendering of the artistic product meant a step away from the artistic self—the original, unifying vision—simply because the processes involved became so inordinately complex. In its mildest form, the specialization of color printing only meant that a single artist could not execute the work from start to finish. At worst, it implied that the color printer—the "technician"—was privy to a secret knowledge surpassing even the artist's. For example, the *chromiste* expert in "analyse des couleurs" was said in the early twentieth century to know better than Turner himself how many colors Turner used in a painting, and exactly in what combination.[14] In the most sophisticated color printing, it was as if the painter had ceded his palette to the print technician.

The challenge for color prints, particularly in the late nineteenth century, was to secure a claim for artistic integrity that could stand up to several distinct criteria of judgment. Was the color print an original print; that is, was it a work of art in its own right? Did it reflect the intention of the original artist? Was it in good taste? In line with the last question, color prints had to persuade critics that they were not merely decorative, illustrative, or otherwise pandering to popular fashion; that they did not make use of cheap effects; that they were not commercial.

Amid all these objections, one can see why André Mellerio's claim in *Original Color Lithography* (1898) rang out like a clarion call: any medium that the artist chooses to express himself is for that

reason legitimate.[15] Yet the loss of control over methods and materials was cause for anxiety, among artists and critics alike.[16] Artists dealt with the problem by working closely with trusted printers. To arrive at the right balance of color tones, many test proofs might need to be pulled, including intermediate states. Mary Cassatt, in her landmark 1890–91 series of color aquatints, pulled early states herself from the press in her Paris apartment-studio and brought in her printer, Leroy, for the final color proofs, which she oversaw [FIG. 38].[17] Paul Signac worked side by side with Auguste Clot, a leading printer and technical advisor to artists, to produce *Boats*, a lithograph from 1897–98. Precious evidence of their collaboration survives. Besides the final version, printed in three colors, there exists a printing from the pink and yellow stones only—plus an annotated proof impression with Signac's own penciled instructions to Clot [FIGS. 39–41].

In contrast to the late eighteenth century, when color prints could be shown at the Salon and supported by the state, later nineteenth-century color prints benefited from no such official sanction. Henri Lefort and other conservatives, defining printmaking strictly as the art of

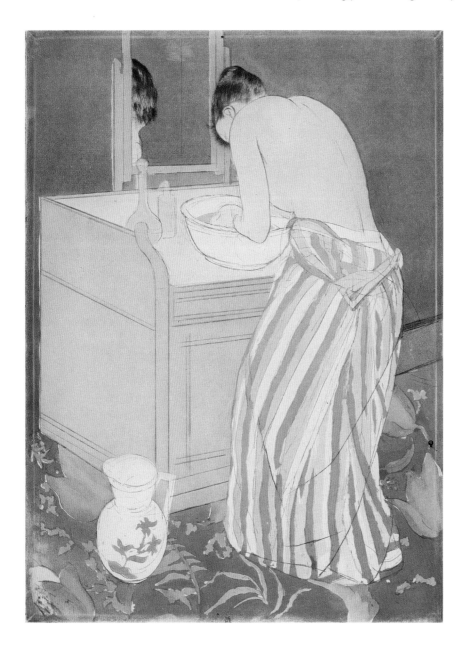

FIGURE 38
Mary Cassatt, *Woman Bathing*, 1890/91, color drypoint and aquatint, National Gallery of Art, Washington, Cat. 52

black and white, excluded color prints from the Salon.[18] In this polarized rhetorical climate, many advocates of color prints went out of their way to trumpet these works' resemblance to popular imagery like caricature and Épinal prints.[19] Some printmakers, too, played up the "rough" aspects of the medium, notably Émile Bernard, who imitated the crude stenciling and garish colors of Épinal prints even as he experimented with jewel-like color effects at smaller scale [FIGS. 42–44]. Jules Chéret, the so-called "king of the poster," broke down perceived boundaries between bourgeois and popular art with his sophisticated if mass-culture productions; his posters were said to constitute a "public, free Salon of the street."[20] Even if state sanction was not forthcoming, highly respected connoisseurs and critics including Roger Marx and Gustave Kahn helped legitimize the poster, as did print reference publications like Henri Béraldi's and dealer catalogues like Edmond Sagot's.[21]

FIGURE 42
Émile Bernard, *The Virgin with Saints*, 1895, hand-colored zincograph, Spencer Museum of Art, Cat. 4

FIGURE 43

Printed by Gangel, *The Prodigal Son*, n.d., hand-colored woodblock print, The Art Institute of Chicago, Cat. 21

FIGURE 43

Printed by Gangel, *The Prodigal Son*, n.d., hand-colored woodblock print, The Art Institute of Chicago, Cat. 21

FIGURE 44

Émile Bernard, *Breton Women Hanging Their Wash*, 1886, woodblock print with color stenciling, Spencer Museum of Art, Cat. 3

Aiding this process of legitimation was the figure of Chéret himself, who, more successfully than anyone else, established credibility in the double role of artist and technician (see Kalba essay, pp. 140–41).[22] From 1866, he headed his own printing company, mainly working in the realm of theater posters. For each design, just three colors were superposed: black, red, and blue/green. That number of lithographic stones was considered sufficient for the large-scale, low-cost, ephemeral imagery that Chéret was being hired to produce. More than that would have been used only in special instances such as show cards, of which the chromolithographer Th. Dupuy displayed a spectacular fourteen-color example at the 1867 Exposition Universelle (see fig. 108). But while Chéret's business required him to limit the number of stones per design, his color harmonies did change over time, as he switched from black to Berlin blue for his darkest tone and began to play up complementary pairs.[23] For *François Les Bas Bleus* [FIG. 45], appropriately enough, Chéret hewed to an all-blue color palette that may even pay homage to Japanese *aizuri-e*, or blue prints, a term given to color woodcuts by Katsushika Hokusai and others that celebrate the arrival of Berlin blue on the commercial market in the 1830s (see Foxwell essay, p. 23). In all his color combinations, Chéret credited the influence of the Japanese, "those master decorators" (as he described them in a text written for Béraldi). A distinctive mix of innovative forms, bright colors, and vivacious modern style became the Chéret "brand," which advertisers used in turn to promote their own products [FIG. 46].[24]

At the opposite pole from the color economics of Chéret's mass-production poster enterprise was the labor-intensive, multiple-block printing of Henri Rivière, working in woodcut at the same period [FIGS. 47–49]. (After 1894 he would turn to color lithography, which allowed larger print runs at much less cost and effort.) Rivière's meticulous technique involved up to ten separate woodblocks for a single design, each individually carved and inked with its own color, then printed successively with impeccable registration on sheets of antique Japanese paper—a stock of which he had obtained, through an importer, from a defunct Tokyo paper factory.[25] Rivière's monogram took the form of a pseudo-Japanese seal in red ink. The attention to all details of the printed result—ink, paper, and stamps and signatures—aligns him with slightly earlier printmakers of the Etching Revival, such as Félix Buhot, who took similar care with aesthetic presentation.[26] But whereas Buhot and his comrades cherished the rapidity and ease of the etching technique—they likened it to drawing—Rivière on the contrary seemed to revel in the difficulty of his process.

Armed with only indirect, approximate knowledge of the Japanese printmaking technique, Rivière came around to a version of it in what has been called an "intuitive rediscovery" based on long and solitary effort.[27] This hard-won mastery, and his execution of all steps in the process, makes him unique among French printmakers of the period. Although Rivière's memoirs attest to an interest in the whole history of Japanese *ukiyo-e* prints, particularly their increasing color complexity over time, it is plain that the landscapes of Hokusai and Utagawa Hiroshige came first in his affections.[28] His *Thirty-six Views of the Eiffel Tower*, a series of color lithographs, pay evident homage to Hokusai's *Thirty-six Views of Mt. Fuji*. The *Breton Landscapes*, it is believed, were originally intended to number fifty-three, to match Hiroshige's *Fifty-three Stations of the Tokaido*. But, perhaps because of the sheer effort required, only forty were completed. For the same reason, Rivière's editions were limited to twenty impressions.

Chéret claimed as much Japanese influence for his lithographic posters as Rivière acknowledged for his more traditional woodcuts—a testament to the versatility of that influence, and of

the color print medium itself. For the late-nineteenth-century avant-garde, imitating paintings or other artistic media was the worst thing color prints could do; but as we have seen, that is what they had often been called upon to do. In late-nineteenth-century France, color was sought as a kind of apotheosis of printmaking across a whole spectrum of techniques, in defiance of a tradition in which a color print had had to apologize to some degree for *being* a print. The acceptance of color printing, helped along by *ukiyo-e*, joined up with the discourse of the original print to create the so-called "color revolution."[29] From the point of view of the Western printmakers who were inspired by them, *ukiyo-e* had two crucial qualities: they were colorful, and they did not reproduce works of art in another medium. They originated as full-color prints, with no intent to masquerade as something else. Yet the example of Cassatt reminds us that no matter how great the popularity of Japanese prints and their talismanic significance for Western artists of the period, the aesthetic transfer was not always straightforward.

FIGURE 45
Jules Chéret, *François
Les Bas Bleus*, 1883, color
lithograph, Boston Public
Library

FIGURE 46
Jules Chéret, *Casino
de Paris*, 1891, color
lithograph, Boston Public
Library, Cat. 11

FIGURE 47
Henri Rivière, *Lobster Boat at the Mouth of the Trieux River (Loguivy)*, 1891, color woodblock print, Smart Museum of Art, Cat. 39

FIGURE 48
Henri Rivière, *The Village of Perros-Guirec*, 1891, color woodblock print, Smart Museum of Art, Cat. 40

FIGURE 49
Henri Rivière, *Vegetable Garden at Ville-Hue (Saint-Briac)*, 1890, color woodblock print, Smart Museum of Art, Cat. 38

The ideal of the print as an original, independent work could set an impossibly high standard. Certain of Cassatt's prints, such as *Feeding the Ducks*, clearly derived from her paintings or works in other media [FIG. 50].[30] Even those that did not could not escape the charge of imitation when they too obviously resembled *ukiyo-e* prints.

And much as *ukiyo-e* were admired as a popular, democratic "art of the people," ambivalence on this point could yield willful misapprehensions. For example, Cassatt's incorporation of Japanese woodblock prints into bourgeois schemes of interior decoration suggests that, in the West, these prints were still the province of a limited, well-off segment of collectors and cognoscenti. People in Japan would have been quick to perceive the incongruity between *ukiyo-e* and the Persian rugs, Chinese vases, and other coveted exotica that Cassatt felt should accompany them in a domestic environment.[31] Moreover, the fact that she never worked in the woodcut medium may reflect her instinctive distaste for its plebeian associations in Japan. (Her avoidance of woodcut has also been explained in terms of a desire to be involved with the entire printmaking process.)[32]

Ambitious printmakers like Rivière and Cassatt created entire series, privately printed at substantial cost and distributed to a small circle of collectors and fellow artists. Even printmakers such as those two, less ideologically committed to making color prints accessible to a broad public, had to grapple with the problem of making their enterprise economically viable. Cassatt was reportedly anxious that her prints be a commercial success. Félix Bracquemond, inspired by the example of Cassatt's second exhibition at Durand-Ruel's gallery, told Edmond de Goncourt (ruefully, one suspects) that a twelve-color etching he intended to make would have to be expensive, because beauty was inconsistent with economy.[33]

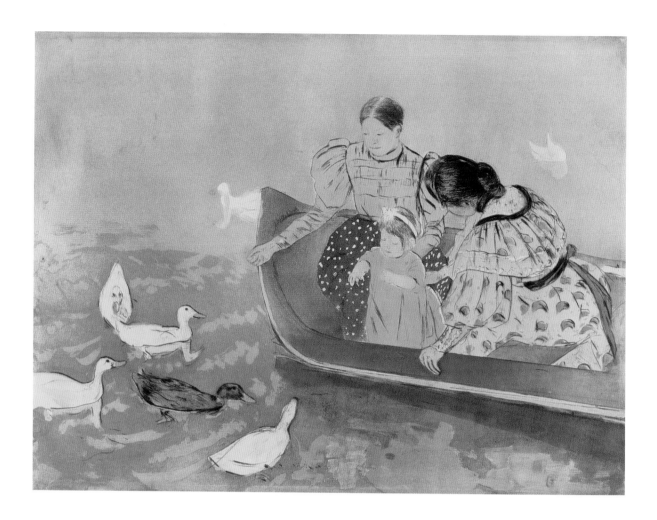

The multi-artist print portfolio offered one solution to this dilemma. Certainly, publishers issued single-artist albums, such as Ambroise Vollard's for Bonnard, Roussel, and Vuillard, respectively. But these were slow to come to fruition and were very often not profitable. *Landscapes and Interiors*, for example, considered Vuillard's masterwork in color lithography, was nineteen months in the making, and according to Vollard, the edition of one hundred copies still had not sold out twenty years after publication (see fig. 92).[34] Multi-artist portfolios, issued at regular intervals, represented a wide range of artists and styles; they offered subscribers the lure of novelty and variety, while filling the public appetite for original, high-quality works of art still within financial reach of the middle class. Artists could contribute their latest work without the pressure of supplying an entire album, and publishers could spread the risk, as it were, over a whole roster of artists, including those lesser known.

L'Estampe originale, published by André Marty with prefaces by Roger Marx, is considered the most prestigious of the late-nineteenth-century print portfolios, appearing in nine impeccably printed albums between March 1893 and early 1895. In all, it featured ninety-five original prints; of these, twenty-eight were color lithographs, including Georges de Feure's *Evil Spring* [FIG. 51].[35] Vollard published two *Albums d'estampes originales*, in 1896 and 1897, likewise admired for their richness and innovation.[36] The second of these included *Boating* by Bonnard (see fig. 110), who also designed that album's cover.

FIGURE 50
Mary Cassatt, *Feeding the Ducks*, c. 1895, color dry-point and aquatint with monotype inking, The Art Institute of Chicago, Cat. 53

FIGURE 51
Georges de Feure, *Evil Spring*, 1894, color lithograph, Smart Museum of Art, Cat. 19

FIGURE 52
Gaston de Latenay,
The Park, 1897, color
lithograph, Smart
Museum of Art, Cat. 27

Later portfolios fell off somewhat in quality and tended to foster diversity and eclecticism. *L'Estampe moderne*, published from May 1897 to April 1899, was printed on cheaper paper and contained more illustrative work, even including photomechanical reproductions of drawings (absolutely taboo according to the discourse of the original print). Mellerio, among the staunchest advocates of color lithography, passed especially harsh judgment: "Its banal and monotonous appearance prevents its having any artistic character, putting it on the level of commercial chromolithography."[37] Granted, the names of the contributing printmakers are not household names today: Mellerio would probably have deemed their oblivion justified, contending that they had done more harm than good for the image of color lithography as an art form. Yet these works have an undeniable visual appeal and testify to the "liberation" of color across an astounding array of techniques and styles [FIGS. 52–54].

Mobilizing a shared impulse to create in and with color, French printmakers of the late nineteenth century ventured in wildly divergent directions. Bracquemond's *At the Zoological Gardens* (1873) and Édouard Manet's *Punch* (1874), for example, are considered the two inaugural prints of the color revolution,[38] yet they could not be more contrasting in visual effect. At small scale, the Bracquemond [FIG. 55], which is not without resemblances to Johannes Teyler's *Landscape in a Medallion* (see fig. 65), deploys all the potential of intaglio toward a fully realized, "painterly" print. The all-over luxuriance of texture and detail operates differently from that in a series of historical prints after Horace Vernet, c. 1820 [FIG. 56], where color "fills in," particularizes, and enlivens a composition that has been already made or decided. In the Bracquemond, forms and figures are beginning to show an independence from pre-established outlines (note especially the soft, fuzzy borders of the woman dressed in white). Bracquemond become a major advocate for leaving "reserve whites" even in black-and-white prints (see p. 68), and this preference is on display in his masterly *Portrait of Edmond de Goncourt* from 1882 [FIG. 57], particularly the areas of sunshine reflected in the mirror at upper right, and the whisper of cigarette smoke that terminates in pure white. The color revolution would go much further in this direction, with a meaningful emblem for color printmakers of the 1890s being the chromatic burst, in Manet's 1874 print, of the character Punch onto a blank background, creating a "strikingness" bordering on insolence [FIG. 58].[39]

Lithography helped dissolve the distinction between mark/trace and patch/plane—that is, between line and color. Because color could be applied in virtually any way, the printmaker was liberated from preconceived ideas about where color belongs; it need not be subordinate or secondary to an overall design. What is astonishing about Charles Huard's *Anglers*, a color lithograph from 1898, is the way that it so conscientiously seeks to imitate woodcut [FIG. 59]. Whether this maneuver constitutes an expression of virtuosity or a betrayal of truth to medium is an open question, but in any event there is some element of masquerade (that word again). The artist is not embracing lithography's most characteristic aspects—and in this, the print is *uncharacteristic* of the aspirations of the period.

Lithography had the most commercial connotations of any print medium because of its low expense, its high print runs, its journalistic origins, and its association with posters. But fine-art printers and commercial printers were often the same person, since the same technical skills were required for both kinds of business. Cassatt's printer, Leroy, who had taken artisanal care with the full run of ten color aquatints in 1890–91, kept thoroughly up to date with the latest commercial processes.[40] Likewise, Rivière's printer of choice for his color lithographs, Eugène Verneau,

FIGURE 53
Luc Olivier Merson,
Salome, 1897, color litho-
graph, Smart Museum of
Art, Cat. 33

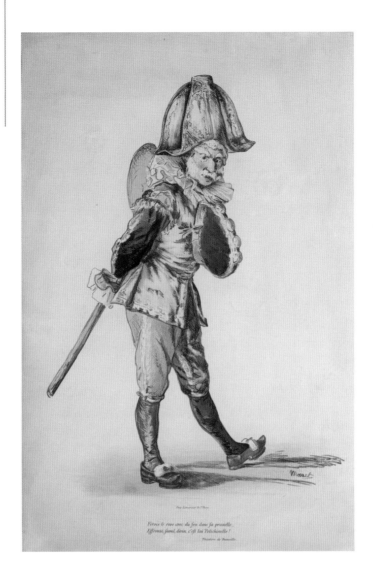

produced (according to the artist's memoirs) color posters, illustrated catalogues for industry, and other incidental printed materials alongside Rivière's delicate *Japoniste* landscapes [FIG. 60].[41]

According to Peter Marzio, modern-day art historians' distinction between color lithographs and commercial chromolithographs "would have puzzled most nineteenth-century printmakers."[42] He argues that since the very invention of lithography, the removal of the individual "hand" from the process had been seen as desirable. Quoting Alois Senefelder: "I shall not admit that lithography has made a great step toward the utmost perfection until the erring work of the human hand has been dispensed with as much as possible and the printing is done almost entirely by machinery."[43] In this sense, the fin-de-siècle color lithographers' investment in artistic expression and individual styles goes against the medium's origins. This was one of the problems of the chromo: aesthetics veered off from where technology had led.

Even if there was little difference in the actual technology used, color lithographers like Vuillard, Signac, and Henri de Toulouse-Lautrec still cherished a commitment to original print-making that sits in direct contrast to a massive art-reproduction enterprise like Louis Prang's. Based in Boston, Prang purchased vast quantities of contemporary American art; his ownership

meant that he could avoid paying royalties to the original artist and copyright the resulting chromo himself.[44] *Oriental Ceramic Art* (1899), a lavish Prang publication, contained chromolithographic reproductions of selected objects from the collection of William T. Walters, which was catalogued exhaustively in the main text [FIG. 61]. For each image, twenty stones or more were successively printed to render the exquisite objects in all their chromatic subtlety.

It is true that, to our eyes, there can be no equivalence between a Prang chromo and a color lithograph like Vuillard's *Interior with Pink Wallpaper II*, published in five colors in the same year (see fig. 92). The skyrocketing complexity of the chromolithographic process resulted in a shift in category designation between the Philadelphia Centennial of 1876 and the Chicago World's Columbian Exposition of 1893: at the earlier fair, lithography was displayed with other art forms (sculpture, paintings, and engravings), whereas at the later one it appeared with "Industrial Arts."[45] All the same, the difference between a chromolithograph and a fine-art color lithograph lies not so much in technical process as in the intent and application of the process.

No doubt Prang and his technicians "needed" twenty or more stones to reproduce Walters's Asian ceramics properly. That need, however, stemmed not from an independent artistic conviction but from a standard of fidelity to an artistic precedent. Chromos may have been garish and mechanical, but above all, they had no *raison d'être* apart from their source. (Prang viewed chromolithography as the handmaiden of painting.)[46] Not much had changed since Le Blon's "tableaux imprimés," which gave primacy to the painting and attempted to conceal rather than celebrate the print medium. If Vuillard and his peers embraced color lithography, it was precisely because it was

not painting: it was a mode of expression offering possibilities that painting did not. The idea of making a lithograph in the guise of a painting—or a ceramic object, or any other art form—would have been anathema.

The potency of the original-print discourse allied to color was such that even a completely outmoded print medium could enjoy resurgence in the 1890s. Auguste Lepère led the charge in reviving wood engraving, which in its earlier incarnation (it was introduced in France in 1817) had been exploited above all for illustration. Here again, the renewal of the medium hinged on its basic repurposing for independent artistic ends. Aesthetic changes followed: as Bracquemond remarked, Lepère moved from complexity toward simplicity, "omitting all secondary or transitory elements while retaining only those essential to the effect" [FIGS. 62, 63].[47] Even in a historically reproductive medium like wood engraving, where it was common to judge the success of individual examples by their resemblance to photographic negatives, the call was now for reserving pure white areas of the paper. (Bracquemond considered these reserve whites the "fundamental element of the print," the most active parts of the composition.)[48] Contrary to John Evelyn's conception of "natural appearances," which a print at all costs had to imitate, by the turn of the twentieth century, a print's appearance had only to be true to its own nature, in exploiting the full potential of paper and ink.

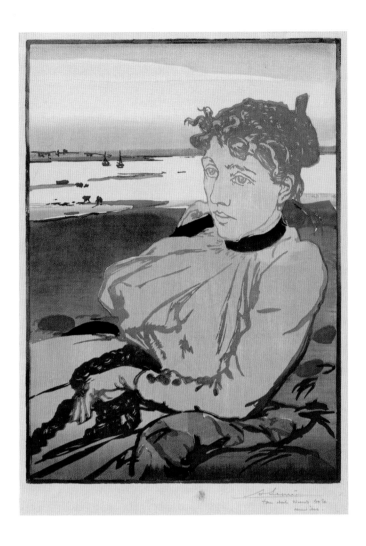

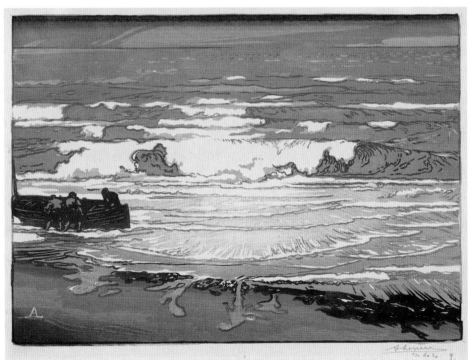

NOTES

1. In the 1996 catalogue *Anatomie de la couleur*, Maxime Préaud reminds us that early prints were not thought of as only black and white. The first woodcuts were understood as guides for the manuscript illuminator, with a notion of white space being "left open" for hand-applied color. See Préaud, "Du coloriage à l'impression en couleur," in *Anatomie de la couleur: L'invention de l'estampe en couleurs*, ed. Florian Rodari, exh. cat. (Paris: Bibliothèque nationale de France; Lausanne: Musée Olympique, 1996), 18. Susan Dackerman's important catalogue *Painted Prints* notes the persistence of hand-applied ("painted") color after the invention of technologies for printed color. See *Painted Prints: The Revelation of Color in Northern Renaissance & Baroque Engravings, Etchings, & Woodcuts*, exh. cat. (Baltimore: Baltimore Museum of Art, 2002).

2. The 2005 exhibition catalogue *Paper Museums* examines the role of the early modern print in disseminating imagery and artistic styles, propagating artistic fame, and bringing art within reach of a wider public, especially for monuments that were difficult of access. Rebecca Zorach and Elizabeth Rodini, *Paper Museums: The Reproductive Print in Europe, 1500–1800*, exh. cat. (Chicago: Smart Museum of Art, 2005). Notable "original printmakers" of the early modern period, like Rembrandt, became touchstones for the nineteenth-century Etching Revival. See Elizabeth Helsinger, *The "Writing" of Modern Life: The Etching Revival in France, Britain, and the U.S., 1850–1940*, exh. cat. (Chicago: Smart Museum of Art, 2008).

3. C. F. Bell, *Evelyn's Sculptura, with the unpublished Second Part* (Oxford: Clarendon Press, 1906), xvi, xviii. Dackerman notes Erasmus's similar conviction that "Dürer's designs did not require the assistance of color." Much of her catalogue is dedicated to overturning the traditional view of added color as a compensation for technical faults in the efforts of lesser printmakers. See *Painted Prints*, 2, 9.

4. Bell, *Evelyn's Sculptura*, 127, 47.

5. Named after the wealthy banker Pierre Crozat, who financed it, the *Recueil* sought to publicize works of art in major French collections, including Crozat's own. The first edition began publication in 1729.

6. Zorach and Rodini, *Paper Museums*, 21–23. On some of the plates from the later version, like the one reproduced here, the words at the bottom of the page specifying "bois… par Nicolas le Sueur" were retained despite the substitution of aquatint by François-Philippe Charpentier.

7. Ibid., 46–49. David Landau and Peter Parshall clarify that the chiaroscuro woodcut was an "especially luxurious type of print," an "elite form of Renaissance woodcut" and a "collector's item" imitating a fashionable kind of drawing. As they note, "the very appearance of the chiaroscuro woodcut is an important indication of the rising status of drawings during the Renaissance." Landau and Parshall, *The Renaissance Print: ca. 1470–1550* (New Haven and London: Yale University Press, 1994), 179, 184.

8. Antoine Gautier de Montdorge, ed., *L'art d'imprimer les tableaux: Traité d'après les écrits, les opérations & les instructions verbales, de J. C. Le Blon* (1756; rpt., Geneva: Minkoff, 1973), 78–79. My translation.

9. Ibid., 28. Godefroy Engelmann's technique of "chromolithographie," introduced almost exactly a century later (1837), also depended on yellow, red, and blue—plus black. His first productions in the medium show a knowledge of Le Blon's treatise on color. See Michael Twyman, *Images en couleur: Godefroy Engelmann, Charles Hullmandel et les débuts de la chromolithographie*, exh. cat. (Lyon: Musée de l'imprimerie, 2007), 9, 35–37.

10. See Maria Gordon-Smith, "The Influence of Jean Pillement on French and English Decorative Arts: Part One," *Artibus et Historiae* 21, no. 41 (2000): 171–96.

11. Zorach and Rodini, *Paper Museums*, vii.

12. Margaret Morgan Grasselli, *Colorful Impressions: The Printmaking Revolution in Eighteenth-Century France*, exh. cat. (Washington: National Gallery of Art, 2003), 7.

13. Maxime Préaud reinstates this dichotomy, emphasizing that the conflict between painter and printmaker—even if they're the same person—is a conflict between color and line. Préaud, "Du coloriage," 32.

14. Peter C. Marzio, *The Democratic Art* (Boston: David R. Godine; Fort Worth: Amon Carter Museum of Western Art, 1979), 73. On the flip side, Pierre Bonnard, who produced startlingly inventive color lithographs in the 1890s, declared that he had "learned a lot that applies to painting by doing color lithography. When one has to study relations between tones by playing with only four or five colors that one superimposes or juxtaposes, one discovers a great many things." Quoted in Colta Ives et al., *Pierre Bonnard: The Graphic Art*, exh. cat. (New York: The Metropolitan Museum of Art, 1989), 25.

15. André Mellerio, *Original Color Lithography*, trans. Margaret Needham, in Phillip Dennis Cate and Sinclair Hamilton Hitchings, *The Color Revolution: Color Lithography in France 1890–1900*, exh. cat. (Santa Barbara and Salt Lake City: Peregrine Smith, 1978), 80–81.

16. Préaud suggests that this is why, as early as the fifteenth and sixteenth centuries, master printmakers like Albrecht Dürer did not like the idea of handing over their work to a colorist. See Préaud, "Du coloriage," 24.

17. Nancy Mowll Mathews and Barbara Stern Shapiro, *Mary Cassatt: The Color Prints*, exh. cat.

(Williamstown: Williams College Museum of Art, 1989), 44.

18. The Salon of the Société des Artistes Français, that is. Cate and Hitchings, *The Color Revolution*, 1.

19. The critic Ernest Chesneau said the strength of Japanese prints was their accentuation of the "essential character" of their subject; Baudelaire referred to *"images d'Épinal* from Japan." See Phylis Floyd, "Seeking the Floating World: The Japanese Spirit in Turn-of-the-Century French Art," in *Hanga ni miru Japonisumu ten*, exh. cat., ed. Tanita Hiroyuki (Yokohama: Taniguchi Jimusho, 1989), 18, 19.

20. See Réjane Bargiel and Ségolène Le Men, *La Belle Époque de Jules Chéret: De l'affiche au décor*, exh. cat. (Paris: Les Arts Décoratifs/Bibliothèque nationale de France, 2010), 53, 56.

21. Sagot first included posters in his catalogue of fall 1886. See Bargiel and Le Men, *Chéret*, 20, 46, and 110; and Cate and Hitchings, *The Color Revolution*, 11–12.

22. Cate and Hitchings, *The Color Revolution*, 3.

23. Bargiel and Le Men, *Chéret*, 42, 61.

24. Ibid., 42, 63.

25. Jocelyn Bouquillard, "Henri Rivière, un graveur à l'âme japonisante, in Valérie Sueur-Hermel, *Henri Rivière: Entre impressionnisme et japonisme*, exh. cat. (Paris: Bibliothèque nationale de France, 2009), 27.

26. See Allison Morehead, "Interlude: Bracquemond and Buhot," in Helsinger, *The "Writing" of Modern Life*, 61–65.

27. François Fossier, Françoise Heilbrunn, and Philippe Néagu, *Henri Rivière: Graveur et photographe*, exh. cat. (Paris: Réunion des musées nationaux, 1988), 10.

28. Bouquillard in Sueur-Hermel, *Henri Rivière*, 27.

29. Cate and Hitchings, *The Color Revolution*, 4, 9: "Until the time of Chéret, there is no history of original color printmaking in France. . . . [The Japanese print] offered the artists in France the precedent of the use of color in original printmaking and in the creation of original prints or a series of prints unrelated to a text."

30. Mathews and Shapiro, *Mary Cassatt*, 51, 174–77.

31. Ibid., 81. The writer Pierre Loti contrasted the spare Japanese interior aesthetic with so-called Japanese rooms in the West, "crammed with imported knick-knacks." See Hans Belting, *The Invisible Masterpiece*, trans. Helen Atkins (Chicago: University of Chicago Press, 2001), 181.

32. Mathews and Shapiro, *Mary Cassatt*, 64.

33. Ibid., 82.

34. Rebecca A. Rabinow et al., *Cézanne to Picasso: Ambroise Vollard, Patron of the Avant-Garde*, exh. cat. (New York: Metropolitan Museum of Art; New Haven and London: Yale University Press, 2006), 196; Anisabelle Berès and Michel Arveiller, *Les peintres graveurs, 1890–1900* (Paris: Galerie Berès, 2002), 241.

35. Cate and Hitchings, *The Color Revolution*, 22.

36. Ibid., 26.

37. Ibid., 27–28; quotation on p. 92.

38. *La gravure impressionniste: De l'école de Barbizon aux Nabis*, exh. cat. (Paris: Somogy, 2001), 130.

39. The quoted term is Michael Fried's, in *Manet's Modernism, or, The Face of Painting in the 1860s* (Chicago: University of Chicago Press, 1996).

40. Mathews and Shapiro, *Mary Cassatt*, 73.

41. Sueur-Hermel, *Henri Rivière*, 216.

42. Marzio, *The Democratic Art*, 11.

43. Ibid., 81, quoting Senefelder in *The Invention of Lithography*.

44. Ibid., 94–95.

45. According to Marzio (*The Democratic Art*, 203–5), by 1890 there were sixteen divisions of specialists. For this reason, the artists reinventing color lithography had to make printers their "servants, not their managers" (Cate and Hitchings, *The Color Revolution*, 106).

46. Marzio, *The Democratic Art*, 95.

47. Quoted in François Fossier, *Auguste Lepère, ou le renouveau du bois gravé*, exh. cat. (Paris: Réunion des musées nationaux, 1992), 12.

48. Ibid., 14. See also Félix Bracquemond, *Étude sur la gravure sur bois et la lithographie* (Paris: printed for Henri Béraldi, 1897).

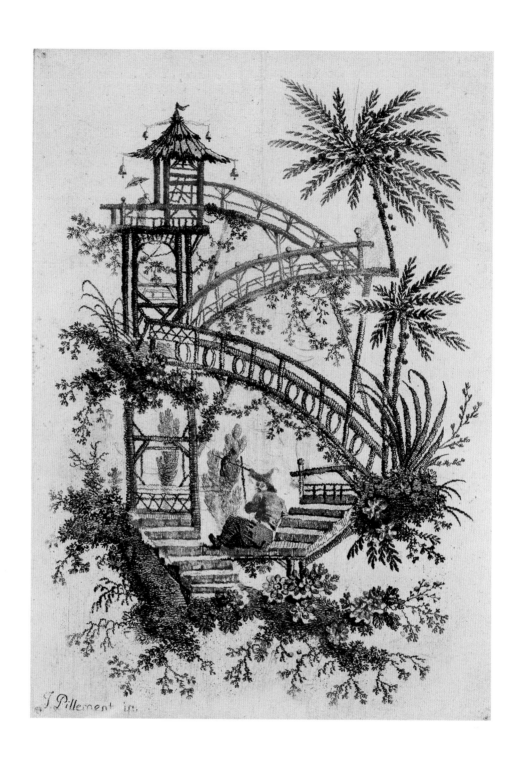

FIGURE 64
Anne Allen after Jean
Baptiste Pillement, plate
1 from *Nouvelle suite
de cahiers chinois no. 2*,
c. 1796–98, color etching,
Smart Museum of Art,
Cat. 1

DAVID ACTON

THREE
THE VIRTUOSO PRINTMAKERS OF EIGHTEENTH-CENTURY FRANCE

DURING THE MID-EIGHTEENTH CENTURY, the flowering of the arts in Bourbon France included remarkable innovation and achievement in color printmaking.[1] As this nation became the richest and most powerful in Europe, the style of its fine arts and luxury goods filtered from the French nobility to new bourgeois markets. While the affluent commissioned buildings and filled them with paintings, a broadening public could enjoy their images as printed reproductions. To supply them, a growing class of artisans adapted traditional intaglio printmaking methods, developing new and more cost-effective processes, while striving for ever-more-colorful effects. The history of these media is an engaging one, with provocative connections between lives of the court, the church, and the merchant classes, revealing craftsmanly ingenuity, effort, and grandiose aspirations in an epoch of mercurial change. The surge in French printmaking began around 1640 and continued through the next century. At its peak, some of the finest European craftsmen were attracted to Paris, and they developed international export markets. Printmakers in distant capitals amended the style and techniques of their own products.

The eighteenth-century explosion in color intaglio was made possible by earlier printmaking achievements, some dating back to the Renaissance, and refined in the Netherlands during the seventeenth century. In Rotterdam, the Dutch mathematician, professor, engineer, and artist Johannes Teyler was granted a patent in 1688 for a multicolor etching process, a method that would be fundamental to the later prints.[2] The apparent simplicity of his technique belies his considerable knowledge of metalwork and chemistry. After etching in the conventional manner, and detailing the copperplate with a burin, he charged it with several colored inks. Teyler used a different cloth to work each pigment into the plate separately, then meticulously wiped the plate before printing all the colors at once on a single sheet. He is presumed to have headed a small workshop that produced about 300 color prints, ranging from landscapes to natural history. The impact of Teyler's work is exemplified by the decorative *Landscape in a Medallion* [FIG. 65], with its precise variations of color—seen in the tree trunks of the middle ground, printed in brown and picked out from the foliage printed in green.

FIGURE 65
Johannes Teyler,
Landscape in a Medallion,
1685–90, color etch-
ing and engraving,
Worcester Art Museum,
Mrs. Kingsmill Marrs
Collection, 1926.1196

When Anne-Claude-Philippe de Tubières, the comte de Caylus, was asked to create repro-
ductions of pen-and-wash drawings early in the eighteenth century, he employed an older
method of etched line combined with relief-printed tone.[3] It was his friend Pierre Crozat, one of
the wealthiest financiers in France, who asked Caylus to make the prints.[4] The central figure in a
broad circle of *cognoscenti* and principal patron of the artist Antoine Watteau, Crozat was an emi-
nent collector. As the king's treasurer, Crozat represented the Regent, Philippe II, duc d'Orléans,
in 1714–21, in negotiations for the purchase of the art collection of Queen Christina of Sweden.
His own collection was particularly rich in drawings, which numbered some 19,000 sheets. To
celebrate these achievements, Crozat and his advisor Pierre-Jean Mariette produced an art book
with reproductions of the Italian paintings he had helped acquire for the royal collection and
his own drawings.[5] The two volumes of the *Recueil Crozat* present a selection of these works by
Roman artists in volume one, published in 1729, and those by Venetian masters in volume two,
published in 1742. By this organization, Mariette, as editor, perpetuated the theoretical diametry
of line and color. Several different engravers were engaged to reproduce the paintings, many on
large, fold-out plates.

In the production of about thirty prints after Italian Old Master drawings from Crozat's col-
lection, Caylus collaborated with Nicholas Le Sueur. A woodcut specialist in Paris, Le Sueur had
been experimenting with Italian chiaroscuro techniques and even exploring the use of clay for
relief matrices.[6] The format of these prints, with their distinctive combination of media, is exem-
plified in *Abbot Saint Restores a Blind Man's Sight*, after Giovanni Bonatti (see fig. 35).

During the years of production for the *Recueil Crozat*, color mezzotints began to appear in
Paris. This tonal engraving technique, invented by a German amateur, depends upon a tool called
a *berceau*, or rocker, consisting of a broad steel blade, with parallel grooves that provide regular

toothlike points along the tool's curved edge [FIG. 66].[7] By rocking the *berceau* in several directions across the entire copperplate, a craftsman roughened its surface into a sandpaperlike texture. If the plate were to be inked and printed at this point, it would produce a deep, all-over black. Instead, the artisan selectively scraped away the tiny metal burrs, to create passages that will hold some ink and print as gray, or burnished the metal smooth so it cannot hold ink, leaving the paper white and unmarked.

As mezzotint spread across northern Europe in the later seventeenth century, it captured the attention of the young J. C. Le Blon,[8] whose French Huguenot family had fled to Frankfurt during the Reformation. Studies in Zurich, Rome, and Amsterdam taught Le Blon the fundamentals of intaglio printmaking as well as the fine points of mezzotint; he also learned the chemistry of inks and dyes. In 1710, the artist made a pivotal experiment, charging separate plates engraved with three complementary mezzotints in yellow, red, and blue inks. These he overprinted on one sheet to make a compound color image.

Le Blon went to London in 1716 to promote his patent applications for multicolor printing and weaving processes. When he finally secured a privilege in 1721, he purposefully announced the license in Paris, the international epicenter of the printmaking industry, with an advertisement in the popular magazine *Mercure de France*. In London, Le Blon persuaded investors to support a retail shop, the Picture Office, where he sold and promoted his color prints. In 1722, he published his proprietary color mezzotint process in a book titled *Coloritto*, which explained his color theory in Newtonian terms, describing its application to painting and to mezzotint printmaking.[9] The book included tipped-in proofs with three-color separations and a finished sample mezzotint. Le Blon produced many color intaglios at the Picture Office, including reproductions of Old Master paintings printed in three or four hues. He preferred images with classicizing figures or pleasant genre scenes, seemingly chosen for consumers. But Le Blon did not meet with success and soon fled to Paris to escape an English debtors' prison.

FIGURE 66
Jean Charles Tardieu after Jean Robert, *Berceaux*, pl. 2 from Antoine Gautier de Montdorge, *L'art d'imprimer les tableaux*, 1756, etching and engraving, Worcester Art Museum, Mrs. Kingsmill Marrs Collection, 1926.1935

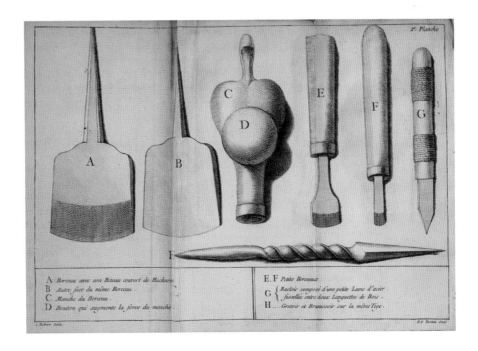

FIGURE 67
J. C. Le Blon, after
Hyacinthe Rigaud,
*André Hercules, Cardinal
de Fleury*, 1738, color
mezzotint with etching,
Worcester Art Museum,
Mrs. Kingsmill Marrs
Collection, 1926.534

By 1735, Le Blon had launched a new workshop, where he inaugurated his business by publishing a grand portrait of *André Hercules, Cardinal de Fleury*, his largest plate [FIG. 67]. In Paris, Le Blon's most successful publications were his reproductive mezzotints after decorative paintings. His studio offered large color prints mounted on wooden stretchers, varnished to make them appear to be painted canvases. By 1741, the artist had attracted a list of subscribers and begun work on a series of anatomical mezzotints, but within months he was dead.

By then, Jacques Fabien Gautier had emerged as Le Blon's rival in business and in society.[10] As a young man in the free trade port of Marseilles, Gautier had wondered whether color pictures could be made in the same way as the vividly printed chintz and paisley fabrics imported from India. In 1736, Gautier went to Paris, where he developed his ideas with the encouragement of Louis-Bertrand Castel.[11] Two years later, he joined Le Blon's workshop, but quit after just a few weeks, displeased with the master's failure to recognize him as more than a mere shop assistant. Eventually he found funding and opened a rival print shop, producing publications that were not as refined as Le Blon's, often finished with watercolor by hand, and presumably cheaper.

Soon after Le Blon's death, Gautier petitioned to assume his royal privilege, and take his place in business. The warrant was granted on September 5, 1741, for a period of thirty years. The artist

announced the award in the *Mercure de France*, along with a list of his stock of twenty-one available color prints. Included in each issue of the magazine was an impression of one of his color mezzotints representing a seashell. In December 1741, the journal advertised Gautier's modestly priced *tableaux imprimés*, reproductions of paintings by such Old Masters as Albrecht Dürer and Salvator Rosa, and others by more contemporary painters like Jean-Baptiste Chardin. These color mezzotints were produced in standard sizes, available loose or mounted, and the shop also sold affordable, ready-made frames to fit the prints.[12]

Gautier succeeded through diversification. Aside from his association with the *Mercure de France*, he provided prints for other serial publications. In 1750, his shop began printing and publishing the periodical *Observations physiques*, to be followed by *Observations sur l'histoire naturelle, sur la physique et sur la peinture* (1752–56), *Observations sur la peinture* (1753–54), and *Journal de monsieur* (1776–77). Gautier occasionally wrote for them, and other journals as well.[13] A proud member of the Academy of Sciences of Dijon, he worked with the surgeon and anatomist Joseph-Guichard Duverney on illustrated albums of anatomical studies meant for study and for teaching medical professionals.[14] Gautier strove for accurate color in these images, and he soon began to regard himself as a scientist. By 1745, he had turned away from reproductions and pictorial decoration, leaving his sons and workshop to maintain this lucrative business while he concentrated on scientific publications and prints. In 1775, he published *Exposition anatomique: Des organes, des sens, jointe à la neurologie entière du corps humain*, supposedly authored by him, illustrated with original color mezzotints [FIG. 68]. Whether Gautier's science was sound, or his artistic talents outstanding, he was fearless in the defense of his work, and used controversy to raise his public visibility.

By 1750, the artist had changed the family name to Gautier d'Agoty. He and his four sons—whose reputations also exceeded their achievements—became prominent in the printmaking industry, and noted members of Parisian art circles. Protecting the royal privilege for color

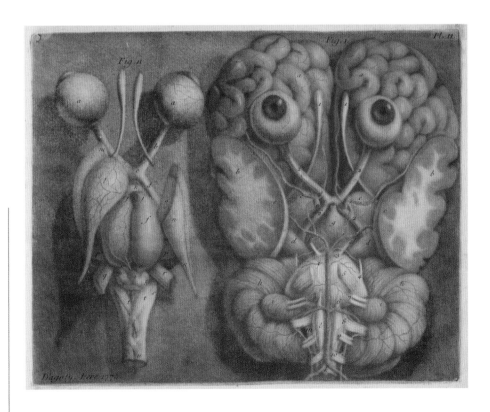

FIGURE 68
Jacques Fabien Gautier-Dagoty, *La base du cerveau*, pl. 2 from *Exposition anatomique*, 1775, color mezzotint with engraving, Worcester Art Museum, Mrs. Kingsmill Marrs Collection, 1926.1922

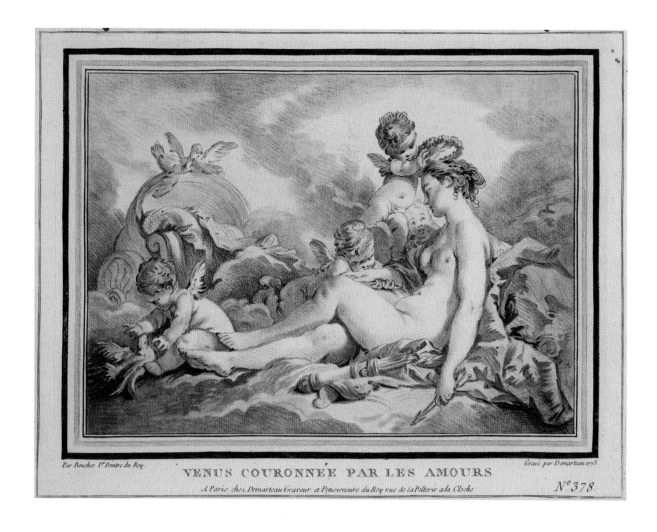

Par Boucher 1er Peintre du Roy. Gravé par Demarteau 1773

VENUS COURONNÉE PAR LES AMOURS

A Paris chez Demarteau Graveur et Pensionaire du Roy rue de la Pelterie a la Cloche

N.° 378.

mezzotint, however, remained crucial to Gautier. He was forced to defend the license when Le Blon's supporters and colleagues, led by Antoine Gautier de Montdorge, petitioned the government to shift its proceeds to Le Blon's dependents. A financial partner to Le Blon at the end of his career, Montdorge published *L'art d'imprimer les tableaux* in the late artist's defense, and as a marketing tool for his remaining stock.[15] He argued that the Newtonian basis for Le Blon's ideas was more important than reproductive accuracy. Gautier published the rejoinder that reproductive printmaking was his trade, and that his products looked more like the original canvases. His process was fundamentally different from Le Blon's, he insisted, because of the printing order of his colors, and for his use of a fourth plate, printed in black.

Gautier's goal as a reproductive artist was also the aim of the chalk-manner intaglio technique, developed in the 1740s by Jean-Charles François with the assistance of Gilles Demarteau.[16] They understood that their chalk-manner engravings would make improved models for art students. Copying drawings remained fundamental to artistic instruction in the mid-eighteenth century; original drawings were scarce, and chalk-manner facsimiles provided more accurate images of technique and effect than engravings. The artists also found that a growing number of collectors became interested in chalk-manner intaglios [FIG. 69]. By mid-century, original drawings had become *de rigueur* as interior decoration for people of taste, and aspirants to style and fashion who could not afford originals used elegantly mounted reproductive prints for a similar visual effect.

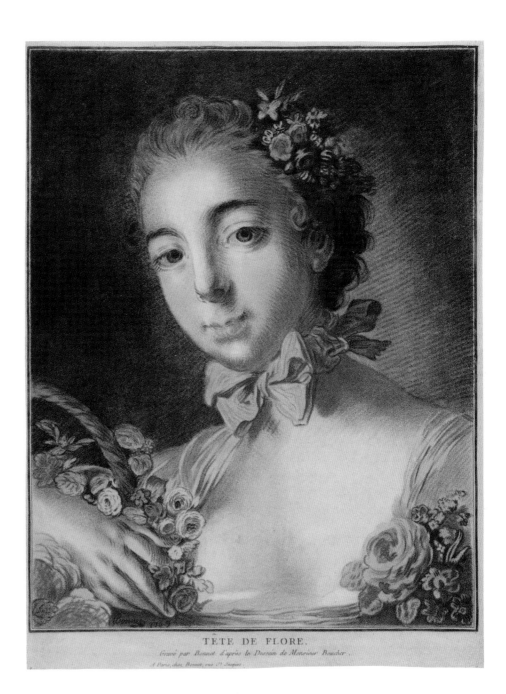

TÊTE DE FLORE.

Louis-Marin Bonnet is often credited as the first to use three complementary plates to print in black, red, and white on cream or blue paper, and reproduce the popular drawing technique of *à trois crayons*.[17] Descended from a family of artisans, he learned the basics of printmaking from his brother-in-law, Louis Legrand, who arranged for Bonnet to work with François in 1756. The youth seems to have been in that master's shop during the development of the chalk manner. When Demarteau opened his own shop, he persuaded Bonnet to join him. By the late 1770s, Bonnet had established a specialty in chalk-manner color intaglios, developing and managing the complexities of mixing and overprinting colored inks. To demonstrate his mastery of reproducing the effects of colored chalk, Bonnet executed *Tête de Flore* [FIG. 70], based upon François Boucher's pastel drawing.[18] His largest and most complex engraving, it was printed from eight plates in eleven colors. Bonnet utilized newly developed inks for some colors, one of which was said to have been made from powdered petrified wood. To accomplish this task, which obviously required moving and repositioning the plates several times, the artisan perfected a new way of using pins to assure correct registration. After piercing the copperplates with four holes, at precisely the same location, he mounted a jig in the bed of his press with four vertical pins protruding. When a drilled printing plate was slipped into position with the pins through the holes, the image lined up on a similarly fixed sheet. Bonnet himself dubbed his process "pastel manner," and published the explanatory pamphlet *Le pastel de gravure* to claim credit for its innovations.

The landscape painter and decorative designer Jean Baptiste Pillement employed a simpler mode of color intaglio to disseminate his style and influence, and to increase his business. A youthful prodigy as draftsman and designer, he began working at the Gobelins tapestry factory at age fifteen. His unique sense of style, and a remarkable breadth of knowledge of the varied decorative arts, drew the attention of affluent clients. After an international career including royal and imperial commissions, Pillement returned to France in 1768, when he began a project for Marie Antoinette in the Petit Trianon at Versailles.

Pillement produced drawings and reproductive prints that provided designers, artisans, and manufacturers with designs to be adapted in the ornamentation of wallpaper, textiles, porcelain, and furniture. Prints after Pillement helped spread the French Rococo style throughout Europe.[19] The artist had worked with other printmakers—including the Gautier workshop—before meeting Anne Allen sometime in the 1770s. Soon she became his primary printmaker, and they later married; her delicate touch distinguishes her plates from the other etchings after his designs.[20] Their collaborations had far-ranging influence, including both single prints and suites published in *cahiers*, or albums, useful to producers of decorative arts. Two of the nine albums they issued represent fantastic designs derived from Chinese art (FIG. 71; see also figs. 37 and 64). For centuries European artists had incorporated the imitation or evocation of Asian art in the ornamentation of luxury goods. During the seventeenth century, the practice was common in England and the Netherlands to decorate works of normal European form. On Pillement's extended professional travels he may have been impressed by these objects, and occasionally by the Asian originals. He melded the delicacy of Asian art with an inclination to asymmetry that suited the Rococo style. However, his designs were more fantastic and whimsical. He represented queerly dressed figures, fanciful landscapes with peculiar foliage, pagodalike and latticed structures. Appropriations from Pillement's designs appeared all over Europe during the following decades: French craftsman used them in fabric, wallpaper, and porcelain design; similar forms and details appeared in England in

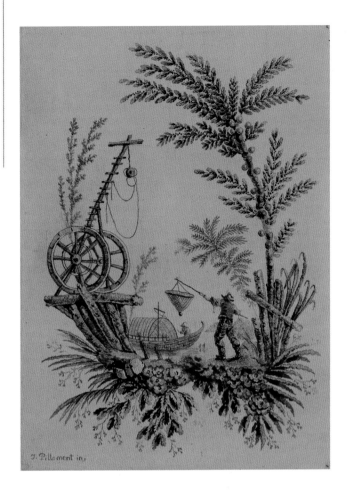

Chinese Chippendale furniture; and in Germany, the Meissen, Nymphenburg, and Höchst porcelain designers employed the same model books. Indeed, the fashion for *Chinoiserie* even survived the Neoclassical reaction against the Rococo style.

To approximate the look of Pillement's drawings, executed in several, fine colored chalks, Allen produced her color prints from one plate as Johannes Teyler had done. For each impression, she applied several colors of ink with small round cloth pads, rubbing pigments one at a time into the incised design to prevent the inks from mixing. In France, the process came to be known as *à la poupée* (with the "puppet" or "doll"), referring to the cloth pad applicators used to ink the copperplate. Each impression was unique because of the differences in the placement of the inks and the selection of the colors.

Aquatint is a tonal intaglio method that emerged in Amsterdam around 1650, at about the time Teyler was becoming interested in color intaglio. The first French experiments with aquatint did not take place until a century later. Printmakers like François-Philippe Charpentier (see fig. 36), Jean Baptiste Claude Richard (abbé de Saint-Non), and Jean-Baptiste Le Prince used the process for elegant prints, but aquatint never caught on in France as an independent medium.[21] Instead, Parisian printmakers combined it with other etching and engraving processes in an unprecedented technical array that achieved the appearance of ink, wash, watercolor, gouache, or oil painting. They usually tried to eliminate the granulated appearance of aquatint and the evidence of tool work for more persuasive reproductions. The complexity of these techniques, and their varied

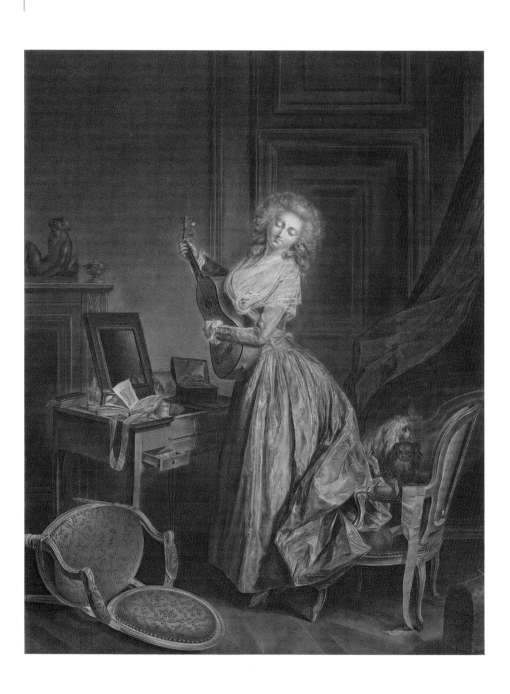

use and modification by different artisans, makes them difficult to unravel, even with the aid of the microscope.

An intaglio master who excelled in these combined media was Jean-François Janinet.[22] The son of a gem engraver of Saint-Germain in Paris, he worked as an apprentice in Bonnet's studio, and also studied at the Académie royale de peinture et de sculpture. He published his first independent plate in 1772, and soon progressed to multiplate prints after fashionable painters such as Jean-Honoré Fragonard, Hubert Robert, and Jean-Baptiste Greuze. When Janinet opened his own shop, he continued to collaborate with Bonnet's studio on the production of printed and gilt mounts for drawings. He progressed from single leaves and small suites to extensive commissions from the leading publishers.

Janinet's *A Woman Playing the Guitar*, after Niclas Lafrensen [FIG. 72], seems to mark a turning point in the printmaker's career, even though it was never published. This stunning fashion plate, produced in about 1788, is known in just four proofs, all of them without inscriptions. Its scale and imagery are similar to others of Janinet's plates from this time, so it may have been conceived as part of a serial project. Compared to the other prints, however, *The Guitar Player* is rather contemplative. The others represent multiple figures in amorous games. Here, only the overturned chair and untidy dressing table suggest the recent presence of a visitor. This print reflects Janinet's continually evolving skill. He printed this image richly, in a way that more accurately reflects the impact of Lafrensen's lush gouache painting. Whether he achieved the effect by working his plates more deeply, or saturating passages by overprinting the same color, this refinement represents a progression from earlier work. Most observers of this piece are enchanted by Janinet's representation of the iridescent cross-woven silk of the young woman's dress. In earlier plates, the artist had tried to represent this effect, so favored by portrait painters, with less success. Soon, however, Janinet turned away from such luxury. It seems clear that the market for expensive fashion plates declined in the prelude to the Revolution. However, he maintained his career through the era, by shifting from society imagery to topical and allegorical subjects.

Janinet's technical refinement and elegance were carried on by his most successful pupil, Charles-Melchior Descourtis.[23] His best-known works are four color prints after small gouache genre paintings of Nicolas-Antoine Taunay, but he produced a sizeable oeuvre of masterful illustrative color prints. In 1788, Descourtis made color illustrations for a deluxe edition of Jacques-Henri Bernardin de Saint-Pierre's popular novel *Paul et Virginie* [FIG. 73].[24] This moral tale relates the sad fate of an innocent child of nature corrupted by the mores of the French upper classes. Set on Île de France—modern-day Mauritius—it is the story of two fatherless children who embody the innocent experience of nature, characterizing Jean-Jacques Rousseau's ideal of the unsullied personality. In adolescence, the couple fall in love but they are forced apart when Virginie is sent to France. In ensuing events, the vulnerability of nature is thrust into conflict with more powerful forces of corruption and artifice, to a tragic end.

During the 1780s, Philibert Louis Debucourt also produced sophisticated color intaglios, including large fashion subjects and illustrative plates in series. A native Parisian, he served as an apprentice in the studio of Joseph-Marie Vien.[25] He also trained as a painter at the Académie royale, and in 1781 the first of several of his canvases was selected for the Salon. It is uncertain how Debucourt learned the refinements of color printing, but when he established an independent studio around 1785, he began by publishing a few large color mezzotints. Two years later, by the

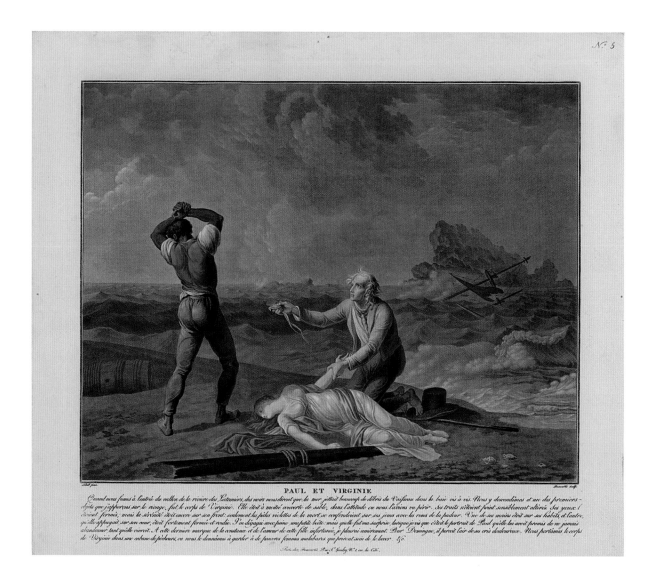

PAUL ET VIRGINIE

Quand nous fumes à l'entrée de la vallée de la rivière des Lataniers, des noirs nous dirent que la mer jettoit beaucoup de débris du Vaisseau dans la baie vis à vis. Nous y descendimes et un des premiers – objets que j'apperçus sur le rivage, fut le corps de Virginie. Elle étoit à moitié couverte de sable, dans l'attitude ou nous l'avions vu périr. Ses traits n'étoient point sensiblement altérés. Ses yeux étoient fermés; mais la sérénité étoit encore sur son front: seulement les pâles violettes de la mort se confondoient sur ses joues avec les roses de la pudeur. Une de ses mains étoit sur ses habits, et l'autre qu'elle appuyoit sur son cœur, étoit fortement fermée et roidie. J'en dégagai avec peine une petite boëte: mais quelle fut ma surprise, lorsque je vis que c'étoit le portrait de Paul qu'elle lui avoit promis de ne jamais abandonner tant qu'elle vivroit. A cette dernière marque de la constance et de l'amour de cette fille infortunée, je pleurai amèrement. Pour Domingue, il perçoit l'air de ses cris douloureux. Nous portimes le corps de Virginie dans une cabane de pêcheurs, ou nous le donnames à garder à de pauvres femmes malabares qui prirent soin de le laver. &c.

Suite des Français Rue S.ᵗ Jacques Nᵒ 1, au ba Côté.

time the artist produced *The Ascent, or The Morning Farewell* [FIG. 74], he had settled on smaller plates in mixed intaglio techniques that achieve the subtle effects of a watercolor or wash drawing. The delicate atmospheric effect of morning sunlight in distant treetops is created by a combination of mezzotint with *lavis* manner etching, done by brushing acid directly onto the plate to roughen its surface and capture a thin film of ink. Debucourt made his reputation with romantic prints, tinged with sensuality and humor. These qualities are apparent in *The Ascent*, the scene of a young couple's parting after a night's tryst. Their passion is suggested by the secret rendezvous, the woman's undress, and the trail of the man's clothing up and over the wall, apparently revealing the route of his arrival the night before. The whole scene creates an atmosphere of conspiracy, as even the barnyard animals avoid detection, if sometimes by bribery. Though often costly, romantic prints of this kind became very popular as boudoir decoration, and remained so for a century.

By the turn of the nineteenth century, the Parisian color intaglio print had become a widely established luxury for illustration or decoration; as elegant products, they could demand high prices. This situation was challenged with the advent of lithography, a wholly new printmaking technology that became faster and more economical, eventually superseding color intaglio.[26]

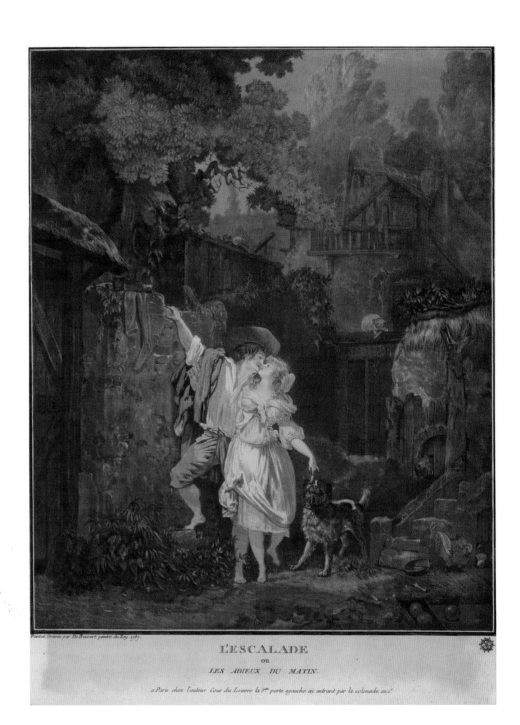

L'ESCALADE
ou
LES ADIEUX DU MATIN.

a Paris chez Laudour Cour du Louvre la 3me porte agauche en entrant par la colonade, au.

FIGURE 73
Charles-Melchior
Descourtis after Jean-
Frédéric Schall, *The
Shipwreck*, 1788, intaglio
color print, Museum of
Fine Arts, Boston, Cat. 16

FIGURE 74
Philibert Louis
Debucourt, *The Ascent,
or The Morning Farewell*,
1787, color aquatint,
National Gallery of Art,
Washington, Cat. 13

FIGURE 75

Godefroy Engelmann,
*Title Page of Album
Chromolithographique,*
1837, color lithograph,
Worcester Art Museum,
Mrs. Kingsmill Marrs
Collection, 1926.1153

Although lithography was invented in Bavaria, some of its pivotal developments took place in France, where it reached an extraordinary level of refinement in the nineteenth century.

Lithography—literally "stone-writing"—is often described as *planographic* technique, since it transfers an image from a flat surface rather than one carved in relief or incised into a printing plate. The process was invented in the 1790s by Alois Senefelder, a playwright who began searching for a fast, accessible way to print and publish his work. He hit upon a printing method based on the principle that oil and water do not mix. In the basic process of lithography, the artist draws an image in greasy ink on the printing surface. The stone is then chemically treated to fix the image and open the unmarked areas of the microscopically porous slab. Once an image has been applied to the printing surface with *tusche*—a greasy liquid ink traditionally called by its German name—or crayon, the pigment can be scraped away to create a white accent in the finished lithograph. The craftsman flushes the stone with water, so that moisture soaks into its unsealed surfaces. When oil-based printing ink is rolled on top, it sticks to the tacky drawing but is repelled from wet areas. After laying a sheet of paper over the inked image, the printer pulls the stone through a press, transferring its design to the sheet. With care, a lithographic image can be reinked and reprinted hundreds of times.

Charles-Philibert Lasteyrie, comte du Saillant, was a pivotal figure in establishing lithography in France.[27] Privileged and well educated, he was fired by the revolutionary ideals of freedom and equality, and later became an advocate for universal education. Intrigued by the invention of

lithography, Lasteyrie traveled to Munich to learn the process from Senefelder himself. A natural draftsman, he learned to draw directly on the printing surface using a broad nib pen and saturated *tusche*. In Paris in 1815, Lasteyrie opened the first commercially successful lithography shop in France. When Senefelder perfected waxy crayons for drawing on the lithography stone, Lasteyrie adopted these, and provided them to his artist-clients, who seem to have preferred their ease and immediacy for printmaking.

Lasteyrie's greatest influence on French printmaking may have been his support of Godefroy Engelmann, a pioneer of color lithography.[28] Born in the small town of Mulhouse on the borders of France, Switzerland, and Germany, Engelmann attended private schools in La Rochelle and Bordeaux, before moving to Paris to join the studio of Jean-Baptiste Regnault. He too was captivated by news of lithography, and its capability for capturing the draftsman's sketchy line. Engelmann journeyed to Bavaria to meet Senefelder, and worked for him over the summer of 1814 to learn the rudiments of the process. In June 1816, Engelmann opened the La Société Lithotypique de Mulhouse, a commercial lithography studio in Paris. With Lasteyrie's fellowship and financial support, he dominated the young industry over the next two decades in France.

Engelmann's greatest innovation was a method of printing in four colors that provided consistently high-quality results. Conceptually, this process derived from color intaglio, for the artisan employed a frame of his own invention in which stones of comparable size and shape could be fixed in the press in the same position to assure accurate registration. He also printed with inks of blue, red, yellow, and black, the same hues used by Le Blon and his successors. In 1837, Engelmann was granted an English patent for his process of chromolithography [FIG. 75].[29]

The French dominance of the graphic arts during the eighteenth century occurred in a time of economic prosperity and cultural confidence, when interest in science flourished, along with the organization of knowledge and new technologies. Artisans applied new printmaking discoveries to fashionable imagery and styles ultimately derived from the monarch and the royal court. They catered to a growing cohort of middle-class consumers similar to that which supported printmaking developments in the Netherlands during the previous century, the foregoing period of graphic arts innovation. French printmakers developed products to appeal to wider audiences. They furnished art teachers and students with prints to use as exercise models, and provided images as design sources for many other craftspeople. Artisans used the prints as craft materials, incorporating colorful prints into the decoration of boxes, brooches, and buttons. Book publishers employed color intaglios for the illustration of their most lavish editions, in books for research, education, and entertainment. Collectors methodically acquired these prints for interest and amusement, often mounting them in scrapbooks, while other buyers valued them as interior decoration. Paris became the leading center of European printmaking, and Parisian intaglios set the trends of style and technique for printmakers across the continent and beyond.

Lithography, a faster and more economical printing method, began to make color intaglio printmaking obsolete soon after 1800. Within decades, this process was able to provide thirty or more colors printed economically on paper, and other supports like on metal. Over the course of the nineteenth century, chromolithographs became so ubiquitous and inexpensive that the term "chromo" became synonymous with cheap inferiority. By that time French artists like Eugène Delâtre and Charles Maurin had begun a revival of color intaglio, yet never were they able to attain the same virtuosity and refinement as their predecessors in the eighteenth century.

NOTES

1. For surveys of French eighteenth-century color printmaking, see Margaret Morgan Grasselli, *Colorful Impressions: The Printmaking Revolution in Eighteenth-Century France*, exh. cat. (Washington: National Gallery of Art, 2003); Victor I. Carlson and John W. Ittmann, *Regency to Empire: French Printmaking, 1715–1814*, exh. cat. (Minneapolis: The Minneapolis Institute of Arts, 1984).

2. On Teyler, see J. A. van Beers and G. Th. M. Lemmens, *Johannes Teyler*, exh. cat. (Nijmegen: De Waag, 1961); Clifford S. Ackley, *Printmaking in the Age of Rembrandt*, exh. cat. (Boston: Museum of Fine Arts; New York Graphic Society, 1981), 302–4.

3. On the comte de Caylus, see Nancy Thomson de Grummond, ed., "Caylus, Anne Claude Philippe, comte de," *Encyclopedia of the History of Classical Archaeology* (Westport, CT: Greenwood Press, 1996), 1: 261–62; Nicholas Crok and Kris Peeters, eds., *Le comte de Caylus, les arts et les lettres* (Amsterdam: Rodopi, 2004).

4. On Crozat, see Cordélia Hattori, "The Drawings Collection of Pierre Crozat (1665–1740)," in *Collecting Prints and Drawings in Europe, c. 1500–1750*, ed. Christopher Baker (Warwick, Aldershot: Ashgate, in association with the Burlington Magazine, 2003), 173–81.

5. Pierre-Jean Mariette, *Recueil d'estampes d'après les plus beaux tableaux, et d'après les plus beaux dessins qui sont en France dans la cabinet du roy et dans celui du Duc d'Orléans, et dans autre cabinets*, 2 vols. (Paris: Imprimerie royale, 1729, 1742). See also Benedict Leca, "An Art Book and Its Viewers: The 'Recueil Crozat' and the Uses of Reproductive Engraving," *Eighteenth-Century Studies* 38 (Summer 2005): 623–49.

6. Le Sueur came from a large family of printmakers originating in Rouen, and active in Paris as well, where both relief and intaglio prints were produced; see Ulrich Thieme and Felix Becker, *Allgemeines Lexikon der bildenden Künstler von der Antike bis zur Gegenwart* (Leipzig: W. Engelmann, 1907–50), 23: 131–32.

7. See Carol Wax, *The Mezzotint: History and Technique* (New York: Abrams, 1990), 15–16.

8. On Le Blon, see O. M. Lilien, *Jacob Christoph Le Blon, 1667–1741: Inventor of Three- and Four-Colour Printing* (Stuttgart: Hiersemann, 1985); Sarah Lowengard, "Jacob Christoph Le Blon's System of Three-Color Printing and Weaving," in *The Creation of Color in 18th-Century Europe* (New York: Columbia University Press, 2006).

9. Johann Christoffel Le Blon, *Coloritto: Or the Harmony of Colouring in Painting, Reduced to Mechanical Practice* (London: Chez J. C. Le Blon, 1725).

10. On Gautier, see A. Bouchard, "Une famille d'artistes français aux XVIIIe siècle," *Mémoires de la commission des antiquités du département de la Côte d'Or* (Dijon: Académie des sciences, arts et belles lettres, 1936–37), 21: 135–40; Corinne Le Bitouzé, "Une entreprise familiale," in *Anatomie de la couleur: L'invention de l'estampe en couleurs*, exh. cat., ed. Florian Rodari (Paris: Bibliothèque nationale de France; Lausanne: Musée Olympique, 1996), 100–5.

11. The Jesuit mathematician Louis Bertrand Castel (1688–1757) and author of the *Traité de physique sur la pesanteur universelle des corps* (Paris: A. Cailleau, 1724) focused his research on physics and natural philosophy. For many years he considered an "ocular harpsichord" based on a notion of color melody, which he described in *Optique des couleurs* (Paris: Briasson, 1740). See Thomas L. Hankins and Robert J. Silverman, *Instruments and the Imagination* (Princeton: Princeton University Press, 1995), 72–85.

12. See Kristel Smentek, "'An Exact Imitation Acquired at Little Expense': Marketing Color Prints in Eighteenth-Century France," in Grasselli, *Colorful Impressions*, 11–12.

13. See Jean Sgard et al., eds., *Dictionnaire des journaux, 1600–1789* (Paris: Universitas; Oxford: Voltaire Press, 1991), §1088–89.

14. Joseph-Guichard Duverney, *Anatomie de la tête, en tableaux imprimés, qui représentent au naturel le cerveau sous différentes coupes, la distribution des vaisseaux dans toutes les parties de la tête, les organes des sens, & une partie de la névrologie, d'après les pièces disséquées & préparées* (Paris: Chez Gautier, M. Duverney, & Quillau, 1763).

15. Antoine Gautier de Montdorge, ed., *L'art d'imprimer les tableaux: Traité d'après les écrits, les opérations & les instructions verbales, de J. C. Le Blon* (Paris: P. G. Le Mercier, Jean-Luc Nyon, and Michel Lambert, 1756).

16. On François, see Jacques Hérold, *Gravure en manière de crayon: Jean Charles François (1717–1769), catalogue de l'oeuvre gravé* (Paris: Société pour l'Étude de la Gravure Française, 1931). On Gilles Demarteau, see M.-L. Blumer, "Demarteau," in *Dictionnaire de biographie française* (Paris: Letouzey et Ané, 1965), 10: 971–72; Albert de Neuville, *Gilles Demarteau* (Turnhout: Brepols, 1920).

17. On Bonnet, see Jacques Hérold, *Louis-Marin Bonnet (1736–1793): Catalogue de l'oeuvre gravé* (Paris: Maurice Rousseau, 1935).

18. On Bonnet's *Tête de Flore*, see Grasselli, *Colorful Impressions*, 68–71; Carlson and Ittmann, *Regency to Empire*, 194–96.

19. On Pillement, see Maria Gordon-Smith, *Pillement* (Cracow: IRSA, 2006); *Jean Pillement: Paysagiste du XVIIIe siècle, 1728–1808*, exh. cat. (Béziers: Musée des beaux-arts de Béziers, Hôtel Fabrégat, 2003).

20. On Allen, see Grasselli, *Colorful Impressions*, 150–53; Carlson and Ittmann, *Regency to Empire*, 316–17.

21. On Charpentier, see also Christiane Wiebel and Wolfgang Schwahn, "Aquatinta, oder, 'Die Kunst mit dem Pinsel in Kupfer zu stechen'," *Das druckgraphische Verfahren von seinen Anfängen bis zu Goya*, exh. cat. (Coburg: Kunstsammlungen der Veste Coburg; Berlin: Deutscher Kunstverlag, 2007). On Richard, see Jean Cayeux, "Introduction au catalogue critique des griffonis de Saint-Non," *Bulletin de la Société de l'histoire de l'art français* (1963): 297–384. On Le Prince, see Jules Hédou, *Jean Le Prince et son oeuvre, suivi de nombreux documents inédits* (Paris: J. Baur, 1879).

22. On Janinet, see Philippe de Carbonnières and Daniel Jouteux, *Les gravures historiques de Janinet*, exh. cat. (Paris: Musée Carnavalet, 2011). Success enabled Janinet to enjoy the pursuits of a gentleman, such as literature and science, particularly the exploration of manned flight. He was especially interested in thermal airships, balloons that were propelled instead of riding on the wind.

23. On Descourtis, see Grasselli, *Colorful Impressions*, 108–11; Carlson and Ittmann, *Regency to Empire*, 272–76.

24. Bernardin de Saint-Pierre, *Paul et Virginie* (Lausanne: Chez J. Mourer, 1788).

25. On Debucourt, see Henri Bouchot, *P.-L. Debucourt* (Paris: E. Moreau & cie, 1904); Musée des arts décoratifs, *Exposition Debucourt: Catalogue des tableaux, dessins, gravures exposés au Musée des arts décoratifs*, exh. cat. (Paris: Palais du Louvre, 1920).

26. On the process and history of lithography, see Alois Senefelder, *A Complete Course of Lithography: Containing Clear and Explicit Instructions in All the Different Branches and Manners of that Art; Accompanied by Illustrative Specimens of Drawings* (1819; rpt., New York: Da Capo Press, 1977); Felix H. Man, *150 Years of Artists' Lithographs, 1803–1953* (London: Heinemann, 1953); Domenico Porzio, ed., *Lithography: 200 Years of Art, History, & Technique* (New York: Abrams, 1983).

27. On Lasteyrie, see Charles Defondon, "Lasteyrie," *Nouvelle dictionaire de pédagogie* (Paris: Hachette, 1911), 64–65.

28. On Engelmann, see Michael Twyman, *Images en couleur: Godefroy Engelmann, Charles Hullmandel et les débuts de la chromolithographie*, exh. cat. (Lyon: Musée de l'imprimerie, 2007); Léon Lang, *Godefroy Engelmann, imprimeur lithographe: Les incunables, 1814–1817*, with preface by Jean Adhémar (Colmar: Éditions Alsatia, 1977).

29. Described in Engelmann's *Traité théorique et pratique de lithographie* (Mulhouse: P. Baret, 1839).

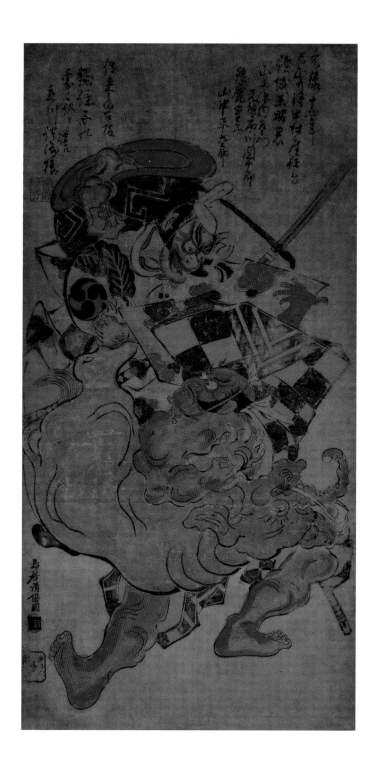

FIGURE 76
Torii Kiyomasu I, *Ichikawa Danjūrō I as Yamagami Gennaisaemon and Yamanaka Heikurō as Soga no Iruka in the play Keisei Ōshōkun*, 1701, hand-colored woodblock print, The Mann Collection, Highland Park, IL, Cat. 94

DAVID WATERHOUSE

FOUR THE DEVELOPMENT OF COLOR PRINTING IN JAPAN: SOME EARLY SINGLE-SHEET PRINTS

THE EARLY HISTORY OF PRINTING and printed illustration in Japan to some extent parallels its history in Europe, in that the first texts and images to be printed were religious, and from the seventeenth century onward, in both East and West, there were simultaneous developments in the printing and illustration of secular and popular literature. However, printing in East Asia has a far longer history than in Europe: the world's oldest examples of block printing (under Chinese influence) are Korean and Japanese, from the middle eighth century and 770, respectively. From the eleventh century onward, movable type was occasionally used, but most printing was from woodblocks, which readily permitted the incorporation of illustration.

Particularly in Japan, with the growth of a new urban culture centered on the three cities of Edo (modern Tokyo), Kyoto, and Osaka, printing was on a vast scale, starting in the later 1600s. Often books contained woodcut illustrations; and from the late seventeenth century onwards single-sheet woodcuts and woodcut albums began to appear too. To begin with, these woodcut prints were black and white, or had applied coloring; but, under Chinese influence, color printing was introduced in the second quarter of the eighteenth century, above all in the figure prints of *ukiyo-e* ("pictures of the Floating World"). At first, in the so-called *benizuri-e*, only two color blocks were used, in addition to the black key block; but by the early 1760s, three color blocks were common; and the later 1760s saw the arrival of the full-color print, or *nishiki-e* ("brocade picture"), first popularized by Suzuki Harunobu. Harunobu's *nishiki-e* used five to seven pigments in addition to that for the key block; and also he produced two books illustrated throughout in full color. After him, the number of color blocks continued to increase, so that by the middle of the nineteenth century, some twenty blocks might go to the making of a landscape print by Utagawa (Andō) Hiroshige.

The technology of color printing in Japan was labor-intensive but highly effective, superb results being achieved through simple means. In the early color prints, a few of the pigments came from mineral sources, but for the most part vegetable dyes were used. Harunobu's prints

generally used *hōsho* ("edict paper"), which was creamy, thicker, and more finely textured than that of earlier *ukiyo-e*, and permitted special effects of embossing such as *karazuri* (heavy printing with an uninked block) and *kimedashi* (printing the lines very heavily, to make the areas in between stand out). As time went on, the number of special printing effects increased: not just over-printing of one color on another, but also gradated inking (*bokashi*) of a single block; and printing with lacquer (*urushi*: usually black), powdered mica (*kirara*), gold, or silver. Techniques of textile printing, whose history in Japan goes back to the eighth century, probably influenced some of these developments.

The subjects of the early prints were mostly human figures: especially statuesque Yoshiwara courtesans and kabuki actors, the latter usually depicted in particular stage roles. However, the subject matter of *ukiyo-e* is endlessly varied, embracing domestic scenes, landscape, allusions to Chinese and Japanese literature, urban folklore, and so on. The examples discussed in this essay show that sometimes it can be a challenge to tease out the meaning of individual prints.

Early Hand-Colored Prints

THE EXHIBITION INCLUDES early hand-colored prints by Torii Kiyomasu I, Okumura Masanobu, and Tanaka Masunobu. The long-lived Torii line of artists first specialized in prints and posters for the kabuki theater, and the example by Kiyomasu, dating to a performance in the eleventh month, 1701, has the character of a poster [FIG. 76].

This print, published by Emiya, came to light in 2004, in the second of two sales from the collection of the Belgian art patron Adolphe Stoclet (1871–1949).[1] It is important for the early history of both *ukiyo-e* and kabuki; but it is possible here to give only a bare summary of conclusions to be drawn from it. The play, *Keisei Ōshōkun (The Courtesan Wang Zhaojun)*, alludes in its title to a Chinese story from the first century BC,[2] but it had a Japanese setting and, like many another kabuki play, was an *olla podrida* of dramatic episodes, loosely connected: in this case centering on the ancient rivalry between Fujiwara no Kamatari (614–69) and Soga no Iruka (d. 645). The scenario was written by Ichikawa Danjūrō I (1660–1704), in four Acts; and Kiyomasu's print portrays a scene from the climax of Act I, in which the hero forcibly drags an elephant away from its villainous owner. There is no elephant in the story of Wang Zhaojun; both she and it were apparently introduced for dramatic effect and to suggest remoteness. The published text was illustrated with anonymous black-and-white woodcuts, including two which depict the elephant (with a female rider). In the scene in question, Iruka enters on the back of a white elephant, which Yamagami Gennaisaemon (as Kamatari) wrests from him; he then hands it over to his wife, Yadorigi, who mounts it.[3] In *Keisei Ōshōkun*, Ichikawa Danjūrō I himself played the part of the hero Yamagami Gennaisaemon, and Yamanaka Heikurō IX played Soga no Iruka. Yadorigi was played by Uemura Izutsu.

Another specimen of this print in the Nelson-Atkins Museum of Art, Kansas City, has long been known,[4] but some of its hand-coloring seems to be a later addition;[5] the present print has a much better chance of being entirely original. Moreover, at the top it bears a long hand-written inscription by Tatekawa Enba (1743–1822), which identifies the date, the theater, the play, and the two actors and their roles. However, Heikurō's role is wrongly given as Suzuka no Ōji (Prince Suzuka, d. 745).[6]

Tatekawa Enba (also known as Utei Enba) was originally trained as a carpenter, but interested himself from a young age in *kyōka* and *haikai* (two kinds of light verse), and in the theater; he became an important figure in the development of *rakugo*, comic monologues. He was the author of several books, including a detailed chronology of kabuki performances (which fails to mention *Keisei Ōshōkun*), and he was an intimate of the Ichikawa Danjūrō family.[7] His inscription on the present print was "written at the request" (*motome ni yorite shiki su*) of a person whose name cannot be read with certainty, but who may have been a fellow admirer of Danjūrō, or could have belonged to another of the literary groups around Enba. He signs his own name as "Tatekawa Danshūrō," with a play on the name Danjūrō.

In the early nineteenth century, a loose copy of Kiyomasu I's print [FIG. 77] was made by the minor artist Torii Kiyomine (1788–1868).[8] At the top it has a long printed inscription by Enba, written "at the age of 70" (which would fix the year as 1812 or 1813). He explains that "this picture is from an old block inherited by Emiya Kichiemon" (*kono zu wa Emiya Kichiemon jiden shi kohan*), who in the spring of 1744 had been responsible for producing the first prints in color. The second part of this statement is corroborated from other sources. According to the learned Ōta Nanpo (1749–1823), a registration device for color prints was devised in 1744 by Uemura Kichiemon of the Emiya: "That which is now called the *kentō* was originally called the *Uemura*."[9] The *kentō* consisted simply of a right-angle projection at one corner of the block, and a horizontal projection along one side. A sheet of paper could then be accurately slotted into place by the printer. (It should be borne in mind that artists did not usually cut or print their own work; this was done by the separate trades of block-cutter and printer, all of whom were in the employ of the publisher.)

Enba continues by repeating his identification of the date and other details, including his mistake concerning the role of Heikurō; and he adds a clever *kyōka*:

wazaoki no	Of strolling players
ujigami nareba	it is the household god: so
chihayaburu	the venerable
e-miya Torii no	Emiya, "picture shrine," keeps
na wo nagorikemu	note of the Torii name.[10]

As with his inscription on the Kiyomasu print, he signs himself "Tatekawa Danshūrō."

Reproduced beside this long inscription is a poem by the youthful Ichikawa Danjūrō VII (1791–1859). In the signature block of the print, Kiyomine says that he drew it by request (*motome ni ōjite*); he proclaims himself to be the "fifth generation Torii"; and he wrongly identifies the original artist as Kiyonobu I, rather than Kiyomasu I.[11] Using the same annotation "fifth generation," the print also copies (with alterations to the address) the publisher's seal from the Kiyomasu; and there is an additional seal *Mura*, of the publisher Murataya Jirobei (Eiyūdō); together with three other seals, of censorship officials.

The Kiyomine print has been described as "homage"; Enba's inscription and poem make clear that it was primarily intended as a tribute to the publishing house Emiya. In the 1830s, Ichikawa Danjūrō VII went on to revive the scene depicted by Kiyomasu I and Kiyomine, under the title *Zō hiki* ("Pulling the Elephant"); and by the 1840s, it had become one of eighteen representative kabuki pieces (*Kabuki jūhachiban*).[12] It has occasionally been performed since, but was never as popular as others from this group. Later *ukiyo-e* artists continued to depict it in almost exactly the same way as Kiyomasu I (or rather Kiyomine), repeating Enba's misidentification of the villain as Suzuka no Ōji.[13]

FIGURE 77

Torii Kiyomine after Torii Kiyomasu I, *The Actors Danjūrō I and Yamanaka Heikurō as Yamagami Saemon and Suzuka no Ōji Grappling with an Elephant in Keisei Ōshōkun, Nakamura Theater*, 1812, color woodblock print, Allen Memorial Art Museum, Oberlin College, Mary A. Ainsworth Bequest, 1950.470

FIGURE 78

Okumura Masanobu, *Daikoku and Ebisu Performing a Manzai Dance at New Year*, late 1710s, hand-colored woodblock print, Collection of Mr. and Mrs. Harlow Niles Higinbotham, Cat. 79

In his handwritten inscription on the Kiyomasu I print, Enba describes it as *denrai no kohan*, "an old block which has been handed down." *Kohan* could be interpreted as referring to either the block or the print itself, but is more likely to refer to the block. Throughout the history of *ukiyo-e*, it was common to reprint from old blocks; Roger Keyes has therefore suggested that both surviving impressions of the Kiyomasu were made from the original block at the same time as Kiyomine's copy, and that Enba himself owned the present print.[14] However, this remains speculative; and it is not proved by the inscriptions on Kiyomine's print. In particular, it is not clear when Emiya made his prints from the "old block"; it could have been done much earlier, perhaps as early as 1701, even if the block too survived into the nineteenth century. The hand-coloring on the present print, with mineral pigments that include green, yellow, gray, and orange-red, appears to be original. At some

point, however, Emiya's descendant showed the Kiyomasu print to Enba, Kiyomine, and Danjūrō VII, and so sparked the eventual inclusion of *Zō hiki* among the *Kabuki jūhachiban*. Kiyomine's print is likely to have appeared first in a very limited edition.

It is noteworthy that in the play text the elephant-pulling scene is not emphasized or named as such; Danjūrō VII and his successors in the role must have taken their cue from its exaggerated depiction by Kiyomasu and Kiyomine.[15] In 1701, the elephant was a fabulous creature mainly familiar from Buddhist art as the vehicle of Fugen Bosatsu (Samantabhadra Bodhisattva), and shown with clawed feet, rather than toenails. The cover woodcut of *Keisei Ōshōkun* shows Yadorigi seated on the elephant in the same manner as Fugen Bosatsu, who in Japanese art is always depicted as female. The first live elephant was brought to Japan as a diplomatic gift in 1408, and others came similarly in 1575, 1597, and 1602; but thereafter there was a gap until 1728, when two arrived together, from Vietnam.[16]

Over his long career, Okumura Masanobu was a prolific and innovative artist. He claimed to be the originator of *uki-e* ("floating pictures"), compositions using European receding perspective and designed to be seen through a special viewing lens (*nozoki karakuri*); he was the first to produce *hashira-e* ("pillar pictures"), long, narrow prints that could be attached to the supporting pillars of a Japanese house; he produced both hand-colored and color-printed single-sheet prints, as well as many black-and-white albums and paintings; his repertoire covered the kabuki theater, the Yoshiwara and its denizens, and a host of other subjects; and he was himself the publisher of many of his prints.

The earliest print by Masanobu in the exhibition [FIG. 78], like that by Kiyomasu I, was formerly in the collection of Adolphe Stoclet.[17] In exceptional condition, it is to be classified as a *tan-e*, after the predominant reddish-orange pigment known as *tan*, made from minium; perhaps in this case with the addition of cinnabar (*shu*). The other main color is a sulphurous yellow, *sekiō*. The publisher of this early print was Igaya Kan'emon (Bunkidō), who was active in the second and third quarters of the eighteenth century. Below the printed black seals of the artist and publisher are small red seals of the art dealer Wakai Kanesaburō (1834–1908) and his partner Hayashi Tadamasa (1853–1906), who supplied many of the early French collectors of *ukiyo-e*.

The subject is a lively New Year song and dance (*manzai*) performed by two of the Seven Gods of Good Fortune, Daikoku and Ebisu. Daikoku (a Japanese transformation of the Indian god Mahākāla) waves a fan emblazoned with a *takarabune* ("ship of treasures"), while Ebisu (a god of Japanese origin) plays a *ko-tsuzumi* hourglass drum. The mallet on the ground is an emblem of Daikoku; the fishing rod and giant bream (*tai*: representing *medetai*, "auspicious") are emblems of Ebisu; and the text across the top of the print describes the song they are singing. The *Daikoku-mai* ("Daikoku dance"), with human performers, first developed in the sixteenth century as a kind of *hayashi-mai*, a folk dance with lively musical accompaniment. It flourished in the late seventeenth and early eighteenth centuries; and in Edo it was particularly associated with the Yoshiwara pleasure district, as well as with the kabuki theater. One notable performance was by Bandō Matakurō II in 1705; and Masanobu's print could be an allusion to this. Separately there was an *Ebisu-mai*; but the two were often combined, and Daikoku and Ebisu are frequently seen together in art.[18]

Another hand-colored print by Masanobu [FIG. 79] depicts a different kind of Ebisu dance: the *Ebisu-kō*, a festival celebrated by merchants in the tenth month of the year to pray for success in business. In this scene of merriment we see a party of three merchants being entertained at a tea-house by a young male actor (*wakashu*). Accompanied by a blind *shamisen* player, he performs

a *yari-odori* ("spear dance") with a decorative spear of the kind carried by retainers in a daimyo procession. Two other performers, sitting to the side, are costumed as Daikoku (seated on bales of rice) and Ebisu (with his fishing rod); while the female participants, sitting in the foreground, are a courtesan, her assistant, and her maid.[19] Naturally, the repast includes a bream.

Two other hand-colored prints are large *uki-e*. One, by Tanaka Masunobu, a disciple and contemporary of Okumura Masanobu, depicts the great entrance gate of the Yoshiwara, and its main street, Naka-no-chō [FIG. 80]. It too was formerly in the collection of Adolphe Stoclet, and bears the seal of Hayashi Tadamasa.[20] Male visitors are coming and going, minus their swords; while along the street courtesans and their assistants solicit custom. The buildings are *ageya*, houses of assignation; the brothels themselves were along side streets. Okumura Masanobu too made a large *uki-e* of the entrance to the Yoshiwara.[21] In another *uki-e* by Okumura Masanobu [FIG. 81], we see a large view of upper rooms in a sumptuous brothel, with a view over the path leading to the enclosure through country fields.[22] In several adjoining rooms, privileged clients are being regaled with music, singing, games, and refreshments, by courtesans, their assistants, and entertainers. The careful hand-coloring in these two prints, datable to the late 1730s, is notable.

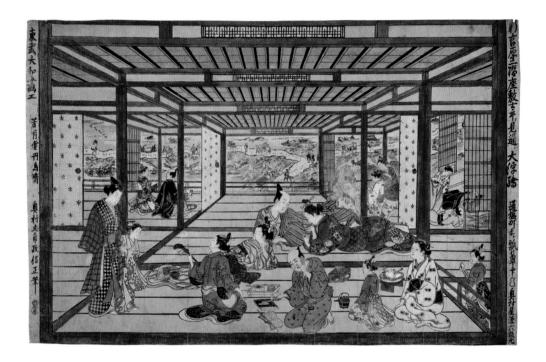

FIGURE 81
Okumura Masanobu, *Large Perspective Picture of a Second-Floor Parlor in the New Yoshiwara*, late 1730s, hand-colored woodblock print, The Mann Collection, Highland Park, IL, Cat. 81

FIGURE 82
Okumura Masanobu, *A Floating World Monkey Trainer on the Sumida River*, late 1740s–early 1750s, color woodblock print, The Mann Collection, Highland Park, IL, Cat. 82

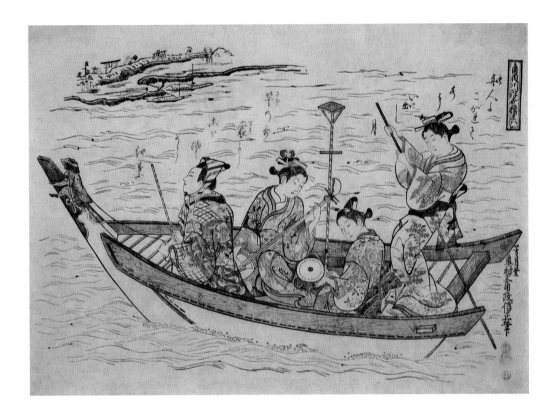

Early benizuri-e

AS EXPLAINED ABOVE, the introduction of the *kentō* made it easier for printers to obtain precise registration. After the *tan-e*, hand-colored prints in the next generation were mostly *beni-e*, so called because the predominant color in them was a strong pink, made from the safflower plant (*benihana*). The first type of color print was the *benizuri-e* ("pink-printed picture"), whose main pigment was *beni*, alongside green or a dull blue. This color scheme was originally indebted to Chinese erotic color prints.

Two *benizuri-e* are included in the exhibition. One, by Okumura Masanobu [FIG. 82], depicts a boating party on the Sumida River in Edo, with three women and a monkey trainer. One woman is poling the boat from the stern, while the two others make music, on *shamisen* and drum; the monkey trainer, crouching in the bows, is controlling his monkey with a lead and a stick. On the opposite bank, wayfarers are passing along a raised path beside the Mimeguri Inari shrine. The two poems on the print indicate that it is an autumn evening. Sarah Thompson has justly remarked, "With only red and green, Masanobu achieves the effect of far greater variety. The intricate textile patterns would have been extremely time-consuming to paint in by hand. Experienced both as an artist and as a publisher supervising the process of engraving and printing, Masanobu knew the strengths of both handcoloring and color printing."[23]

The other *benizuri-e* [FIG. 83] is by another Torii artist, Kiyohiro. It is in the narrow *hosoban* format, but is unusually large; it is carefully printed using three color blocks: pink, green, and blue. On stylistic and technical grounds, it can immediately be dated to the late 1750s or early 1760s, when it became more common to use three color blocks. It depicts the kabuki actor Onoe Kikugorō I, and has been identified as showing him in a stage role of the first month, 1760, at the Ichimura-za (one of the three main theaters in Edo).[24] The play in question was *Furiwakegami Suehiro Genji*,

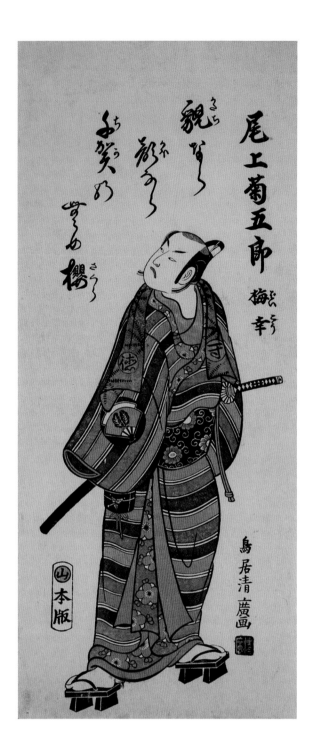

FIGURE 83
Torii Kiyohiro, *The Actor Onoe Kikugorō I, called Baikō, as Issun Tokubei*, 1760, color woodblock print, The Mann Collection, Highland Park, IL, Cat. 93

FIGURE 84
Suzuki Harunobu, *Young Woman Jumping from the Kiyomizu Temple Balcony with an Umbrella as a Parachute*, 1765, color woodblock print, Collection of Mr. and Mrs. Harlow Niles Higinbotham, Cat. 83

in which Kikugorō played four roles in succession; we see him here in the second act, as Tokubei.[25] Issun Tokubei, a gallant commoner, was originally a character in an Osaka puppet play dating from 1745;[26] but in the 1760 kabuki play, the part of Tokubei seems to have been incidental, and the unusual nature of this print suggests that it might not refer to a particular performance, but have been more of a souvenir for fans of the actor.[27] The inscription gives Kikugorō's name, together with his *nom de plume* as a *haikai* poet, Baikō ("Plum Blessings"); and there is a poem, which seems to allude to this name, as well as to the plum flower decoration of his inner kimono: *katachi nara / kao nara chika no / mume sakura* ("Whether in his appearance or his face, a thousand shelves

of plum and cherry!"). Kikugorō, originally from Kyoto, played both male and female roles in his youth; but he moved to Edo in 1742, and from 1752 played only male roles. He was frequently portrayed by *ukiyo-e* artists. He died in Osaka in 1783, at the age of 67.

Suzuki Harunobu and the Early nishiki-e

THE FULL-COLOR WOODCUT, to be understood as one that uses more than three color blocks in addition to the black key block, made its appearance in 1765; although prior to that there had been isolated experiments with multiple blocks. The immediate stimulus came from privately commissioned prints, professionally executed on behalf of the members of light poetry groups; and the majority of these first *nishiki-e* were pictorial calendars (*egoyomi*), in which information about the long and short months for the year (in the old lunar calendar) was ingeniously concealed in the design.

Most of these calendar prints have survived in single impressions, not always in good condition; but often new editions were made, with alterations to the blocks (for example, to remove the calendrical information). Suzuki Harunobu was the most important artist who worked for the poetry groups; though he had already established a small reputation for his work, his career took off after 1765. By the time of his sudden death in 1770, he had produced some 1,100 full-color single-sheet prints; he also illustrated more than two dozen albums, of which two are also in

full color.[28] One of his *egoyomi* for 1765 [FIG. 84] depicts a girl leaping in a test of love from the high balcony of Kiyomizudera, the famous Hossō Buddhist monastery in Kyoto.[29] Her kimono has a pattern of duckweed and shells, the latter incorporating the numbers of the long months for 1765: *dai* ("large"), 2, 3, 5, 6, 8, 10.

This print exists in three states. The first, in the Wadsworth Atheneum in Hartford, Connecticut, and in the Bibliothèque Nationale in Paris, has the signature of the artist (*Suzuki Harunobu ga*) and the block-cutter (*Takahashi Rosen chō*), as well as a seal (*Kosen no shō*), presumably that of the connoisseur who commissioned the print. In the second state, represented here and by another impression in the Museo d'Arte Orientale "Edoardo Chiossone," Genoa, the signatures have disappeared, but the seal and calendrical marks remain. A third state, in the Museum of Fine Arts, Boston, in poor condition, has neither signatures nor seals, and the duckweed pattern is strongly defined in a different color; but the calendrical markings remain.

More *egoyomi* calendars appeared in 1766; but Harunobu's most famous prints of that year were a tribute to the memory of the Osaka writer Yuensai Teiryū, commissioned by Ōkubo Tadanobu, a middle-ranking but very well-connected samurai who served in the Edo Castle guard. Using his *nom de plume* Kyosen, he had Harunobu design a series of eight prints entitled *Zashiki hakkei* ("Eight Parlor Views"). The *Zashiki hakkei* prints are based on the theme of the *Ōmi hakkei* ("Eight Views in Ōmi [Province]"), beside Lake Biwa; which in turn derive from the Chinese *Xiao Xiang bajing* ("Eight Views [at the confluence] of the Xiao and Xiang Rivers"), in Hunan Province. There are fifteenth-century *tanka* poems about each of the *Ōmi hakkei*; but the *Zashiki hakkei* prints were inspired by an eponymous set of *kyōka* by Teiryū, and incorporate witty allusions to them or to the titles of the *Ōmi hakkei*.

Kyosen's personal set of the *Zashiki hakkei* prints, in superb condition, together with its original wrapper, is in the Art Institute of Chicago. Each print bears the signature and seal of Kyosen; but it has never been doubted that Harunobu himself was the actual artist. A complete second state, from which Kyosen's name has been removed, and showing other small changes, is in the Hiraki Ukiyo-e Museum, Tokyo; and has its own wrapper, which lists the titles of the prints. In other collections, there are variants of both the first and second states; and, in some cases, still later states, to which the signature of Harunobu has been added. Two examples of prints from the second state are *Autumn Moon in the Mirror Stand* [FIG. 85], and *Evening Snow on the Floss Shaper* [FIG. 86], whose titles play, respectively, on *Autumn Moon at Ishiyama (Ishiyama no shūgetsu)* and *Evening Snow on [Mt.] Hira (Hira no bosetsu)* from the *Ōmi hakkei*; and the prints have indoor rather than landscape settings. In the former, we see a young woman having her hair dressed by her maid, in front of a moon-shaped mirror on a stand; while outside the window are waving stalks of *susuki*, one of the Seven Grasses of Autumn (*aki no nanakusa*). In the latter, we see a *watatsumi*, together with her maid. *Watatsumi* were low-class prostitutes who operated hat-blocking establishments as a front for their activities; the *nurioke* (literally "lacquering bucket") was a phallic shaper for making *eboshi*, ceremonial hats of which the raw material was white floss silk, here standing for the white snow on Mt. Hira.

The commercial reissue of *Zashiki hakkei* and other privately commissioned *nishiki-e* by Harunobu launched the Japanese color print. He borrowed freely from other artists, but he was a superb designer, and his use of color is delicate and sometimes daring. Many themes in later *ukiyo-e* were first made popular by him; and his mature work is conspicuous for the range of its subject matter, and for its playful allusions (*mitate*) to Chinese and Japanese literature, Nō drama, local

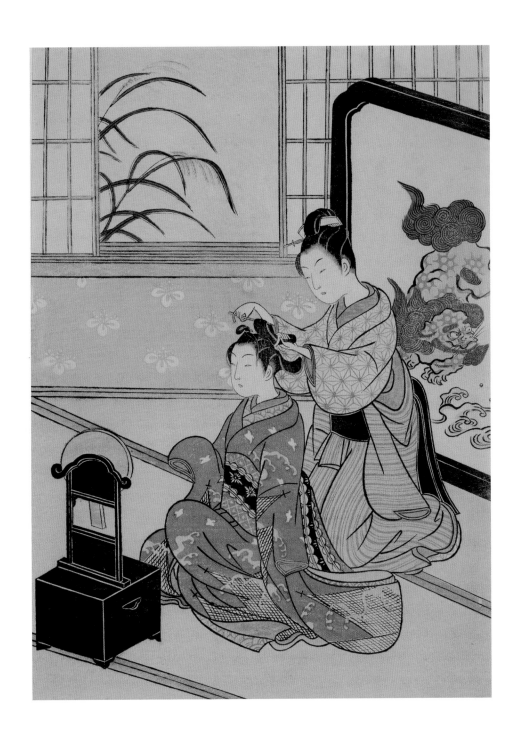

FIGURE 85
Suzuki Harunobu,
*Autumn Moon in the
Mirror Stand*, c. 1766,
color woodblock print,
Smart Museum of Art,
Cat. 84

customs, and so on. *Mitate* is a term deriving from linked-verse composition, in which a following verse would give a new twist to the meaning of the previous one; in Harunobu's work, a classical theme is often treated facetiously, or given a new interpretation. The message may be disguised, however; and new identifications are still being made.

The *Zashiki hakkei* prints are *mitate*; and the exhibition includes three further examples. One [FIG. 87, see fig. 5] started as a calendar print for 1766 and represents the second state, lacking calendrical marking. A young couple is gazing at each other's reflection in a well, from either side of a square wooden well-head (*izutsu*). This is an allusion to section 23 of the ninth-century *Ise monogatari*, "Tales of Ise", describing the youthful encounter of Ariwara no Narihira with the daughter of Ki no Aritsune at the well-head of Isonokami. This encounter was depicted similarly in many illustrated editions of *Ise monogatari* from the seventeenth century onward;[30] and Harunobu's contemporaries would immediately have recognized the allusion.

FIGURE 88
Suzuki Harunobu,
A Young Woman Visiting a Shrine on a Stormy Night,
c. 1768, color wood-block print, The Mann Collection, Highland Park, IL, Cat. 87

Another Harunobu print, likewise unsigned, depicts a young woman visiting a Shinto shrine at night [FIG. 88]. There is another impression of this rare print in the Tokyo National Museum. Roger Keyes has noticed that the crest-badge on the woman's lantern identifies her as Kagiya Osen, proprietor of a tea-stall at the Kasamori shrine, who was much depicted by Harunobu between 1768 and 1770; and that the print alludes to the Nō play *Aridōshi*, by Zeami (1363–1443).[31] In this play, the court poet Ki no Tsurayuki visits the Aridōshi shrine near Osaka; whose proprietor, holding a lantern, turns out to be the god of the shrine. Osen is therefore portrayed as tutelary goddess of the Kasamori shrine. In popular folklore, the type of collapsible lantern she is carrying connoted an old man's penis, so it was probably an intentional joke by Harunobu to show it being carried by an attractive young woman.

A rare print by Harunobu bearing the seal of Hayashi Tadamasa [FIG. 89] has previously been identified as depicting a "Winding Water Banquet" (*kyokusui no en*) or as a *mitate* of *Kikujidō*, but the details do not fit.[32] In the former case, there should be several people seated or standing beside a sinuous and gently flowing stream, preparing to write poems. In the latter case, there should be only one person, plus chrysanthemums: in the Buddhist legend (and an associated Nō play), Kikujidō, "Chrysanthemum Boy," attained immortality after drinking water from a stream into which he had cast verses from the *Lotus Sūtra* inscribed on a chrysanthemum leaf.

The print is much more likely to be a *mitate* of another Nō. We see two women in a rustic setting, beside a rushing stream. The younger of the two is filling a *sake* kettle from the water, and glances back at the other, who sits on a cloth-covered bench beneath a mulberry tree. Overshadowed by dwarf pine trees, the stream flows past mossy banks and is crossed by a stone plank bridge. The older woman is wearing a kimono with a design of cranes, symbols of longevity. These various elements seem to allude to the Nō play *Caring for the Aged (Yōrō)*, by Zeami, in which the principal characters are an elderly woodcutter and his young son. The son has discovered that limpid water from the stream in the shade of pine trees below a waterfall called Yōrō (in modern Gifu Prefecture) restores his energy. When he gives it to his father, it rejuvenates him. In highly wrought language, replete with quotations from Chinese and Japanese classics, this miraculous water is likened to fine *sake*; and at the climax of the play there are auspicious signs from heaven.[33] In Harunobu's print, the older woman corresponds to the woodcutter, and the younger one to his son. At the same time, the stone bridge and the pine trees correspond to the *hashigakari* (the passage connecting the stage to the green room), fronted in a Nō theater by three small pine trees; and, from this point of view, the older woman is holding the round fan against her shoulder roughly in the position of a *ko-tsuzumi* drummer; the domed lid of her lacquered smoking set (*tabakobon*) resembles one half of an hourglass drum; the books beside her could be the text of the play; and the mulberry tree corresponds to a pillar at the corner of the stage.[34]

Harunobu had many pupils and imitators; but after his death, and particularly after the middle 1770s, there were many changes in art styles, fashions, and so on. The larger *ōban* size of print became the most popular; new pigments were introduced; the figures became taller; women's hair styles became more elaborate; and the landscape print assumed more prominence. Nevertheless, the themes introduced by the early Torii artists, by Okumura Masanobu, and by Harunobu continued to influence all later *ukiyo-e*.

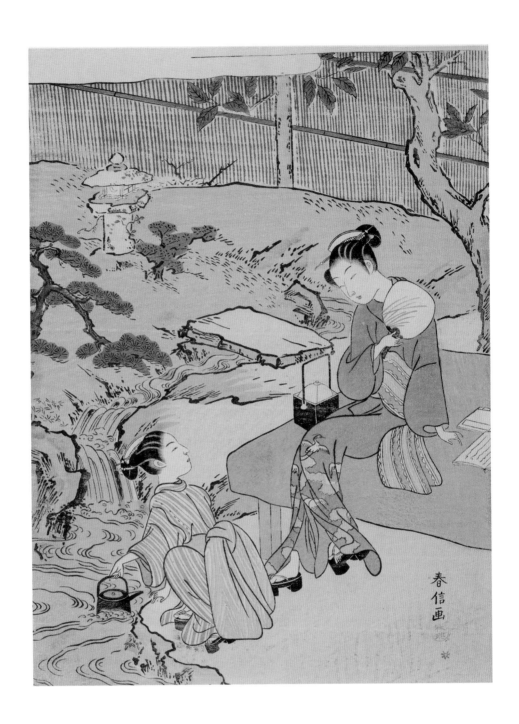

FIGURE 89
Suzuki Harunobu,
*Two Women Seated
by a Stream*, 1768–69,
color woodblock print,
Collection of Mr. and
Mrs. Harlow Niles
Higinbotham, Cat. 88

NOTES

1. See *Important Japanese Prints, Illustrated Books and Paintings from the Adolphe Stoclet Collection*, catalogue by Suzannah Yip (London: Sotheby's, June 8, 2004), no. 11.

2. The story of Wang Zhaojun had been known in Japan since the 11th century. For details, and further references, see David Waterhouse, *The Harunobu Decade* (Leiden: Hotei Publishing, 2012), ad No. 9: an early 3-color print by Suzuki Harunobu of Wang Zhaojun on a horse.

3. For an edited text of *Keisei Ōshōkun*, based on the 1701 edition, but with added Chinese characters, and including reproductions of the accompanying woodcuts, see Takano Tatsuyuki and Kuroki Kanzō, eds., *Genroku Kabuki kessaku shū* (1925; rpt., Kyoto: Rinsen Shoten, 1973), 1: 309–38. The publisher of the original text was Kaifuya, in Sakai-chō, Edo.

4. 32-143/9. For a color illustration, see Howard A. Link, *The Theatrical Prints of the Torii Masters: A Selection of Seventeenth- and Eighteenth-Century Ukiyo-e*, exh. cat. (Honolulu: Honolulu Academy of Arts 1977), pl. 13.

5. Link, *The Theatrical Prints*, 25–26.

6. The performance took place in the first month, 1701, at the Nakamura-za, one of four kabuki theaters in Edo at the time. Heikurō's role is correctly identified not only in the original script but also in the authoritative chronology by Ihara Toshirō, *Kabuki nenpyō*, ed. Kawatake Shigetoshi and Yoshida Teruji (Tokyo: Iwanami Shoten, 1956–63), 1: 272–74.

7. Satō Naosuke and Hirata Kōji, (*Shinpan*) *Sekai jinmei jiten. Nihon hen* (Tokyo: Tōkyōdō Shuppan, 1973), 98; Imamura Nobuo, *Rakugo handobukku* (Tokyo: Nishizawadō Shoho,1967), 6, 10; Taguchi Akiko, *Nidaime Ichikawa Danjūrō: Yakusha no ujigami* (Kyoto: Mineruva Shobō, 2005), 104–5. Enba's chronology of kabuki was *Kabuki nendaiki* (1811–12).

8. I am indebted to George Mann for first drawing my attention to this print, and for supplying photographs and other information. There are impressions in the Tokyo National Museum and at the Allen Memorial Art Museum, Oberlin College. See Tōkyō Kokuritsu Hakubutsukan, ed., *Tōkyō Kokuritsu Hakubutsukan zuhan moku-roku: Ukiyo-e hanga hen* (Tokyo: Tōkyō Bijutsu, 1960–63), 2: no. 1629; and Roger S. Keyes, *Japanese Woodblock Prints: A Catalogue of the Mary A. Ainsworth Collection* (Oberlin, OH: Allen Memorial Art Museum, 1984), pl. 211 and no. 446. In later impressions, the inscription and other details are lacking or are replaced with simpler identifications: see *Japanese Prints and Paintings* (New York: Sotheby Parke Bernet, December 17, 1981), lot 1A (attributed to Kiyonobu I). In 1815, following the death of his teacher Kiyonaga, Kiyomine took the name Kiyomitsu II; see Inoue Kazuo, *Ukiyo-e-shi den* (Tokyo: Watanabe Hanga-ten, 1931), 43.

9. For translations of many of the relevant passages, see D. B. Waterhouse, *Harunobu and His Age* (London: Trustees of the British Museum, 1964), 15–18.

10. In this poem, *wazaoki* is an old word describing dancers and singers at Shinto shrines, and later used of actors in general; *chihayaburu* is an ancient "pillow word" (*makura-kotoba*) of uncertain meaning, an epithet of Shinto gods; *e-miya*, written with different characters, plays on the name of the print publisher Emiya; and *nagori* is a memento or keepsake. In my slightly free translation I have sought to preserve the Japanese syllable count.

11. One could say in his defense that the early history of the Torii school is confused, and that distinctions between the work of Kiyonobu I and Kiyomasu I are not always easy to make.

12. For *Zō hiki* and the *Kabuki jūhachiban*, see Kawatake Shigetoshi, *Kabuki meisaku shū* (Tokyo: Dai Nihon Yūbenkai Kōdansha, 1936), 2: 3–14; idem, *Nihon engeki zenshi* (Tokyo: Iwanami Shoten, 1959), 341–44; and Shimonaka Kunihiko, ed., *Ongaku jiten* (Tokyo: Heibonsha, 1959–60), 1: 622.

13. For example, Torii Kiyosada (1844–1901), who did a set to illustrate all eighteen pieces: see http://www.ishibi.pref.ishikawa.jp/syozou/ukiyoehanga/sakka/sakuhin_list_sakka.php?Id=k00014.

14. Keyes, *Japanese Woodblock Prints*, 122; and correspondence with George Mann, June 16, 2004.

15. Mutō Junko, in a recent detailed study of early kabuki prints, discusses *Keisei Ōshōkun*, and refers to the Kansas City impression of Kiyomasu's print; but she does not seem to have looked carefully at the text of the play, and is puzzled by the female rider. She is unaware of the Stoclet impression, with its handwritten inscription. See Mutō Junko, *Shoki ukiyo-e to Kabuki: yakusha-e ni chūmoku shite* (Tokyo: Kasama Shoin, 2005), 217.

16. See David Waterhouse, "Korean Music, Trick Horsemanship and Elephants in Tokugawa Japan," in *The Oral and the Literate in Music*, ed. Tokumaru Yosihiko and Yamaguti Osamu (Tokyo: Academia Music Ltd., 1986), 359–60. A pair of Kakiemon porcelain elephants in the British Museum (1980.0325.1–2) has been dated to the period 1660–90; but they have toenails, rather than claws, and are most likely to represent the elephants brought to Nagasaki in 1728. See Lawrence Smith et al., *Japanese Art: Masterpieces in the British Museum* (London: British Museum Press, 1990).

17. *Important Japanese Prints ... from the Adolphe Stoclet Collection* (2004), no. 15. According to a handwritten note on the mount, Stoclet purchased the Masanobu print from Yamanaka in London, 13 October 1909. See also Sarah E. Thompson, "The Original Source (Accept No

Substitutes!): Okumura Masanobu," in *Designed for Pleasure: The World of Edo Japan in Prints and Paintings, 1680–1860*, exh. cat., ed. Julia Meech and Jane Oliver (New York: Asia Society and Japanese Art Society of America, 2008), 64, fig. 39.

18. Gunji Masakatsu, *Nihon buyō jiten* (Tokyo: Tōkyōdō, 1977), 48, 233, 331.

19. For *Ebisu-kō*, see Yoshida Teruji, *Ukiyo-e jiten* (Tokyo: Gabundō, 1965–71) 1: 165; for *yari-odori*, see ibid., 3: 385, and Gunji, *Nihon buyō jiten*, 424–25.

20. See *Catalogue of Important Japanese Prints, Printed Books, Lacquer Boxes, Inro and Netsuke, The Property of Mr. Philippe R. Stoclet (From the Collection of the late Adolphe Stoclet)* (London: Sotheby & Co., May 3, 1965), no. 77.

21. Illustrated in David Waterhouse, *Images of Eighteenth-Century Japan: Ukiyo-e Prints from the Sir Edmund Walker Collection* (Toronto: Royal Ontario Museum, 1975), pl. 26.

22. See Thompson, "The Original Source," fig. 51.

23. See ibid., 78 and fig. 53: with transcriptions and translations of both poems by Roger Keyes. This print has long been known in the West, being exhibited in Paris in 1909 from the collection of Henri Vever (1854–1943): see Charles Vignier and Hogitaro Inada, *Estampes Japonaises Primitives... exposées au Musée des Arts Décoratifs en février 1909* (Paris: D.-A.Longuet, 1909), no. 139. It surfaced again at the sales of the Vever collection in 1974 and 1975: see Jack Hillier, *Japanese Prints and Drawings from the Vever Collection* (London: Sotheby Parke Bernet, 1976), 1: pl. 41.

24. *Important Japanese Prints... from the Adolphe Stoclet Collection* (2004), no. 52. According to George Mann, there is another specimen of this rare print in the Museum of Fine Arts, Boston (21.5398): it is in the Spaulding collection and was acquired through Frank Lloyd Wright in 1921.

25. See Tatekawa Enba, *Hana no Edo Kabuki nendaiki*, rev. Yoshida Teruji (Tokyo: Kabuki Shuppanbu, 1926), 285; Toshirō, *Kabuki nenpyō*, 3: 402–3.

26. There is a translation by Julie A. Iezzi of this puppet play, *Natsu matsuri Naniwa kagami*, in James R. Brandon and Samuel L. Leiter, eds., *Kabuki Plays on Stage* (4 vols. Honolulu: University of Hawaii Press, 2002), 1: 197–232.

27. A similar large *hosoban benizuri-e* by Kiyohiro, also using three color blocks, and from the same publisher (Yamamoto), depicts the actor Yamashita Kinsaku II (Rikō). There is a specimen of this print in the Honolulu Academy of Arts (16,315); see Howard A. Link et al., *Primitive Ukiyo-e from the James A. Michener Collection in the Honolulu Academy of Arts* (Honolulu: The University Press of Hawaii, 1980), 209 (ill.); it has not been possible to relate it to a particular performance.

28. In *The Harunobu Decade* (Leiden: Hotei, 2012), I have catalogued in detail 721 woodcuts in the Museum of Fine Arts, Boston, by Harunobu and his immediate followers. This catalogue includes much additional information about the first three Harunobu prints discussed here.

29. There was a smaller copy in Edo, the Kiyomizu-dō: but Japanese viewers of this print would automatically identify the location as Kiyomizudera.

30. See Fritz Rumpf, *Das Ise Monogatari von 1608 und Sein Einfluss auf die Buchillustration des XVII. Jahrhunderts in Japan* (Berlin: Würfel Verlag, 1932), plates I–XII.

31. Roger S. Keyes, "Harunobu's Color," in *Seishun no ukiyoe-shi Suzuki Harunobu—Edo no kararisuto tōjō*, ed. Chiba-shi Bijutsukan (Chiba-shi: Chiba-shi Bijutsukan and Yamaguchi Kenritsu Hagi Bijutsukan, Uragami Kinenkan, 2002), 296. For an annotated text of *Aridōshi*, see Sanari Kentarō, ed., *Yōkyoku taikan* (Tokyo: Meiji Shoin, 1930–31), 1: 213–24.

32. This print is also from the Vever collection; see *Highly Important Japanese Prints, Illustrated Books, Drawings and Paintings from the Henri Vever Collection: Part III* (London: Sotheby Parke Bernet, March 24, 1977), no. 47. For a previous identification (rightly questioned by Jack Hillier), see Tōkyō Kokuritsu Hakubutsukan, ed., *Tōkyō Kokuritsu Hakubutsukan zuhan mokuroku*, 1: no. 488.

33. For annotated texts of *Yōrō*, see Sanari Kentarō, ed., *Yōkyoku taikan*, 5: 3127–40; Yokomichi Mario and Omote Akira, eds., *Yōkyoku shū, jō (Nihon koten bungaku taikei)* (Tokyo: Iwanami Shoten, 1960), 40: 226–32; Koyama Hiroshi, Satō Kikuo, and Satō Ken'ichirō, eds., *Yōkyoku shū*, Vol. 1 (*Nihon koten bungaku zenshū*, Vol. 33. Tokyo: Shōgakkan, 1973), 66–75. For a translation into French, see General G. Renondeau, "Choix de pièces du théâtre lyrique japonais, transcrites, traduites et annotées. V: Yôrô," *Bulletin de l'École française d'Extrême-Orient* 27 (1927): 15–43.

34. As it happens, the text of *Yōrō* alludes both to the Winding Water Banquet and to Kikujidō; and in other prints Harunobu depicted both of these subjects (see Waterhouse, *The Harunobu Decade*, nos. 333 and 88, respectively).

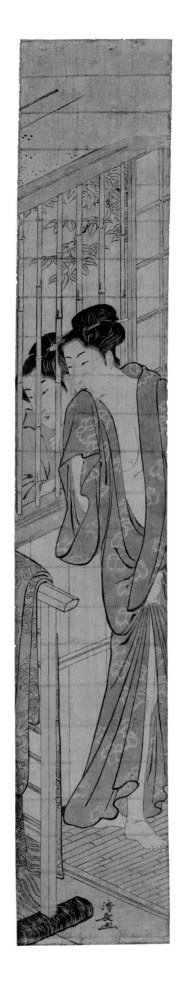

FIVE
WORKING AT THE EDGE: JAPANESE ELISION AND WESTERN PRINTMAKERS

AT THE END OF THE NINETEENTH CENTURY, the lineage of color printmaking was freshened by contact between two great traditions; when Japan opened its borders, the latent charge built up by its long separation from the European tradition sparked fascination on both sides. For both, the incandescent contact with distinctly different and profoundly sophisticated cultural products brought to light differences in perspective that continue to be assimilated to this day. For Westerners in the nineteenth century, the intimations of the tremendous energy of the unfamiliar culture were largely transmitted by ship: paintings, *objets d'art*, and those most portable of cultural fruits, prints.

Made by the thousands and pervasive in their home culture, Japanese woodcut prints inevitably became a source for inspiration among European artists once they were in worldwide circulation. Not only conveniently inexpensive, but also colorful, graphic, and largely accessible without knowledge of Japanese, these prints beguiled artists into a marriage of styles; we can spot something of this liaison in its printed descendants. Flat colors, distinct outlining, and a new freedom from the constraints of classical perspective are often mentioned as chief among the distinctive traits of the Western-born hybrids. Less has been made of European printmakers' growing interest at the end of the nineteenth century in elision, dismissed as "radical cropping," though it follows close on the heels of the introduction of Japanese prints into the West.

The stance toward elision popular in Western art history is concisely stated by Colta Ives in her pioneering study *The Great Wave: The Influence of Japanese Woodcuts on French Prints*:

> The similarity between Degas's compositions and those of Japanese printmakers was noted at least as early as 1880 when [writer and critic Joris-Karl] Huysmans noted the way figures were cropped "as in some Japanese prints." The Japanese must have suggested to Degas the possibilities of cutting figures slightly by columns, screens or . . . by a doorway. However, it is more likely Degas's interest in photography that prompted the abrupt cropping of heads and legs that occurs in his paintings. Such radical cropping seldom appears in Japanese prints.[1]

Artists of Degas's generation and following were undoubtedly deeply influenced by the new view of the world that photography gave them, but this essay will attempt to argue that there is still value in pursuing Huysmans's observation and tracing the contribution of Japanese prints to distinctive kinds of elision in European prints (even those of Degas). Moreover, although it is perfectly true that "radical cropping" is not common in most Japanese prints, it is nevertheless a technique that Japanese printmakers regularly deploy. It had a refined practitioner in Utagawa (Andō) Hiroshige, one of the most collected Japanese printmakers in Europe. These factors justify a more thorough consideration of the practice of elision in Japanese prints and in European prints of the late nineteenth century, when *Japonisme* infused the art of Europe.

In Japanese prints of the eighteenth and nineteenth centuries, two formats frequently exhibit the sorts of elision that we often see in the work of European artists: the pillar print and the triptych. The pillar print (*hashira-e*), with its very tall and slender format of about twenty-eight by five inches, regularly arranges figures into striking compositions in which the area outside the frame of the image is suggested by what lies within. In *Girl in a Blue Robe Whispering to a Man Outside through a Latticed Window* [FIG. 90], Torii Kiyonaga exploited the format to create a dramatic print that puts the right edge of the composition in counterpoint to the curves of the young woman. At the left edge, the habiliments of the room are hinted at by the robe stand, which intrudes slightly into view. The result is a work in which the scene is artfully partial, inviting the viewer to extrapolate; this bold compositional technique needs no verbal explanation to be conveyed either to its intended audience in Japan or to vastly more distant audiences.

We can see an American artist's interest in this kind of elision in the work of Arthur Wesley Dow. His *Ipswich Bridge/The Old Bridge* [FIG. 91] uses a tight, vertical format for a subject that may seem better suited to a horizontal composition. However, he employs it intentionally in the service of elision; the bridge, the house, the tree, and the Ipswich River itself are all cut off by the edges of the print. It seems clear that the print demonstrates not only the Japanese woodcut techniques that Dow regularly taught, but also some of the compositional techniques that he observed in Japanese prints.

Another variety of cropping in Japanese printmaking comes from the habitual elisions of print polyptychs. For the designers of these prints, the necessity of dividing the image arose from the standardization of print sizes. By standardizing, publishers could be assured that the processed materials instrumental to making prints—the select, cured wooden blocks that carried the designs and the carefully formulated paper that received them—would be readily available from the craftspeople who manufactured them. *Ōban* (about fifteen and a half by ten and a half inches) was by far the most common print size throughout the nineteenth century. Smaller prints were commonly a simple subdivision of the *ōban* size: one-half, one-third, or one-fourth. Larger images were made by continuing the image on two or more abutting, *ōban*-sized sheets. Japanese print polyptychs were sufficiently familiar to European artists that Henri Rivière's five-panel color woodcut *The Pilgrimage of Sainte-Anne-la-Palud (Le pardon de Sainte-Anne-la-Palud)* of 1892–93 harks back to Japanese woodcut polyptychs depicting processions in Edo.[2] Although Japanese printmakers designed polyptychs that stretch across five or even six prints, the most common multiple-panel woodcut was the triptych, comprising three prints with a continuous design.

Many surviving Japanese print triptychs have slightly mismatched colors, which suggests that the works might have been assembled by collectors after their original printing. The implication is that each individual portion of a triptych could have a life of its own in the market, being sold as

an art object in its own right, capable of being independently appreciated, or collected individually in hopes of eventually acquiring the other parts. Certainly, it is very common for each panel of a triptych to bear the artist's and publisher's names or trademarks, which indicates that the producers expected these prints to be separated and felt it wise to assert their ownership of each segment. Further support for the notion of an independent life for each sheet of the triptych is the inevitable group of partial triptychs that lies, mostly ignored, in many Japanese print collections.

Édouard Vuillard playfully engages the Japanese triptych's propensity for division in his *Interior with Pink Wallpaper II* [FIG. 92]. *Interior II* is one of three closely related prints from the dozen that make up the portfolio *Landscapes and Interiors*. The three are linked by their titles (*Interior with Pink*

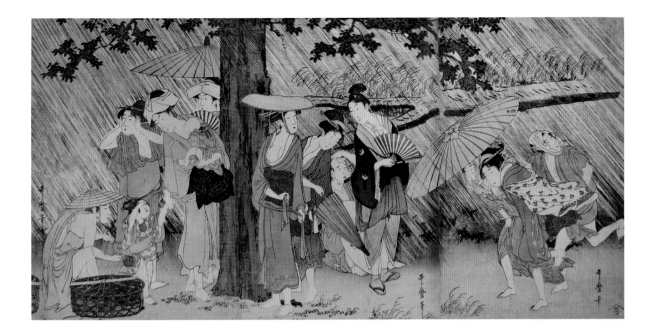

Wallpaper I, II, and *III*) and by their distinctive coloration dominated by pink and red. The hanging lamp cut off by the left edge of the composition in *II* continues at the right-hand side of *I*; maddeningly, *III*, which depicts the same obsessively patterned wallpaper of *I* and *II*, cannot be placed so that it continues the composition of the other two. One might interpret this intentional discontinuity as a reinforcement of the independence of the three compositions—Vuillard making absolutely certain that his audience doesn't treat *I* and *II* as a single, continuous composition, but instead thinks of them as wholly independent (though related). One might also see Vuillard as making an amusing allusion to the plight of the collector who owns three clearly related Japanese prints, only two of which are contiguous, while the third just doesn't quite fit: a familiar frustration for collectors trying to complete a partial polyptych.

Japanese-print collectors quickly become attuned to the hallmarks of a print that is part of a larger composition: the intrusion of a stray bit of textile, architecture, or landscape from the edge of the print; and a tendency for the figures' gaze to be fixed on something beyond the print's edge. Consider the effect of separating a triptych in the case of Utamaro's *Taking Shelter from a Sudden Summer Shower under a Huge Tree* [FIG. 93]. Any of the individual panels might pass for an independent image, since each bears a signature. Still, the panels bear hints that they are part of a larger whole: the odd inclusion of the edge of an umbrella at the center panel's right edge and the headlong rush of the three figures in the right panel reveal that the composition continues beyond the edge of the single *ōban* sheets. Unlike the elisions of the pillar print, which respond to and reinforce the composition of the image, the elisions of triptych panels press into the image in a way that is often a bit jarring.

The most likely places for Europeans and Americans to have observed either kind of elision were in the print portfolios of dealers and collectors, so it is worth noting that Hiroshige—among the best-known of Japanese printmakers for late-nineteenth-century Westerners—was creatively engaged with just such kinds of elision. His works were widely available, both because he was an extraordinarily productive designer of prints and because the designs continued to be printed long

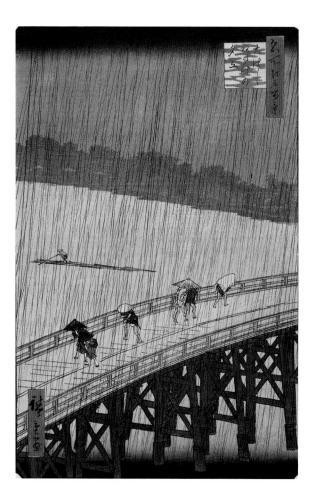

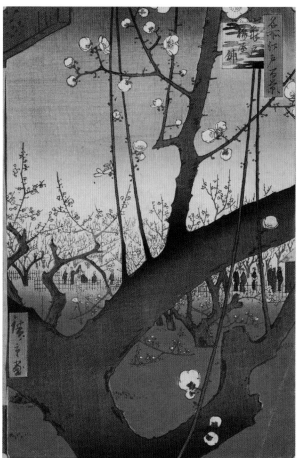

after his death in 1858. His popularity among European artists was such that luminaries including James Abbott McNeill Whistler and Vincent van Gogh depicted his prints in their paintings.

One of Whistler's first forays into *Japonisme, Caprice in Purple and Gold: The Golden Screen* (c. 1864; Freer Gallery of Art, Smithsonian Institution, Washington, DC), depicts a European woman amid a scattering of Hiroshige prints, most of which are from his series *Pictures of Famous Places in the Sixty-odd Provinces*.[3] Though we may wonder whether showing another artist's works scattered across a floor honors or dishonors them, the fact that they are Hiroshige prints demonstrates both Whistler's access to the Japanese artist's work and his assumption that they would be familiar to the sophisticated Europeans who were his intended audience and who are exemplified by the woman in the painting.

Vincent van Gogh also clearly had access to and interest in Hiroshige's prints; he famously reinterpreted two from his *One Hundred Views of Famous Places in Edo*. Van Gogh's paintings *Flowering Plum Tree: After Hiroshige* and *Bridge in the Rain: After Hiroshige* (both works 1887; both Van Gogh Museum, Amsterdam) are quite true to Hiroshige's remarkably elided compositions. The source for *Bridge in the Rain*, Hiroshige's *Evening Shower at Atake and the Great Bridge* [FIG. 94] is an example of the sort of elision familiar from pillar prints and Dow's *Ipswich Bridge/The Old Bridge*: both ends of the bridge extend beyond the image, with the curve of the bridge and the opposite shore of the river creating dynamic, unanchored diagonals across the composition.

Van Gogh's other Hiroshige choice, *The Plum Orchard at Kameido* [FIG. 95], exhibits both sorts of elision outlined above. As in *Evening Shower at Atake*, the foreground of *The Plum Orchard* exists in a kind of visual *medias res*, dominated by a truncated segment of a plum tree, showing neither root nor crown. In the distance, more plum trees and small figures are visible, but intruding into the image at the extreme left edge and top left corner of the print, faithfully reproduced by Van Gogh, are a slim brown line and roughly triangular shape: the sort of simple torii gate that is a regular feature of shrines in Japan. Despite the fact that Hiroshige's print is not part of a triptych, this bit of architecture is strongly reminiscent of the sorts of marginal hints that suggest the image continues onto another sheet. Hiroshige frequently included these challenging-to-parse edge-intrusions in his prints, particularly in his series *The One Hundred Views of Famous Places in Edo*.

This series, the last of Hiroshige's life, was well known to European collectors of prints, and it includes some of the most strikingly cropped compositions of his oeuvre. Henri de Toulouse-Lautrec's poster *Divan Japonais* (see fig. 112) is an apt expression of the *Japonomanie* that was sweeping Paris at the time, and its elisions may ultimately spring from Hiroshige's series. Commissioned as a poster for the eponymous nightspot, which featured a Parisian interpretation of Japanese décor, *Divan Japonais* was an apt place for Toulouse-Lautrec to have deployed his take on Japanese graphic style. It pays homage to Japanese art in its gleeful elision: of the fan held by the central figure, Jane Avril, of the side of the body of her companion Édouard Dujardin, and—most daringly—of the head of the singer, Yvette Guilbert, onstage in the background. Guilbert and Avril both were favorite subjects of Toulouse-Lautrec. Another print of the same year, his poster entitled *Jane Avril* [FIG. 96], has several similar elements that tie both prints to a particular work by Hiroshige. Like *Divan Japonais*, *Jane Avril* uses the bass-fiddle head rising up out of the orchestra pit as a significant motif, but in *Jane Avril* it is given greater prominence.

Placed at a diagonal at the lower right of the composition, the head and neck of the bass viol isolate the head of the wild-haired bassist in the lower right corner of the image. His hairy knuckles grip the neck of his instrument in the foreground as he plays the quick sequence of eighth-notes

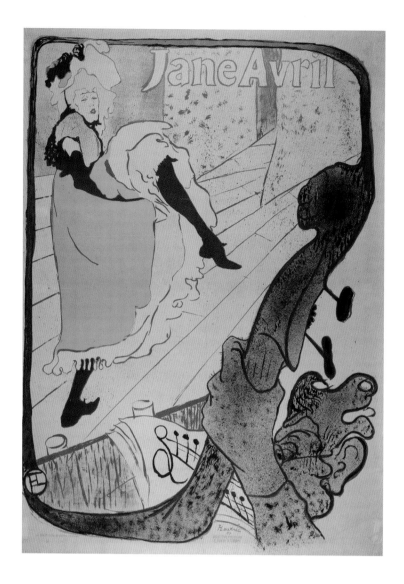

on the score before him. His bass also becomes an emphatic black counterpoint to the pastel, backgrounded Avril. All of these aspects of the composition link it to Hiroshige's print *The Benten Shrine and the Haneda Ferry* [FIG. 97], where a similarly hairy, straining, cropped male figure in the foreground becomes a frame for the distant calm of the shrine. It is an example of Hiroshige's elision at its most drastic. Here the shrine, the nominal subject of the print, is dwarfed, framed by the ferryman's oar, hairy leg, and arms. At the lower right of the image, so elided as to be nearly unreadable, is the edge of a parasol—the signifier for the beautiful woman whose form, in nearly any other artist's depiction of the subject, would be the focus of the composition. Hiroshige seems to have designed the print to bear the hallmarks of the elision of triptychs, but load them with greater import. They no longer refer to an adjacent image for completion, but demand that the viewer flesh them out by means of a familiarity with icons from the visual culture of Edo: the ferryman and the beauty he conveys.

Lautrec may have taken further inspiration for these lithographs from a pair of prints by Edgar Degas, both entitled *On Stage (Sur la scène)* and made fifteen years before.[4] Degas's etchings also contrast the bass-viol's volute rising from the dark pit with the brightly lit stage dancers, to similar

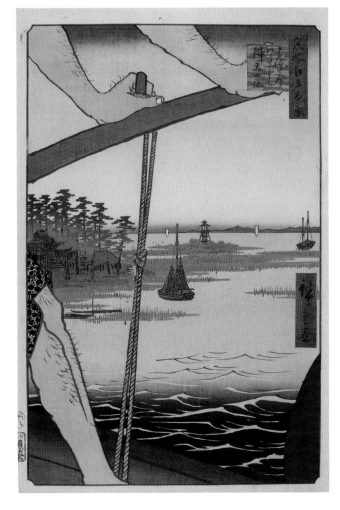

(though less colorful) effect. Thus it could reasonably be argued that Degas and not Hiroshige is the source for Toulouse-Lautrec's elisions. However, it is nonetheless plausible that the influence can ultimately be traced to Hiroshige, since Degas's compositions and those of his friend Mary Cassatt seem deeply influenced by the sort of elision the Japanese artist practiced.

Several of Degas's and Cassatt's compositions experiment with the sort of minimal intrusion of a vertical band along the edge of the print, much like that copied by Van Gogh from *The Plum Orchard at Kameido*.[5] Degas played with the trope in one of his compositions showing Cassatt at the Louvre. He assayed the composition twice in prints, and it is in the second print version that the influence of Japanese prints is most apparent. Degas placed a band of texture at the extreme left that nearly obscures one of the figures and compresses the rest of the composition into a pillar-print-like format. In its monochromatic versions, the print is difficult to read; the figures merge into each other and into the texture of the column. However, in the Art Institute of Chicago's impression [FIG. 98], Degas used pastel to reinforce the separation of the elements, allowing the viewer to read the textured band at the print's edge as a marbled column.

Degas's use of the pillar in his image of Cassatt at the Louvre thus continues Hiroshige's experiments. As sophisticated print-viewers, we are expected to read the textured band at the edge of the print as a pillar, in the same way that Hiroshige expects his viewers to be able to infer

figures and objects from hints dropped at the margins. Since, in Degas's print, the base and top of the pillar are outside the window of the image, and because the band has few indications of the pillar's three-dimensional shape, it shares the quasi-representational quality that we see in Hiroshige's elisions. It vacillates between two readings in the same way that the section of torii gate does in Hiroshige's *The Plum Orchard at Kameido*; the marks on the prints can just manage to be representational but easily collapse back into being mere patterns on paper.

In her color print *The Letter* [FIG. 99], Cassatt, too, experimented with a strong vertical intruding from the edge of the print, carefully engineering her image so that a mere sliver implies a presence outside the field of the composition. The drop-front desk is deftly implied by the vertical brown rectangle that defines most of the right edge of the print. We are only able to read this as a desk by the presence of the writing surface in front of the figure. Cassatt's use of color is crucial in allowing this reading; the brown rim of the writing surface links it to the brown rectangle, letting the viewer understand it as a whole and allowing us to imagine the extent of the desk beyond the edge of the print.

Vuillard's *Interior with Pink Wallpaper* prints, like Cassatt's and Degas's prints, also use color for those supplemental clues that allow the composition to be read as the artist intends. So fundamental is color to these artists' embrace of the kind of elision found in Japanese prints that it becomes difficult to separate the use of color from that of elision. The striking palettes of Japanese prints that first caught the eyes of Western printmakers also became key to their ability to manage the radical cropping we occasionally find in their works.

NOTES

1. Colta Feller Ives, *The Great Wave: The Influence of Japanese Woodcuts on French Prints*, exh. cat. (New York: The Metropolitan Museum of Art, 1974), 36.

2. No. 38 from the *Breton Landscapes (Paysages Bretons)*. Color woodcut, 13 3/8 x 45 in., Chazen Museum of Art, John H. Van Vleck Endowment Fund purchase, 2001.49.

3. The woman holds *Saijo in Iyo Province* (no. 57), and before her on the floor is *Sakura Island in Osumi Province* (no. 66), *The Pine Grove at Mio in Suruga Province* (no. 12), and *The Bridge of Boats at Toyama in Etchu Province* (no. 34), all from *Pictures of Famous Places in the Sixty-odd Provinces*. I have not identified the other visible print, but judging to the position of its cartouches, it is from a different series and is possibly by a different artist.

4. Edgar Degas, *On Stage (Sur la scène)* (second plate), 1877, soft-ground etching, roulette and aquatint, 3 15/16 x 4 15/16 in., Chazen Museum of Art, Eugenie Mayer Bolz, Harry and Margaret P. Glicksman, and John S. Lord Endowment Funds, and Art Collections, Class of 1956, and Verex Funds purchase, 1983.24.

5. In relation to Degas, it is relevant to note that several of Hiroshige's designs of this period crop figures in a similar way to his *Mary Cassatt in the Paintings Gallery of the Louvre* (fig. 98). Notably, in *Cotton Goods Lane at Odemmacho*, from the series *The One Hundred Views of Famous Places in Edo*, Hiroshige partly obscures one of a pair of female figures with a pillar.

FIGURE 100
Tsubaki Chinzan,
Nandina domestica,
1869, color woodblock
print, National Museum
of American History,
Cat. 101

ANDREAS MARKS

SIX

THE "DECADENT" JAPANESE WOODBLOCK PRINT: APPLICATION AND PRESERVATION OF COLOR IN THE MID-NINETEENTH CENTURY

JAPANESE WOODBLOCK PRINTS of the nineteenth century have been dubbed by some mid-twentieth-century scholars as "decadent" because of the rich, bold colors that distinguish them from seventeenth- and eighteenth-century examples. These prints were possible only through technical advancement and are the product of changing consumer taste, which did not regard them as a product of an art form in decline. This essay will address the printmaker by looking into the tools that were used for color printmaking in Japan; it will then discuss the practice of serious nineteenth-century collectors, who compiled their prints into albums in an effort to preserve them and keep their brilliant colors fresh and alive.

Perception of Japanese Woodblock Prints by Early Western Collectors

EUROPEAN WRITERS BEGAN to use the term "decadence" for certain prints as early as 1904.[1] The popular use of the term "decadent" (*makki* or *tai-hai*) to characterize mid-nineteenth-century *ukiyo-e* is seen in the publication of *The Decadents*. In John Bester's English translation of the original, innocuously titled Japanese version, *Later Ukiyo-e (Kōki ukiyo-e)* from 1965, one of the authors, Oka Isaburō, uses the word "decadence" in reference to the "stereotyped actor portraits" and "contorted," "overripe" beauties with "almost hunchbacked figures" depicted in prints of the late Edo period (1603–1868).[2] Several more recent scholars expressed concerns about the inappropriate, negative use of this term when interpreting the later part of *ukiyo-e* history, which has resulted in the disappearance of this term in scholarly works today.[3]

One of the reasons for the perceived deterioration of woodblock prints was the use of color, which Oka, at that time working at the Tokyo National Cultural Properties Research Institute, criticized as "garish" and "heavy."[4] For many early Western connoisseurs as well, nineteenth-century prints were not desirable; because of their vivid colors and recent production, they were dismissed

as "modern" and lacking the refinement of earlier favorites such as Suzuki Harunobu (see figs. 5, 84–89). Attitudes have changed, and even Meiji-period (1868–1912) prints are being collected seriously today.

Japanese woodblock prints at any time in history are at once the product of technical developments and an expression of the market's interests during that specific period. Color is of central importance to a print design and functions as an indicator of technical possibilities as well as of consumer taste. Susceptible to deterioration with the passing of time and exposure to light, the colors of prints today do not necessarily reflect how they looked like at the time of production. The patina one can find in old objects of metal or wood is accepted, even desirable as a sign of old age, but fading is only negatively perceived and directly translates to devaluation of the print.

The aim of this essay is to introduce the application of color in the production of prints during the mid-nineteenth century by outlining the required tools and materials with reference to an actual tool set received by the Smithsonian Institution in 1892. It will then focus on collecting habits in the nineteenth century, and the ways in which serious collectors of that time preserved prints' fragile colors, through analysis of an album of prints in the collection of the Smart Museum of Art.

Development of Printing in Japan

LIKE THE EARLIEST EUROPEAN woodcuts and engravings, the earliest woodcuts in China and Japan were executed in monochrome. Before the advent of technology to allow the use of more than one printing matrix per print—whether in woodcut, metalcut, or copperplate engraving—the vast majority of Renaissance prints, like those of Albrecht Dürer, were colored by hand or, in the case of woodcuts, with rather imprecise stencils. The use of color for these prints was denigrated by contemporaries such as Erasmus of Rotterdam, who condemned the use of color in Dürer's prints as unnecessary, even detrimental to their effect.[5]

The most common hand-applied colors in European prints were green, red, and yellow. In Japan in the late seventeenth century, monochrome *sumizuri-e* ("ink-printed pictures"), the earliest type of *ukiyo-e*, were first hand-colored with red lead, hence the name *tan-e* ("red lead pictures"). Yellow and green were rarely employed. In the first half of the seventeenth century, carthamin or scarlet (*beni*) became popular.

With the invention of registration marks (*kentō*) around 1745, printers were able to precisely replicate the position of the paper on the woodblock, making possible the printing of several blocks. The creation of a separate block for each color was soon favored over the labor-intensive process of hand-coloring. The earliest images with printed color are called *benizuri-e* and employ two colors, carthamin and green. From the early 1760s, prints with an expanded color palette including yellow and blue emerged. The year 1765 marks the birth of multicolor prints (*nishiki-e*). In that year, pictorial calendars (*egoyomi*) for private poetry clubs, and soon thereafter commercial prints with several colors (especially by Harunobu), began to be produced. The technique used at this time became standard for all color woodblock prints thereafter and continues today.

In 1889, the Japanese government gave the Smithsonian Institution a set of woodcutting and printing equipment, blocks, print proofs, and instructions for two designs: a triptych in the *ukiyo-e* tradition, and a single-sheet print, *Nandina domestica*, designed by the respected painter Tsubaki Chinzon [FIG. 100].[6] Until the late 1990s, this material was on display at several branches of the Smithsonian and is now housed at the Department of Graphic Arts of the National Museum of

FIGURE 101
Utagawa Kuniteru II,
Farmers, 1869, color
woodblock triptych,
National Museum of
American History,
Cat. 115

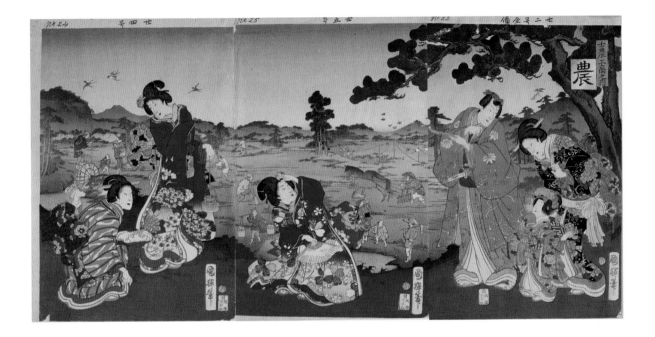

American History (NMAH). The original communication between the donor, T. Tokuno, the Chief of the Bureau of Engraving and Printing of the Japanese Ministry of Finance, and Sylvester Rosa Koehler, the Smithsonian's Curator of Graphic Arts, who received this material, was published in the Smithsonian's Annual Report in 1893.[7]

In 1982, Peter Morse reproduced Koehler's text and added some comments.[8] Morse noted that the material was remarkably complete, given its age.[9] It is clear that the blocks and proofs for the triptych predate the printing tools. Helena Wright, the present Curator of Graphic Arts at the NMAH, attests that the tools, comprising items like knives and chisels, look unused and therefore were probably new at the time of the donation. Unmentioned in the original correspondence and by Morse was that the triptych carries a date seal of the first month of 1869 and was therefore published twenty years prior to the donation.

The *ōban* triptych was designed by Utagawa Kuniteru II and published by Daikokuya (Matsuki) Heikichi. The serial title *The Four Occupations* (*Shi-nō-kō-shō no uchi*) indicates that it was intended to be part of a series of four triptychs; however, no other design of this series is known. This design is titled *Farmers* (*Nō*) and belongs to a subgenre of *ukiyo-e* called *Genji-e* ("Genji pictures"), which depicted characters and scenes from Murasaki Shikibu's classic novel *The Tale of Genji* (*Genji monogatari*) or *A Rustic Genji by a Fraudulent Murasaki* (*Nise Murasaki inaka Genji*) [FIG. 101]. The latter was an enormously popular serial novel written by Ryūtei Tanehiko and illustrated by the print designer Utagawa Kunisada, published from 1829 to 1842.[10]

A characteristic of *Genji-e* is their lavish use of colors and special printing features like graduated toning (*bokashi*) and embossing (*karazuri*). Kuniteru II juxtaposes Mitsuuji, the Casanova-like hero of *A Rustic Genji*, with farmers engaged in various kinds of labor in the background. Such imaginative situations were commonly conceived during the mid-nineteenth century, but it seems that this particular design was not very popular. Other than the Smithsonian copy, there is only one other version known, located at the Japan Ukiyo-e Museum (JUM) in Matsumoto. The publisher seems to have discontinued this series after just one design. Nevertheless, he held on to the woodblocks, as it might have been possible to reuse them at some point for a new edition or sell them to another publisher. In this case, the publisher, by 1889 in its fourth generation and one of the most successful publishing firms, must have given them to Tokuno, realizing that there was little use for them anymore as the craze for *Genji-e* had come to an end.

The exact circumstances of how Tokuno received the blocks remain unclear, but it could be speculated that he knew the firm well and he made inquiries with publishers in the late 1880s for a full set that they could spare. Publishing firms are commercial operations, and it is highly unlikely that anyone would have let go of the blocks for a brand new design just being released. Blocks were kept for further editions if there was a market for them and only discarded when they were worn down and no longer useable.

Blocks in the nineteenth century were carved from mountain cherry (*yamazakura*), a sturdy hardwood. As wood was expensive, block-cutters and printers printed from both the front and back surfaces of a block and often created more than one printing surface per side. Examples from the second half of the 1840s show that for a multicolor print, one key block for the black outlines and three to five color blocks with six to eleven printing surfaces were used. Kuniteru II's complex triptych of 1869 needed a total of twenty-one blocks with thirty-seven different printing surfaces for completion.[11]

In his instructions, Tokuno introduced the colorants that were used for printing and described the main five as black, white, red, blue, and yellow. These were made from either organic or inorganic raw materials; for some colors, several options existed. The color blue, for example, could derive either from dayflower (*tsuyukusa*), indigo (*ai*), or Berlin blue (*bero*). A pigment maker in Berlin discovered the latter blue in 1704, and by the 1830s it had replaced indigo because it produces a clear blue color and its particles are so small that they do not wear away the surface of the woodblock.[12]

Tokuno spoke about the brilliant purple (*murasaki*) in the Kuniteru II triptych and stressed that it was not an aniline color, as might be expected, but rather a mixture of scarlet and blue. Usually this meant safflower with indigo or dayflower, but in this case Tokuno mentioned Berlin blue.[13] Ninety years later, Morse interpreted Tokuno's statement as a denial of the use of modern colorants and found this "amusing." However, Morse failed to realize that the triptych was created in 1869, a time when aniline colors were still rather rare, and judging from the superb impression at JUM, Tokuno's assessment was correct.[14] Scarlet made from safflower is rather fragile and fades quickly after being exposed to air and sunlight; so does purple because of its scarlet component. To ensure a more lasting effect, synthetic, aniline colors came into use in the Meiji period. However, they were denigrated by early Western connoisseurs as well as by the majority of Japanese collectors in the twentieth century.

Collecting Prints in the Edo Period

IN THE EDO PERIOD, responsibility for print production fell to publishers, many of whom operated shops where prints could be bought. Some designs were available in a standard quality as well as in luxury editions that were differentially priced.[15] Hundreds of new images appeared every month, and the average consumer expected to enjoy his or her purchases for a limited time rather than carefully preserving them for posterity.

The concern of a serious institutional or private print collector is to ensure that the condition of his or her prints does not deteriorate in any way. Light, air, and humidity are three factors that can modify a print. Organic colors may fade irreversibly, while some inorganic colors can darken. Fresh and vibrant hues, especially purple, are an indication that a print was well conserved. Such prints provide an accurate picture of how a design looked at the time it was issued and are more valuable on the market today.

In the Edo period, it became customary for collectors who wanted to retain their prints to sew or paste them into accordion-style albums (*orihon*), sometimes also trimming them. The advantage of such albums was that the prints were kept tightly together when closed, protecting them from light and circulating air and therefore preserving the colors as much as possible. Starting from right to left, assorted prints were combined according to the inclinations of an individual collector. Each album is therefore unique, reflecting personal taste and providing a window into what was fashionable at a certain time. Such albums are becoming hard to find; they are likely to be disassembled by print dealers who can increase their profit by selling the contents piecemeal.

The majority of albums date to the nineteenth century, but earlier ones exist as well. Albums could contain designs from one specific series or just one artist. They could also contain prints of one particular genre; especially popular in this context were actor prints. The prints in an album may have been released during a period of several months or a few years. The number of prints could range from around ten to one hundred with the prevailing print-size being *ōban*. In the case of horizontal *ōban* that are approximately fifteen and a quarter inches (thirty-nine centimeters) wide, the prints were frequently folded in half in order to create a more compact album that measures only seven and three-quarters inches (nineteen and a half centimeters) wide.

The collectors did not inscribe their names or other personal details in their albums and therefore almost always remain anonymous. Very few records have survived about early Japanese collectors. A few (especially early Western collectors) placed their personal seals on their prints, marking them as their possession in the same way that Chinese collectors traditionally did with paintings. There are over two thousand prints in the collection of the Tsubouchi Memorial Theater Museum of Waseda University, Tokyo, that bear a red, round seal reading "Sōto," indicating that these prints once belonged to Waseda University Library (Waseda Daigaku Toshokan). The seals of the writer Ōta Nanpo and the artist Kawanabe Kyōsai have been read, but some seals remain unidentified today.

In 2005, one such album was donated to the Smart Museum of Art. It contains seventy-four *ōban*-size prints pasted as end sheets and on each side of thirty-six accordion-bound leaves. The seventy-four *ōban* are actually thirty-four compositions: fourteen triptychs, twelve diptychs, four single-sheet horizontal *ōban*, two single-sheet vertical *ōban*, and two vertical *ōban* that were originally part of multi-sheet compositions. The majority of designs are by Kunisada (twenty-two); eleven are by another popular print designer at that time, Utagawa Kuniyoshi; and one is by Kuniyoshi's student Utagawa Yoshifuji.

The album consists of actor prints that were published over a period of a little more than four years, between the second month of 1847 and the third month of 1851. If the album had been put together slowly over time, through adding each newly purchased print, it would have resulted in a consistent chronological order from the beginning of the album to the end, but this is not the case. Unlike present-day stamp collectors, who may leave gaps in an album to add missing stamps later, an Edo-period collector would probably not have left such gaps for his prints, as albums accommodate a much smaller number of these relatively larger items.

We can infer that the entire album was assembled after all the prints in it had been collected. It reflects the taste of the anonymous collector whose goal was to conserve and keep his treasures in a way pleasing for him to look at, not to pursue a historical timeline with the prints. The prints are arranged by format rather than by designer or the depicted actor or kabuki play. The album starts with the fourteen triptychs, beginning with *Elegant Coming and Going in Spring*, a triptych by Kuniyoshi unrelated to a specific kabuki performance [FIG. 102]. Each one of the three sheets features seven popular actors, for whom neither names nor roles are given. Set in front of a plain gray background, the actors are strolling, dressed in costumes from various plays. The succeeding triptychs are related to several different plays. In three cases, two triptychs refer to the same performance; however, the collector decided to place them apart from each other rather than arranging them together and creating clusters.[16]

The triptychs are followed by the twelve diptychs, which seem to have been arranged spontaneously. Surprisingly, after eight diptychs, the two vertical *ōban* from incomplete compositions

and the two single vertical ōban were inserted. It is unknown why the compiler did not abide by his original system and finalize the diptychs before adding these four single sheets. We also don't know what happened to the missing sheets that originally belonged to the incomplete compositions. The first single sheet, depicting the actor Onoe Baikō IV as Oritsu in the play *Hama no masago tsukinu gohiiki* (Kawarazaki Theater, III/1851), belongs to a vertical diptych of which the upper sheet showing Ichikawa Ebizō V as the thief Ishikawa Goemon is missing.[17] However, the second single sheet, of Bandō Hikosaburō IV as the adventurer Tenjiku Tokubei, is a very rare print of which no other copy is known [FIG. 103]. It can only be assumed that it belongs to a diptych.

This print is not the only rare find; there are two hitherto unrecorded diptychs in this album as well. One, by Kuniyoshi, depicts a scene in the play *Igagoe yomikiri kōshaku* (Kawarazaki Theater, IX/1848), with Matsumoto Kinshō as Ishidome Busuke, Sawamura Sōjūrō V as Karaki Masaemon,

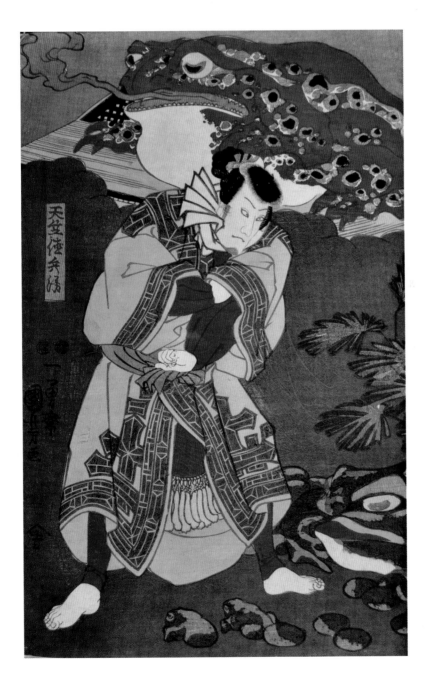

FIGURE 104

Utagawa Kunisada, *The Actor Iwai Kumesaburō III in seven different roles in the play Osome Hisamatsu ukina no yomiuri*, 1850, color woodblock triptych in bound album, Smart Museum of Art, Cat. 112

and Bandō Hikosaburō IV as Sawai Matagorō. The second rare diptych by an unidentified publisher ("Maru-Han") is the only work by Yoshifuji in this album and relates to the play *Mimasu mimasu karigane Soga* (Nakamura Theater, I/1850), depicting Ichikawa Danjūrō VIII as Hanaoka Bunshichi, Bandō Shuka I as Otaka, and Ichikawa Hirogorō I as Honjō Soheita.

The album concludes with the four single-sheet horizontal *ōban*. From 1848 to early 1852, actor prints in horizontal format were very popular. Kunisada was commissioned to design over two hundred of them, mostly in untitled series for different publishers. Kuniyoshi produced a few prints of this category as well, one being featured in this album. To enjoy these horizontal *ōban*, the viewer needs to turn the album ninety degrees, making for a memorable finale.

Flipping through the pages of the album, one is struck by the freshness and vibrancy of the prints' colors, and few traces of dirt and wear. This suggests that the prints were not often looked at before the album was put together and that the album was rarely opened after it was completed. The state of preservation of these prints is close to ideal, allowing the present-day viewer to enjoy an authentic taste of mid-nineteenth-century "decadence."

Kunisada's triptych of the actor Iwai Kumesaburō III in seven different roles within one performance is a formidable example of this near-to-perfect preservation [FIG. 104]. The rich blue background against which the figures are set makes this an unusual design. The garments of several of the female roles employ the brilliant purple discussed earlier—and in a condition that appears to be fresh from the press.

NOTES

1. Chelsea Foxwell, "*Dekadansu: Ukiyo-e* and the Codification of Aesthetic Values in Modern Japan, 1880–1930," *Octopus: A Visual Studies Journal* 3 (2007): 21–41.

2. Suzuki Jūzō and Oka Isaburō, *The Decadents*, Masterworks of *Ukiyo-e* 8 (Tokyo and Palo Alto, CA: Kodansha International, 1969), 9–10.

3. For example, Timothy T. Clark, "Kunisada and Decadence: The Critical Reception of Nineteenth-Century Japanese Figure Prints in the West," in *Nihon kindai bijutsu to Seiyō: Kokusai shinpojūmu*, ed. Meiji Bijutsu Gakkai (Tokyo: Meiji Bijutsu Gakkai, 1992), 89–100.

4. Suzuki and Oka, *The Decadents*, 9–10. The Tokyo National Cultural Properties Research Institute (Tōkyō Kokuritsu Bunkazai Kenkyūjo) is today the National Research Institute for Cultural Properties, Tokyo (Tōkyō Bunkazai Kenkyūjo).

5. For a detailed study of hand-colored Renaissance prints, see Susan Dackerman, *Painted Prints: The Revelation of Color in Northern Renaissance & Baroque Engravings, Etchings, & Woodcuts*, exh. cat. (Baltimore: Baltimore Museum of Art, 2002).

6. The single-sheet *chūban* of *Nandina domestica* by the painter Tsubaki Chinzan (1801–1854) might be from a posthumously published painting manual. See Peter Morse, "Tokuno's Description of Japanese Printmaking," in *Essays on Japanese Art Presented to Jack Hillier*, ed. Matthi Forrer, Neil K. Davey, and Jack R. Hillier (London: Sawers, 1982), fig. 6.

7. Sylvester R. Koehler, "Japanese Wood-cutting and Wood-cut Printing," in *Annual Report of the Board of Regents of the Smithsonian Institution, Showing the Operations, Expenditures, and Condition of the Institution for the Year Ending June 30, 1892* (Washington: Government Printing Office, 1893), 221–44.

8. Morse, "Tokuno's Description of Japanese Printmaking."

9. Tokuno's calculations for the cost of producing *ukiyo-e* are discussed in Andreas Marks, *Publishers of Japanese Woodblock Prints: A Compendium* (Leiden and Boston: Hotei, 2011).

10. For a comprehensive discussion of *Genji-e*, see Andreas Marks, *Genji's World in Japanese Woodblock Prints*, with contributions by Bruce A. Coats, Michael Emmerich, Susanne Formanek, Sepp Linhart, and Rhiannon Paget (Leiden and Boston: Hotei, 2012). This triptych is listed in Appendix I, G441.

11. Eight complete sets of woodblocks are illustrated in National Museum of Japanese History, ed., *Nishiki-e wa ika ni tsukurareta ka* (Sakura: National Museum of Japanese History, 2009), 43–67.

12. Sasaki Shiho, "Materials and Techniques," in *The Hotei Encyclopedia of Japanese Woodblock Prints*, ed. Amy R. Newland (Amsterdam: Hotei, 2005), 1: 335.

13. Koehler, "Japanese Wood-cutting and Wood-cut Printing," 227; or Morse, "Tokuno's Description of Japanese Printmaking," 128.

14. Morse, "Tokuno's Description of Japanese Printmaking," 133.

15. For a description of print economics, see Marks, *Publishers of Japanese Woodblock Prints*, 22–26.

16. The fifth and fourteenth triptych relate to the play *Tsuki no ume megumi no Kagekiyo*, performed at the Nakamura Theater in the first month of 1848. The eighth and twelfth triptych relate to *Date kurabe Okuni kabuki*, performed at the Kawarazaki Theater in the third month of 1849. The fourth and eleventh triptych relate to *Sukeroku kuruwa no hanamidoki*, performed at the Nakamura Theater in the third month of 1850.

17. There are actually two versions of the bottom sheet of this vertical diptych. The second version shows Sawamura Chōjūrō V (1802–1853) as Mashiba Tairyō Hisayoshi in front of the same background as Oritsu.

FIGURE 105
Plates VIII, XXIV, XLIV
and XXIII from George
Ashdown Audsley, *The
Art of Chromolithography:
Popularly Explained and
Illustrated by Forty-four
Plates* (Paris: Lemercier
& Cie, 1883). Mortimer
Rare Book Room, Smith
College, Northhampton,
Massachusetts

LAURA ANNE KALBA

SEVEN
COLOR IN
THE AGE OF
MECHANICAL
REPRODUCTION:
CHROMO—
LITHOGRAPHY
IN NINETEENTH—
CENTURY
FRANCE

CHROMOLITHOGRAPHY PLAYED A VITAL role in the democratization of the visual practices and pleasures associated with color. Until its widespread popularization in the second half of the nineteenth century, color images were generally found in expensive journals and books, and most of them were hand-colored. By the end of the century, however, French printers were producing a wide variety of ephemeral color images expressly designed for short-term, renewable consumption. Indeed, alongside their ubiquity and bright, eye-catching colors, posters' evanescence figured among their most remarkable qualities. "Barely put in place," a contemporary trade journal noted, "the poster vanishes. It's something that lasts but a couple hours, often only a couple instants. The poster is an ephemeron with paper wings. The very night after it blooms, it becomes the prey of the vagrant ragpicker, or, the next day, it's covered up and decimated by a new flood of posters."[1]

At the same time, a growing number of French avant-garde artists also directed their attention to chromolithography for the production of longer-lasting original art prints. "It seems to us that color lithography has not existed before in the conditions in which we recently have seen it bloom and, consequently, is the distinctive artistic form of our time," André Mellerio declared in response to this new artistic trend.[2] In fact, according to print scholar Phillip Dennis Cate, the combined expansion of posters and original art printing amounted to a veritable "color revolution"—a rapid and dramatic transformation in the production and consumption of colorful images.[3]

The history of chromolithography, however, long predates and vastly exceeds the posters and original art prints of fin-de-siècle France. By situating these works within the larger context of nineteenth-century color lithographic printing, the present essay seeks to expand the definition

of "color revolution" to include a fuller range of colorful printed matter. In so doing, it highlights how the technology and techniques of color lithographic printing constituted a central object of critical attention for printers and their publics. For most of the nineteenth century, what was deemed a successful color print depended on much more than just the image's final aspect: it also involved viewers' assessment of what was an appropriately modern use of lithographic technology. As such, the history of chromolithography demands that we look through the modernist surface of the sheet to the materials, skills, and social and economic conditions of the artistic process.

The "Invention" of Chromolithography

IN THE LATE 1830S, the Alsatian lithographer Godefroy Engelmann coined the term "chromolithography" for a process that, as he readily acknowledged, had already been in existence for several decades. Alois Senefelder, the celebrated inventor of lithography, also produced the first color lithograph, which he referred to simply as *farbendruck* (color print) in his publication *A Complete Course on Lithography*.[4] In fact, by Engelmann's time, a number of European lithographers, including C. Hildebrandt in Germany and Charles Hullmandel in England, were already producing colored images involving multiple, successive printings.[5] What distinguished Engelmann's prints from these earlier efforts was, he insisted, how they were produced. "The prints in this book," Engelmann wrote in his *Album chromolithographique* (1837), "are such that *they emerge from the press without any retouching*; the tools I use are simple; any artist who has a feeling for color and knows how to handle a lithographic crayon can execute these plates; their printing is based on trustworthy and precise mechanical means, thus any good lithographic printer can complete an impression."[6] The emphasis is hardly surprising. For, after all, what Godefroy Engelmann and his son presented to the Société industrielle de Mulhouse in 1837 and patented that same year was not color lithographs per se but rather a new method for producing these types of images.

The color lithographs produced earlier in the century required such a rare degree of technical skill to obtain accurate color registration that Godefroy's son, Jean Engelmann, later claimed they mostly existed as "*tours de force* to be classified among lithographic curiosities rather than industrial products."[7] The Engelmanns' invention, consisting of a registration chase, was expressly designed to remedy this problem. Composed of two wooden frames, the chase kept the lithographic stone and paper precisely aligned during the different steps of the printing process. The end result was not only pleasing to the eye, but also could be achieved inexpensively, without recourse to hand coloring or extensive training. "The process is less expensive than all others known to us, since a printer who had no previous training in this type of work already produces 100 prints a day," Godefroy proudly highlighted.[8]

Similarly, commentators on the Engelmanns' device directed attention simultaneously to the nature and quality of the images and the facility and rapidity of their production. As one early critic remarked:

> One of the significant advantages of this new lithography relates to its printing, based on mechanical means so trustworthy and precise that it is possible to assign [the task] to any lithographer. We insist on this point because it resolves . . . all the problems that had until now plagued successive printings with multiple colors, whose accurate translation depended on the printers' level of focus or dexterity. Now, the artist is solely responsible for the quality of his work.[9]

Thanks to the Engelmanns, the artist's work, this author suggested, shined forth unimpeded by the printer's unfaithful translation; color printing had finally become an act of direct, transparent reproduction.

Aesthetic considerations clearly remained important to printers. The title page of the Engelmanns' *Album chromolithographique* was ornately decorated, printed in four colors, and gilded with gold leaf and bronze (see fig. 75). The album itself included a diversity of subjects, showing off chromolithography's ability to reproduce everything from purely ornamental to figurative and highly detailed images.[10] Of these, reproductions of artworks were commonly regarded as the most difficult and prestigious type of chromolithographic work. Inviting comparison with original paintings, the *Album* included, for instance, reproductions of a portrait of Étienne Jeaurat by Jean-Baptiste Greuze [FIG. 106] and Thomas Lawrence's *Master Lambton*, which many readers would have remembered from the 1827 Salon.

Writing in response to lithographers' exhibits at the 1855 world's fair, economist Armand Audiganne noted, "Chromolithography . . . has succeeded in producing marvelous effects, namely in the printshops of Mr. Lemercier, Engelmann & Graff [*sic*], and Haugard-Maugé. Who hasn't seen the plants, stained-glass windows, coats of arms, and medieval tableaux? The carefully-handled colors seem to have sprung from the most delicate brush."[11] Still, absolute realism in the

FIGURE 106
Godefroy Engelmann,
*Portrait after Greuze
of Étienne Jeaurat,*
from *Album chromo-
lithographique,* 1837,
© The Trustees of the
British Museum

PORTRAIT D'APRES GREUZE

reproduction of artworks was not in and of itself a sufficient criterion of excellence. Indeed, like the Engelmanns before them, most French printers in the second half of the nineteenth century continued to draw attention not only to the printed image's subtle gradations of hue and tone but also to the invisible processes by which these effects were achieved.

Reproductive Prints and the Display of Skill

PUBLISHED BY THE ARUNDEL SOCIETY in England, Curmer in France, and a number of other editors, finely detailed art reproductions featured prominently at world's fairs and other public exhibitions [FIG. 107]. The French worker delegates to the 1862 exhibition in London were particularly impressed by English printers' achievements in this category. "They are willing to make any and all sacrifices in order to achieve perfection," they remarked. "And, these [prints] sell very well, which explains why lithography is especially employed for the reproduction of paintings and watercolors."[12] As these French printers saw it, however, perfection was something that could be determined only after close, detailed inspection of the image: "Every brushstroke on a chromolithographic proof is a shameful mark of weakness or lithographic imperfection."[13] It is hardly incidental that the human hand responsible for coloring or retouching images typically belonged to a woman. Indeed, criticisms of hand-coloring were more than merely evidence of printers' technophilia or the pride they took in their craft; they were also expressions of well-established gender stereotypes, which dismissed women's work as unpredictable and inefficient.[14]

Printers' technical know-how was not only discussed in specialized trade publications but also publicly illustrated and displayed. While more elaborate than most, publications such as George Ashdown Audsley's *The Art of Chromolithography: Popularly Explained and Illustrated by Forty-four Plates* (1883), which visually illustrated the printing process, were quite common in the nineteenth century (see fig. 105).[15] Printed by Lemercier in Paris, the series of progressives speak simultaneously to the reigning taste for Japanese imagery, the collective fascination with chromolithography as a visual technology, and the conflation of labor and aesthetic value in the popular imagination. The tools and technical skills of printers, the book showed, were not simply a means of executing the vision of the artist—they were not transparent or neutral—but entailed a form of knowledge and aesthetic of their own. Progressives instructed viewers in a new way of seeing, challenging the experience of unmediated representation in a manner that simultaneously destabilized and glamorized the surface of the image and the technological process by which it was made.

The show card produced by Th. Dupuy, a printer specializing in commercial works, fits within this category of lithographic products designed for the express purpose of displaying printing technology and techniques [FIG. 108]. The exact significance of the Renaissance-inspired design, including suits of armor, heraldic imagery, and other symbols, fades in relation to the extraordinary efforts expended to produce the image: the gradated background patterned with golden fleurs-de-lis, the carefully placed highlights and shadows on the armor, and the intricate decoration seemingly engraved on their surface, among other virtuosic passages. The text discourages the viewer's gaze from lingering too long on the figures. It directs attention first to the surface of the printed page, second to the printers' physical labor, and lastly to the tools used to make the image: "This fourteen-color print was produced in public at the Palais of the INTERNATIONAL EXPOSITION OF 1867 (Galerie des Machines. Classe 59.) ON THE CHROMO-LITHOGRAPHIC-MECHANICAL PRESS OF TH. DUPUY." Together, the image and the text structure the viewer's appreciation of the image as a

process made visible. This visual experience, one suspects, is what Walter Benjamin had in mind when he wrote about the disappearance of pre-industrial craft and the emergence, in its place, of a different but no less compelling imaginary power unique to mass-produced objects. The meaning of the artifacts of modern culture, he suggested, could be found not only in the final product, but also in the activity of making.[16]

The production and consumption of color lithographic imagery underwent another profound change in the 1860s, following the introduction of mechanical presses such as the one used to print the Dupuy show card. These steam-powered machines gradually replaced the hand presses used by Engelmann and his successors. Alfred Lemercier, for example, the founder of one of the premier lithographic firms in Paris, acquired his first mechanical press in 1863. "In the space of only a couple months," he later recalled, "we already had four machines, including two Voirin and two Aluzet, each of which had an excellent printer driving it. Thanks to the repeated modifications we requested from manufacturers . . . [printers] gradually became able to execute the most difficult type of work whether in terms of color or registration."[17]

Printers continued to employ hand presses for art reproductions and other high-quality prints. Meanwhile, these new steam-powered machines dramatically expanded the quantity and type of images available in color. Color posters, trade cards, calendars, and scraps—the broad range of disposable print products we associate with the color revolution—became economically conceivable for the very first time. Furthermore, as indicated by Lemercier's telling use of the verb "driving" to describe the printer's work, mechanical presses dramatically redefined what was expected of workers in terms of knowledge and skill.

La Belle Époque *of French Color Lithography*

LITHOGRAPHERS HAD ALWAYS distinguished between art prints, by which they generally meant reproductions of artworks or original art prints, and the commercial work that constituted their bread and butter. Starting in the 1860s, however, the gulf between the two categories grew deeper, and many printers voiced their dissatisfaction about the growing pressure to always produce more and always more quickly. Opportunities to exercise one's craft were few and far between, they complained: "[Our publishers] bargain with artists and especially with printers; they then end up with a bungled execution, which experts see for its true worth."[18] And the spread of mechanical presses, they opined, only accentuated this trend.

Print shop owners, in contrast, mostly welcomed the technological innovation, especially as the century progressed. Speaking in the early 1880s, Lemercier described the gradual disappearance of reproductive art printing with little hint of regret. "Hence, I say that lithography is completely transformed; it no longer does what we used to call works of art, copies of great masters, ancient or modern, meant to be framed."[19] His company, he went on to explain, now focused on color imagery destined for "a great publicity," pointing to trade cards as a particularly emblematic and interesting example of this new type of production: "Today, we print little images, which are distributed free of charge to children by big *magasins de nouveautés*. There's a series made up of fifty or sixty of these images, which bear on their back writing that serves as advertising. You see, chromolithography has genuinely become an industrial art."[20] Finally, Lemercier specifically emphasized the role of technological progress in this change: "It is not like when we used to print using hand-operated presses; [then] the worker had to have artistic talent, a sense of harmony to put into his drawing; today the machine can do all the work."[21]

The mechanical presses of the late nineteenth century made the Brisset hand press equipped with the Engelmanns' registration chase seem quaint and hopelessly artisanal in comparison. And yet, the two devices originally elicited very similar reactions. Echoing the first descriptions of the Engelmann device, promoters of the new steam-powered presses similarly deemphasized printers' contributions. The "conductor," as the printer was now called, was in charge of operating the press; another worker fed the paper into the machine; and, if the machine was not equipped with automatic fly-hands, yet another, generally an apprentice, was trusted with the job of collecting the prints when they emerged from the press. While conductors were usually the most experienced, many of them having previously worked on hand presses, it was the feeder who was responsible for the delicate task of ensuring proper color registration. However, as one handbook noted, the automatic color registration controls of many of the mechanical presses meant that "any person can fulfill the role of feeder [*margeur-pointeur*], since he only has to put the paper under the guides, and the mechanism then brings the sheet to its [proper] place."[22] The automation of the

printing process, these sources suggested, transformed the mass-production of color imagery into a neutral, depersonalized activity.

In an unexpected reversal of much recent scholarship on authorship, mass-reproduction seems, therefore, to have facilitated the emergence of artists—specifically commercial artists—as autonomous authors, distinct from the printers who employed them.[23] The most famed among these was unquestionably Jules Chéret, whose iconic posters have come to embody this era in French graphic design. By 1889 Chéret had designed over one thousand posters, and his reputation as a genuine artist with a distinct personal style was steadily rising.[24] Published in 1891, *Casino de Paris* is typical of the artist's production during this period. The diagonal composition, featuring a female figure dressed in yellow and a diminutive red-colored companion, cast against a blue background, reappears in several other posters [FIG. 109].[25] At the same time, however, the poster captures several unique features of the performance being advertised. Chéret expertly depicts, for instance, singer Camille Stéfani's delicate countenance; the subtlety of her movements and facial expression contrasts sharply with the seductive over-the-shoulder gaze of the woman to her left. In the same way, the whirling acrobat above the singer's head is more than an ornamental accessory, for Stéfani's performances were generally accompanied by, as one critic put it, "acrobats who display by the floodlights their heroically muscular bodies."[26] Finally, Chéret's poster shows the unusual visual effects created by the Casino's electric lighting system, which the same critic described as "pouring torrents of light onto the continually-renewed waves of people."[27] Here, the electric floodlights cast their distinctive, low-angle illumination on the performers. In fact, their entire appearance seems dictated by some powerful colored lights glowing from beyond the frame.

This and other posters by Chéret were highly coveted by collectors in the late nineteenth century, and critics enthusiastically defended their status as genuine works of art. In their articles, books, and catalogue essays on the subject, critics (who were generally not printers) continued to place heavy emphasis on production methods. Printed using mechanical presses, Chéret's designs were not only inexpensive to produce, they insisted, but also served their function more effectively than more elaborate designs. "It is impossible to see one of his designs without immediately grasping the nature of the work he puts forward. If the eye is satisfied, the spirit is no less so. His posters stand out on the walls and command attention," noted Ernest Maindron.[28] Critics perceived Chéret's oft-imitated style, featuring bold, flat surfaces of color, as originating in posters' mechanical mode of production. Art critic Albert Wolff noted, for instance:

> The composition that is the signature of the artist Chéret is created in such a way that the lithographer does not stumble against anything preventing a rapid and easy execution. To complete his work, one must therefore possess both talent and ingenuity, a fine decorative sense and a perfect knowledge of the lithographic printer's craft. These two qualities, combined in one man, are what make Mr. Jules Chéret what he is: a marvellously imaginative painter and an artisan meant for reproduction.[29]

The fact that Chéret was not only an illustrator but also trained as a printer was central to the way critics understood his work. In their view, Chéret's intimate mastery of lithographic technology dictated the simple elegance of his designs. His posters, they claimed, exemplified the perfect harmony between form and function, between compositional elements and the technological means by which they were produced.[30] And yet, the diversity of color lithographic products and styles in Chéret's oeuvre alone indicates that there was little about the artist's engagement with chromolithographic materials and machinery that was necessary or self-evident.[31] In other words,

when critics paid homage to modern production methods, they were largely paying homage to a fantasy of their own invention.[32]

The great diversity of types and styles of color imagery produced in the late nineteenth century suggests that Chéret's posters were only one approach among many; other commercial artists had a very different view of what constituted an appropriately modern use of printers' tools and labor. In fact, despite all their insistence on production methods, poster aficionados had remarkably little to say about printing.[33] Details about who printed the posters, using what kind of press and inks, and other technical information are noticeably absent from writings about "artistic posters," suggesting that, much like twentieth-century references to the "machine aesthetic," these nineteenth-century references to production methods conceal as much as they reveal.

From Poster to Original Art Print

IN HIS 1898 ESSAY *Original Color Lithography*, Mellerio traced a direct connection between Chéret's posters and avant-garde artists' adoption of color lithography for the creation of original art prints. These connections, he suggested, were more than merely material; they were also stylistic and ideological. Just as Chéret and a coterie of other talented poster artists had transformed

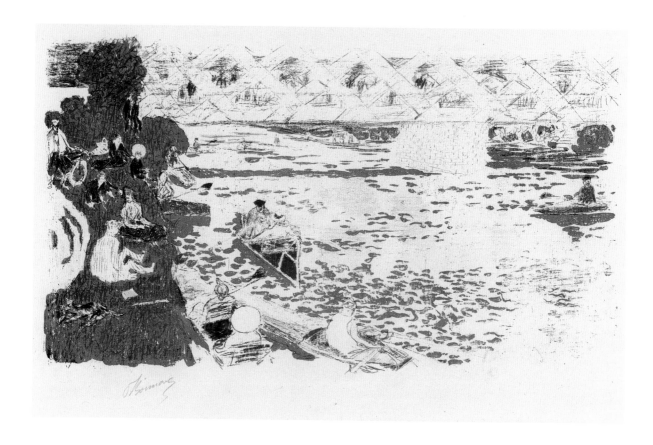

the streets of Paris into an "open-air museum," artists involved in the color movement of the 1890s wished to make art for the masses.[34] "One might almost say of Chéret's posters and Rivière's prints that they are the frescos, if not of the poor man, at least of the crowd," wrote Mellerio.[35] More importantly, perhaps, Mellerio insisted that the prints designed by Henri de Toulouse-Lautrec, Paul Signac, Pierre Bonnard, and Édouard Vuillard were original, autonomous creations; like Chéret's posters, their prints were not reproductions of oil paintings or watercolors, "but a personal conception, something realized for its own sake."[36] Moreover, the original art prints, like Chéret's simplified designs, laid bare the medium's inherent principles and unique capacities. As Mellerio argued,

> An artistic inspiration joined in advance with a technique expressed itself directly in the chosen process of execution. This principle, applied victoriously by Chéret to the poster, whose nature and function made it special, was to be applied by others to the print, whose characteristics differed in certain ways. And so original color lithography was born, and a simple sheet of paper for which mechanical means procured the advantage of unlimited copies, attained a real value as an art form.[37]

In other words, despite all that separated Mellerio from the printers who wrote about chromo-lithography earlier in the century, modes of production still played a central role in his description of these new artifacts of visual culture.

The argument was a compelling one. The smaller size of original art prints relative to posters opened the door to more detailed designs. Otherwise, Mellerio explained, the two genres displayed many of the same formal characteristics: a simplified, bright palette; the strategic use of

FIGURE 110

Pierre Bonnard, *Boating*,
1897, color lithograph,
Smart Museum of Art,
Cat. 5

FIGURE 111

Édouard Vuillard,
The Avenue, 1899,
color lithograph,
National Gallery of Art,
Washington, Rosenwald
Collection, 1950.16.267

the white of the paper; and, finally, bold flat lines and large areas of unmixed color. These aspects contribute to the unfinished, progressive-like appearance of Bonnard's *Boating* and Vuillard's *The Avenue* [FIGS. 110, 111]. Indeed, their limited color palette and simplified design, noticeably devoid of dark outlines, make it easy to imagine adding or subtracting a color from the print. And, as in the case of the poster, Mellerio suggested, the lithographic medium constituted the very substance of the work, therefore making it possible to fully grasp how these images were made by simply looking at their surface.

According to Mellerio, Toulouse-Lautrec's *La Goulue* and *Moulin Rouge* represented hybrid visual forms: "This is no longer just a poster, and it is not yet quite a print; a work of a hybrid pungency deriving from the two, or rather, it *is* the modern color print."[38] The orange hair of singer

FIGURE 112

Henri de Toulouse-
Lautrec, *Divan Japonais*,
1892–93, color lithograph,
Smart Museum of Art,
Cat. 46

Jane Avril, the central seated figure in Toulouse-Lautrec's *Divan Japonais* poster, seems to move forward against the cut-out-like form of her black body [FIG. 112]. Together, the curvilinear yellow chair, beard, cane, and handbag create a pattern of flat colored shapes similar to those seen in the original art prints of the same time period. These types of similarities, Mellerio hinted, laid bare the unorthodox origins of the original art print and the irreducible chromolithographic characteristics of the two genres.

And yet, posters and original art prints were not printed in the same manner. While Chéret's and Toulouse-Lautrec's posters were printed on mechanical presses, prints by Bonnard, Vuillard, and Signac were produced using hand presses—the very same machines and methods used for creating the much-discussed and despised reproductions of artworks. The simplification of form and palette evidenced in the original art prints of the 1890s was neither necessary nor self-evident, therefore, but part of a much more comprehensive redefinition of commercial, artistic, and social production and their relationship to one another.

As Pat Gilmour and Sinclair Hamilton Hitchings rightly point out, critics' censure of printers' excessive enthusiasm for technique—a stereotype that still besets printers today—had every-thing to do with artists' desire to establish themselves as the exclusive authors of their work.[39] Additionally, the modernist notion that materials and mode of production were clearly discernible

on the surface of the page accorded a certain psychic autonomy to the print and reinforced its difference from other consumable goods and images. For, as suggested earlier, rather than actually revealing the materials and process of printmaking, the modernist discourse on original art prints reiterated the notion that modes of production and labor were always already visible. By insisting that the final image displayed its own work processes, they discouraged viewers from looking beyond surface phenomena. As such, they ensured the primacy of aesthetics over social or economic considerations and the separation of art-making from other forms of making.

In short, the elevation of the poster to the status of art and the expansion of original art printing of the 1890s did not constitute a clean break from the history of color printmaking. Considered within this larger context, the color revolution appears as merely one episode in a long series of displacements of art's proper relation to technology and labor. From Engelmann to Vuillard, the works featured here provide a broader, richer, and more colorful view of modern visual culture that embraces both high art and popular commercial imagery. More fundamentally, however, the history of color prints invites us to reevaluate the status of materials and process in our understanding of modernism and the extent to which the process of making images intersected with other forms of artisanal and industrial making in nineteenth-century France.

NOTES

The author wishes to express her gratitude to Anne Leonard and Catherine Clark for their suggestions and expert editorial assistance.

1. "Affiches et placards," *Bulletin de l'imprimerie*, 9e année (September 1883): 269. This and all other translations, unless noted, are the author's.

2. André Mellerio, *Original Color Lithography*, trans. Margaret Needham, in Phillip Dennis Cate and Sinclair Hamilton Hitchings, *The Color Revolution: Color Lithography in France 1890–1900*, exh. cat. (Santa Barbara and Salt Lake City: Peregrine Smith, 1978), 79. First published in 1898.

3. Cate and Hitchings, *The Color Revolution*.

4. Alois Senefelder, *A Complete Course of Lithography: Containing Clear and Explicit Instructions in All the Different Branches and Manners of that Art; Accompanied by Illustrative Specimens of Drawings* (London: R. Ackermann, 1819). First published in German in 1818.

5. Michael Twyman, *Images en couleur: Godefroy Engelmann, Charles Hullmandel et les débuts de la chromolithographie*, exh. cat. (Lyon: Musée de l'imprimerie, 2007), 20, 64–87.

6. Godefroy Engelmann, *Album chromolithographique, ou Recueil d'essais du nouveau procédé d'impression lithographique en couleurs inventé par Engelmann père et fils à Mulhouse* (Mulhouse: l'auteur, 1837), not paginated.

7. Jean Engelmann, *Notice sur la chromolithographie* (Paris: s.n., 1864), 6.

8. Godefroy Engelmann, *Rapport sur la chromolithographie* (Mulhouse: J. P. Risler, n.d. [read at the meeting of March 29, 1837]), 7–8.

9. *Archives des découvertes et des inventions nouvelles* (Paris: Treuttel et Würtz, 1839), 192.

10. Engelmann, like most other printers at the time, produced a great variety of lithographic imagery and documents, including "all kinds of prints, records, statements, circulars, letterhead, bills, exchange and coach letters, labels and printing of every kind." Engelmann et fils letterhead, dated August 7, 1840. Correspondance reçue par Thierry Frères (19TT 3B), Engelmann & Cie, Mulhouse Municipal Archives, Mulhouse, France. Twyman, *Images en couleur*, 44.

11. Armand Audigane, *L'industrie contemporaine, ses caractères et ses progrès chez les différents peuples du monde* (Paris: Capelle, 1856), 172–73.

12. A. Sauvé, Salmon, and Godefroy, *Délégations ouvrières à l'Exposition Universelle de Londres en 1862. Rapports des délégués imprimeurs lithographes et des délégués imprimeurs en taille douce* (Paris: Publié chez la commission ouvrière, 1863), 11.

13. Ibid., 13.

14. On the hand-coloring of images, see Émile Théophile Blanchard et al., *Nouveau manuel complet du coloriste, ou instruction simplifiée et élémentaire pour l'enluminure, le lavis et la retouche des gravures, images, lithographies... contenant la description des instruments et ustensiles propres au coloriste...* (Paris: Librairie encyclopédique Roret, 1856); and Raymond Gaudriault, *La gravure de la mode féminine en France* (Paris: Les Éditions de l'Amateur, 1983), 126–33. Joseph Lemercier dismissed hand-coloring as expensive and producing only mediocre results in *Commission d'enquête sur la situation des ouvriers et des industries d'art instituée par décret en date du 24 décembre 1881* (Paris: A. Quantin, 1884), 177.

15. Michael Twyman, *Breaking the Mould: The First Hundred Years of Lithography* (London: The British Library, 2001), 105.

16. Esther Leslie, "Walter Benjamin: Traces of Craft," *Journal of Design History* 11, no. 1 (1998): 5–15.

17. Alfred Lemercier, *La lithographie française de 1796 à 1896 et les arts qui s'y rattachent. Manuel pratique s'adressant aux artistes et aux imprimeurs* (Paris: Ch. Lorilleux, 1899), 157.

18. Sauvé et al., *Délégations ouvrières à l'Exposition Universelle*, 15–16.

19. *Commission d'enquête sur la situation des ouvriers et des industries d'art*, 179.

20. Ibid.

21. Ibid.

22. Mathieu A. Villon, *Nouveau manuel complet du dessinateur et de l'imprimeur lithographe* (Paris: Roret, 1891), 117.

23. Especially Ellen Lupton, "The Designer as Producer," in *The Education of a Graphic Designer*, ed. Steven Heller (New York: Allsworth Press, 1998), 159–62. See also Molly Nesbit, "What Was an Author?," *Yale French Studies* 73 (1987): 229–57.

24. Lucien Puech, "Chez Jules Chéret," *Gil Blas* (1889), in Coupures de presse relatives à Jules Chéret, Estampes et Photographie, Bibliothèque Nationale de France, Paris.

25. The Pierrot peeking from behind Stéfani's sleeve and the mandolin in the foreground also recall Chéret's longstanding infatuation with the figures and themes of the *commedia dell'arte*.

26. "Paris-Concerts," *Le Nouvel Écho* 1 (January 1, 1892): 30.

27. Ibid.

28. Ernest Maindron, "Les affiches illustrées (deuxième et dernier article)," *Gazette des Beaux-Arts* 33, no. 2 (January–June 1886): 546.

29. Albert Wolff, "M. Jules Chéret," *Figaro* (1889), in Coupures de presse relatives à Jules Chéret, Estampes et Photographie, Bibliothèque Nationale de France, Paris.

30. Laura Anne Kalba, "How Media Were Made: Chromolithography in Belle Époque France," *History and Technology* 24, no. 4 (December 2011): 441–53.

31. For an excellent survey of Chéret's entire oeuvre, see Réjane Bargiel and Ségolène Le Men, *La Belle Époque de Jules Chéret: De l'affiche au décor*, exh. cat. (Paris: Les Arts Décoratifs/Bibliothèque nationale de France, 2010).

32. Reyner Banham makes the same argument in reference to modernist architecture and criticism in his classic essay "Machine Aesthetic," *The Architectural Review* 117, no. 700 (April 1955): 225–28.

33. Miriam Levin, "Democratic Vistas–Democratic Media: Defining a Role for Printed Images in Industrializing France," *French Historical Studies* 18, no. 1 (Spring 1993): 102.

34. Ibid., 89; and Karen Lynn Carter, "L'âge de l'affiche: The Reception, Display, and Collection of Posters in Fin-de-Siècle Paris," Ph.D. diss., The University of Chicago, 2001, esp. 91–108.

35. Mellerio in Cate and Hitchings, *The Color Revolution*, 96–97.

36. Ibid., 80.

37. Ibid.

38. Ibid., 82.

39. Pat Gilmour, "On Originality," *Print Quarterly* 25, no. 1 (March 2008): 36–50; and Sinclair Hamilton Hitchings, "Simplicity of Means," in Cate and Hitchings, *The Color Revolution*, 101–14.

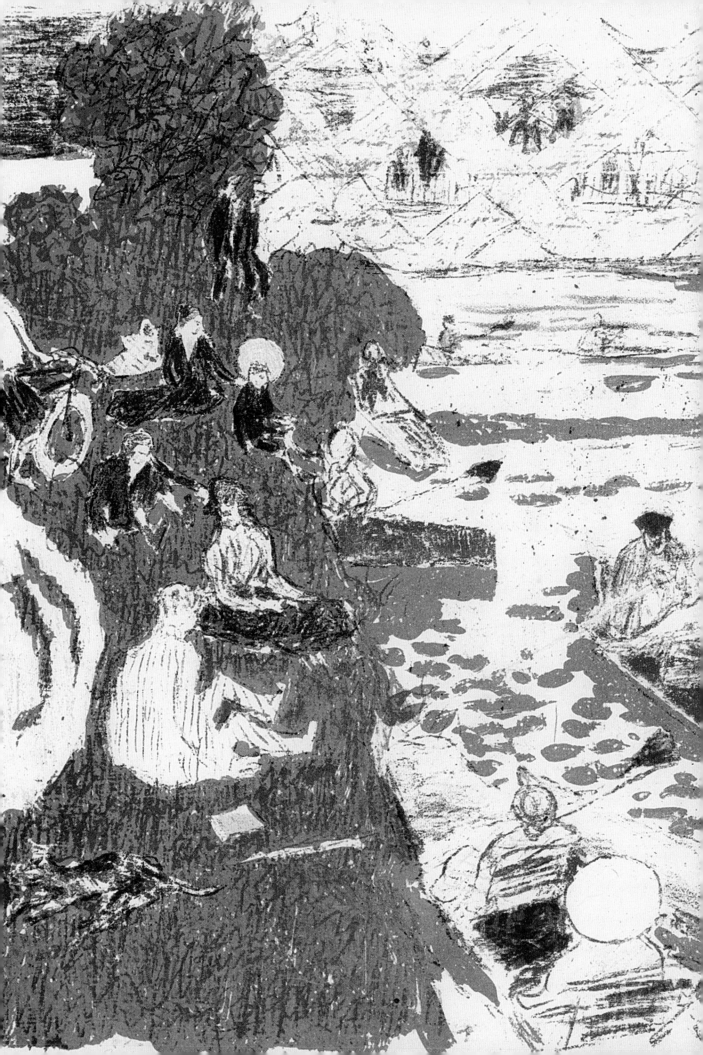

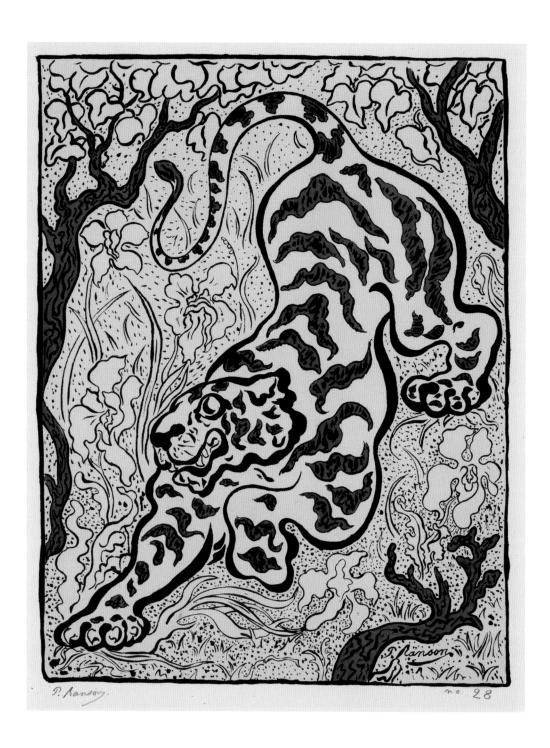

FIGURE 113
Paul Elie Ranson, *Tiger
in the Jungle*, 1893,
color lithograph, Smart
Museum of Art, Cat. 34

ANNE LEONARD

EIGHT
THE COLOR WOODBLOCK PRINT: SOME THOUGHTS ON TRANSLATION

IT IS REMARKABLE HOW MANY of the artists most closely associated with *Japonisme* never worked in color woodcut, the defining medium of *ukiyo-e*. Édouard Manet, Pierre Bonnard, and Henri de Toulouse-Lautrec are only a few of the celebrated artists who fall into this category (see figs. 58, 110, and 112). By contrast, the man who went further than any other French artist in the assimilation of *ukiyo-e* technique—Henri Rivière—is much less well known, in the United States at least (see figs. 47–49).[1] When Rivière made his *Breton Landscapes* at the beginning of the 1890s, there could be no doubt that this color woodblock series constituted a direct homage to Andō Hiroshige's *Fifty-three Stations of the Tokaido.* Nevertheless, other prints are considered far more iconic of that moment of French *Japonisme*: Mary Cassatt's *The Letter* (1890/91) (see fig. 99), Toulouse-Lautrec's *Divan Japonais* (1892–93) (see fig. 112), and Paul Ranson's *Tiger in the Jungle* (1893) [FIG. 113]. None of these prints are woodcuts; nor are the two lithographs that were designed as programs for Le Théâtre Libre, by George Auriol (1889) and Henri-Gabriel Ibels (1892), respectively [FIGS. 114, 115].

Rivière is not unknown to American audiences. There is an English-language book on him from 1983, and he has been the subject of recent exhibitions at the Fresno Art Museum and Santa Barbara Museum of Art.[2] Even so, his stateside renown remains rather limited for someone who has been described as the "most *japonisant*" of all French artists.[3] As a 1988 French catalogue put it, "To pull dozens of prints in twelve, even fourteen colors, represented a technical tour de force and an exhausting job that [Rivière] was really the only one of his time to dare to undertake."[4] What I am calling Rivière's underexposure in the United States relative to his achievement raises an unavoidable issue of translation, which I would like to address from several points of view. Has a paucity of English-language scholarship—that is, a hurdle of translation—made Rivière a more obscure figure in this country than, say, Toulouse-Lautrec or Paul Signac?[5] What was Rivière's own process of translation in understanding Japanese print traditions for himself and then making them intelligible to his French contemporaries? Finally, how did translation figure differently in the work of two American woodblock printmakers profoundly influenced by Japanese models, Arthur Wesley Dow and Helen Hyde?

FIGURE 114
George Auriol, *Program for Le Théâtre Libre*, 1889, five-color lithograph, Spencer Museum of Art, Cat. 2

FIGURE 115
Henri-Gabriel Ibels, *At the Shore*, 1892, color lithograph, proof before letters, Museum of Fine Arts, Boston, Cat. 23

What one notices immediately in a survey of French *Japonisme* is just how many forms it could take. Under this umbrella one finds an astonishing range of media, subjects, and styles. Moreover, the label encompasses a certain amount of material whose relation to Japanese art is tenuous or minimal at best. Stylistic influence can be hard to trace, besides being a problematic concept in itself, and it is not the aim of this brief essay to disentangle such complex genealogies. Looking solely at the question of materials and methods, however, one can say with confidence that Rivière was a full-blooded *Japoniste*. He sought what one might call a literal translation of Japanese print technique, rather than the free adaptation or imitation that most artists chose. Most printmakers, rather than trying to duplicate Japanese methods, tended to use techniques with which they were already familiar in order to mimic a Japanese visual effect.

Paul Ranson, known as "the Nabi more *japonard* than the *japonard*," made allusions to Japanese art throughout his oeuvre.[6] *Tiger in the Jungle* bears close resemblances to woodblock prints of tigers by Kitagawa Utamaro and Katsushika Hokusai, and although the arabesque shapes (particularly the tiger's stripes) are intended to evoke Chinese ink drawings, the print medium—lithography—was quite atypical of Asian art. *Tiger in the Jungle* won instant prestige upon its inclusion in André Marty's first *L'Estampe originale* album, in 1893.

George Auriol's floral-themed program for Le Théâtre Libre, also a lithograph, connects visually with Japanese precedents like Hokusai's so-called *Large Flowers* (see figs. 2–4). Despite Hokusai's own likely exposure to European botanical prints, such as those of Redouté [FIG. 116], for an 1890s French audience Auriol's flowers would have been strongly redolent of Japanese aesthetics.[7] Henri-Gabriel Ibels, in his design for Le Théâtre Libre several years later, likewise found lithography congenial to his very different manner of adapting Japanese features, particularly with regard to composition. Ibels's angular perspectives and flat planes of color juxtaposed without transition become even more dramatic with the irregular shape of the image, indicating the areas held in reserve for the printed details of the program.[8]

Whether because of its ease of execution or its more forgiving economics of production and distribution, lithography was the medium chosen by the vast majority of French printmakers with *Japoniste* leanings. As Félix Bracquemond put it, "lithography has no technique," another way of saying that anyone could do it.[9] Woodcut, by comparison, was demanding work: Arsène Alexandre, in his prologue to Rivière's *Thirty-six Views of the Eiffel Tower* (published as lithographs), noted the "hard labors" that Rivière the woodblock carver had undertaken fifteen years before.[10] Already in the early shipments of Japanese art to France, Rivière had noticed particular qualities that made the woodcuts distinct from European examples: the use of water-based pigments, and the practice of printing by hand rather than from a press. He began his own attempts in the medium in 1888–89.

Rivière was an acute observer and relentless experimenter who, despite never traveling to Japan himself, managed to construct a color woodblock method from the ground up. His approach combined authenticity of technique with truth to materials. As he remarked in his memoirs, "It was a little ridiculous thus to invent an already existing process. When I got to know him later, Hayashi [Tadamasa, a major force in exhibiting and marketing Japanese prints in France] was very amused to see my primitive instruments which had long served Japanese printers, only in much better-quality versions, naturally."[11] Yet Rivière's journey in the woodblock medium lasted only five years or so, and by 1894 he too—like so many of his *Japoniste* compatriot artists—had converted over to color lithography once and for all (see fig. 60).

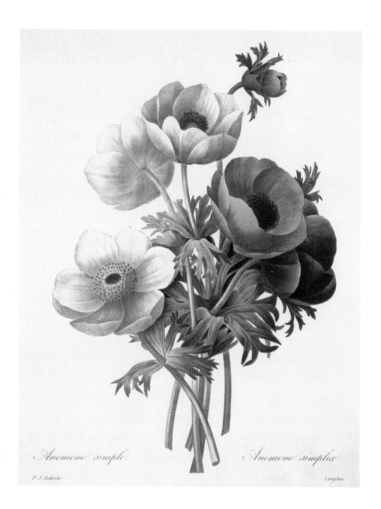

FIGURE 116
After Pierre-Joseph
Redouté, *Anemone
simple*, 1827, color stipple
engraving finished by
hand, Minneapolis
Institute of Arts, Cat. 35

The underestimation of Rivière's achievement in this country may be due in part to his works being rarer here, but also to the fact that the prints make so few concessions. Such a strong similarity has been noted to certain works of Hokusai, for example, that the composition of some of Rivière's prints "appears almost traced from those of the great Japanese master."[12] Acts of reverence such as these, providing Western viewers with a direct channel to Japanese visual traditions, are unlikely to score Rivière many points with those who consider innovation and originality as the key criteria for judging a work of art. One might say that Rivière translated his Breton landscapes directly into Japanese, with 100 percent transparency of style; this literal translation, depending on one's point of view, can be praised for its meticulous fidelity to the model or faulted on identical grounds ("if it's so similar, it can only be derivative"). And even those who value meticulous fidelity to a model will find ways in which the prints fall short, no matter how heroic Rivière's efforts.

Imitation vs. original (or copy vs. original) is no doubt a value-laden dichotomy in Western art, though no less so than the dichotomy of imitation vs. authentic. In each of these scales of values, "imitation" finds itself at the negative end. Yet Rivière's very act of imitating a Japanese model so thoroughly and conscientiously ensured his distance from the popularized versions of imitation *Japonisme* that were also circulating at the time. As François Fossier has pointed out, what most French people knew of Japan from the universal expositions of 1878 and 1889—what Rivière could have adopted for his own art but did not—was a motley collection of exotic yet banalized

motifs: the lotus flowers, dragons, and so on that tea shops and kimono merchants used to sell their wares.[13] Rather than accepting this kitsch version, Rivière brought back whatever mediated sense he had of landscape in Japanese prints to nature itself, ensuring the authenticity of his own production.

Even those French viewers who did have the benefit of exposure to genuine specimens of Japanese art—whether in exhibitions, boutiques, or private collections—may have felt a need to have those objects translated back, so to speak, into something they recognized from their native tradition. Examples of this phenomenon include Charles Baudelaire's dubbing of *ukiyo-e* as "Épinal prints from Japan."[14] Other critical commentaries, conversely, attempted to "naturalize" the *Japonisant* aspects of certain French art of the period, thus making it seem less foreign—such as when Ernest Maindron likened Jules Chéret's posters to eighteenth-century French pastels (an assertion that may seem surprising today).[15]

The American printmakers who embraced Japanese woodblock printing at the end of the nineteenth century were likewise necessarily engaged in a process of translation. Arthur Wesley Dow, "by far the most influential figure" in American *Japonisme*,[16] made a copy of an Utagawa Kunisada print around 1891 or 1892 that demonstrates his "struggle to comprehend a foreign visual language."[17] Much like Rivière, Dow developed a technique closely resembling traditional practice without travel to Japan (which he did not visit until 1903), only by studying the works of the masters. He had access to those in great abundance at the Museum of Fine Arts, Boston, which had become a leading repository of Japanese prints under the curatorship of Ernest Fenollosa and Sylvester Rosa Koehler. Dow was fortunate to have Fenollosa and Koehler as "interpreters" of the Japanese print tradition, and with their guidance, he built a *ukiyo-e* collection of his own. The corpus of woodcutting and printing equipment that Koehler had accepted from the Japanese government in 1889 for the Smithsonian Institution in Washington, where he held a simultaneous curatorial post, was doubtless also an indirect catalyst for Dow's investigations (on this material, see Marks essay, pp. 124–26). In 1892, Koehler edited *Tokuno's Japanese Wood-cutting and Wood-cut Printing*, which explained to English-speaking audiences the use of woodblocks and tools as well as the division of labor in Japanese printmaking between designer, block-cutter, and printer.[18]

Helen Hyde, a San Francisco artist whose background and life itinerary contrast markedly with Dow's, encountered the same Tokuno blueprint for color woodblock printing by a quite different channel.[19] That was Emil Orlik, a Central European artist working in Japan who had closely studied the woodblock printing treatise and made illustrations for it. When Hyde first came to Japan in 1899, Orlik shared with her the knowledge of *ukiyo-e* techniques he had gained during his residence there, providing her with tools and demonstrating block-cutting. Hyde also studied the Japanese language and traditional brush painting.[20] Yet her immersive approach, undertaken on Japanese soil, elicited a sometimes dubious critical response. A *New York Times* review of Hyde's April 1906 exhibition of prints read, "Pretty as these little pictures are, one hesitates to welcome them as cordially as perhaps may be their due, because an artist who is not born an Oriental seems to be wasting time and energy while engaged in such work."[21] While the reviewer's note of condescension may stem from multiple sources and reflect period anxieties not directly related to Hyde's prints, certainly something appears to have been lost in translation.

In any event, there was no turning back: by then it was already fifteen years since Hyde's first introduction to *Japonisme* while studying in Paris with the artist Félix Régamey.[22] The year

1891 proved to be a decisive one for Dow and Hyde alike, in that Dow's lifelong fascination with Japanese art has been pinpointed to that precise moment: "On the evening of February 24, 1891, at the Boston Public Library, Dow picked up a book on the Japanese master of color woodcut Katsushika Hokusai, and he was enchanted."[23] This year is also, notably, when Rivière's *Breton Landscapes*—so closely modeled on the example of Hokusai and Hiroshige—were appearing in full tide.[24] To all of these Western practitioners, however, "touched" at the same moment, the Japanese color woodblock print meant something distinct.

Both Rivière and Dow insisted on executing the whole process from start to finish, while Hyde entrusted the block-cutting and printing to Japanese masters, overseeing their work to obtain the results she wanted. (This delegation of all but the design steps calls to mind Mary Cassatt's total abstention from woodcut; see p. 57.) Most of Hyde's prints were made in Japan, "reveal[ing] a relatively unadulterated *Japonisme*" [FIG. 117],[25] whereas Rivière subjected landscapes that were plainly French to a Japanese technique and vision. Dow's equipment allowed him to make hundreds of prints from the same blocks, colored differently. Rivière's print runs, meanwhile, were more uniform, more laborious because of the number of blocks used—and far smaller, twenty impressions. Hyde's editions ran anywhere from 100 to 250 impressions, an astonishing number that would be much lower if the physical effort of production had been her own.[26]

Unlike Rivière, Dow eliminated the key block (the linear "skeleton" of the composition) entirely from certain prints, manipulating the masses of color that remained into more variable abstract designs [FIGS. 118-21].[27] As David Acton points out, "His prints became something quite different from *ukiyo-e* woodcuts. Rather than inexpensive, identical multiples, produced by a team of artisans, they were unique, creative works, by an individual artist, who used the woodcut process as a creative tool."[28] From his sustained study of Japanese prints and the repeated act of

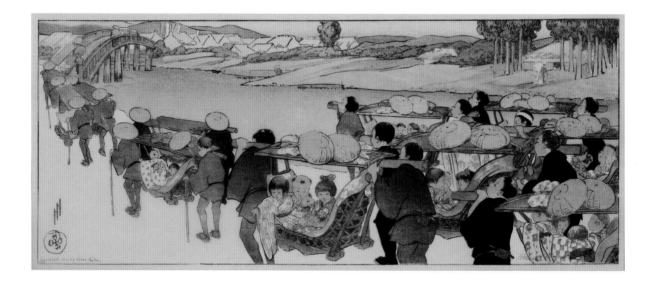

FIGURE 117
Helen Hyde, *Going to the Fair*, 1910, color woodblock print, Smart Museum of Art, Cat. 58

making, Dow wanted to distill essential principles, and he was willing to experiment for a long time with countless permutations to arrive at his holy grail, good design. Nonetheless, Dow did eventually package ten landscape prints into a series, *Along Ipswich River*. Each portfolio was unique because of color variations in the individual prints from one set to another. Like Rivière's *Breton Landscapes* (though more casually so), the series made a nod to Hiroshige's *Fifty-three Stations of the Tokaido*, evoking a "picturesque ramble" around his native Ipswich, Massachusetts.[29]

Besides being a printmaker, Dow was above all a teacher but also a curator who was able to use his position at the Museum of Fine Arts, Boston, to get a show of his own work there—200 prints' worth—with a catalogue introduced by his mentor, Fenollosa.[30] All of these activities, along with his publications, allowed him to communicate his ideas to a wide audience. Hyde, an energetic promoter of her own work who enjoyed gallery representation throughout her career, was keenly engaged with her American public and attuned to its tastes. When she pieced together old paper to make the overall sheet long enough for the composition of *From the Rice Fields*, a print from 1901, "the seam, of no importance in Japan, was regarded as a flaw in this country." Following poor sales, "she did not try this experiment again."[31] This example illustrates how, with each printed "experiment," Hyde and other *Japonistes* faced a potential need to recalibrate their methods of visual communication, for there were limits to what could be translated.

Rivière's situation was somewhat different. He was far from "going native," as Hyde did, but neither did he stay quite as grounded as Dow in his home town. Summer sojourns in semi-exotic Brittany took him away from the Paris art world and set him face to face with nature. Of the three artists, Rivière appears to have had the least concern for public approbation of his art. As Victoria Dailey has remarked, his lack of gallery representation and exhibitions did not seem to bother him in the least.[32] In the end, what mattered most to him was not translating Japanese art for the French public, but rather finding within it his own connection to something yet more elemental: the language of nature.

1. Jocelyn Bouquillard, "Henri Rivière, un graveur à l'âme japonisante," in Valérie Sueur-Hermel, *Henri Rivière: Entre impressionnisme et japonisme*, exh. cat. (Paris: Bibliothèque nationale de France, 2009), 31.

2. See Armond Fields, *Henri Rivière*, intro. Victoria Dailey (Salt Lake City: G. M. Smith/Peregrine Smith Books, 1983). The exhibitions were respectively titled *The Landscapes of Henri Rivière: Selections from the Elisabeth Dean Collection of French Prints* (June 10–August 17, 2008) and *Echoes of Japan: The Prints of Henri Rivière (1864–1951)* (October 1, 2011–January 1, 2012).

3. Bouquillard in Sueur-Hermel, *Henri Rivière*, 23.

4. François Fossier et al., *Henri Rivière: Graveur et photographe* (Paris: Éditions de la Réunion des musées nationaux, 1988), 9. This and all other translations, unless noted, are the author's.

5. Other important factors include his never having achieved renown as a painter and the concentration of his best work in just one decade—the 1890s—of his long life (he died in 1951).

6. See Brigitte Ranson Bitker, "Paul-Elie Ranson (1861–1909)," *Nouvelles de l'estampe* 129 (August 1993): 11–24. "Japonard" was coined to rhyme with [Pierre] Bonnard, who was considered among the most *Japoniste* of the Nabi group of artists.

7. Auriol was closely associated with Rivière, designing a monogram for him and collaborating with him on his *Thirty-six Views of the Eiffel Tower* (1902).

8. This program served for *Les Fossiles*, a four-act play by François de Curel given at the Théâtre Libre (Menus-Plaisirs) on November 29, 1892. See Geneviève Aitken, "Les Nabis, un foyer au théâtre," in *Nabis: 1888–1900*, exh. cat., ed. Claire Frèches-Thory and Ursula Perrucchi-Petri (Munich: Prestel, 1993), 410.

9. Félix Bracquemond, *Étude sur la gravure sur bois et la lithographie* (Paris: printed for Henri Béraldi, 1897), 16.

10. Henri Rivière, *Thirty-six Views of the Eiffel Tower* (San Francisco: Chronicle Books, 2010), n.p.

11. *Les détours du chemin*, quoted in Bouquillard in Sueur-Hermel, *Henri Rivière*, 24.

12. Bouquillard in Sueur-Hermel, *Henri Rivière*, 31.

13. Fossier, *Henri Rivière*, 9.

14. Quoted in Phylis Floyd, "Seeking the Floating World: The Japanese Spirit in Turn-of-the-Century French Art," in *Hanga ni miru Japonisumu ten*, exh. cat., ed. Tanita Hiroyuki (Yokohama: Taniguchi Jimusho), 19.

15. Ernest Maindron, "L'affiche illustrée," *La Plume* 110 (November 15, 1893): 477. "Il [Chéret] a modifié ses procédés et les a rendus plus délicats encore.... On croirait qu'il expose à nos yeux, de véritable pastels aux couleurs chatoyantes, fines et véloutées. C'est tout simplement délicieux."

16. Tim Mason and Lynn Mason, *Helen Hyde* (Washington and London: Smithsonian Institution Press, 1991), 14.

17. David Acton, *Along Ipswich River: The Color Woodcuts of Arthur Wesley Dow* (New York: Hirschl & Adler Galleries, 1999), 9.

18. Ibid.

19. Whereas Dow's father had seen his weaving business fold, leaving the younger Dow with no money to go to college (he began teaching elementary school to support himself), Hyde was from a wealthy, socially prominent California family; she received art instruction in New York, Berlin, Paris, and finally Japan, where she would spend half of her adult life. Dow went to Paris for art study in 1884, and visited the American artists' colony in Brittany, but upon return to Ipswich in 1889 he did not undertake overseas travel again until his year-long world tour beginning in fall 1903—when he met Hyde in Japan, his first stop. See Mason and Mason, *Helen Hyde*, 11–13; and Acton, *Along Ipswich River*, 5–6, 28.

20. Mason and Mason, *Helen Hyde*, 18–19.

21. Quoted in ibid., 23.

22. Régamey, a devoted *Japoniste*, had traveled to Japan in 1876 with Émile Guimet, the distinguished founder of the Musée Guimet, today still the leading museum of Asian art in Paris; besides giving his publications and teaching a Japanese focus, Régamey also amassed a major collection of Japanese art and artifacts. See Mason and Mason, *Helen Hyde*, 14.

23. Acton, *Along Ipswich River*, 7.

24. Likewise in 1891, Mary Cassatt's ten Japanese-inflected color aquatints were exhibited, but Hyde did not arrive in Paris in time to see them; she saw the same suite exhibited at Durand-Ruel's gallery in 1893. Their thematic and stylistic influence on Hyde's art was substantial. Mason and Mason, *Helen Hyde*, 14.

25. Mason and Mason, *Helen Hyde*, 27.

26. Ibid., 19.

27. In some cases Rivière omitted the key block for the background, to obtain misty atmospheric effects that contrasted with the clarity and precision of the foreground. Bouquillard in Sueur-Hermel, *Henri Rivière*, 28.

28. Acton, *Along Ipswich River*, 15.

29. Ibid., 20.

30. Ibid., 21–22.

31. Mason and Mason, *Helen Hyde*, 19.

32. Victoria Dailey, "Introduction," in Armond Fields, *Henri Rivière*, xviii.

FIGURE 122
Yamamoto Kanae,
Bathers in Brittany, 1913,
color woodblock print,
Collection of Charles H.
Mottier, Cat. 120

STEPHANIE SU

NINE
CLASSICIZING THE CREATIVE PRINT: YAMAMOTO KANAE IN FRANCE

BORN IN 1882, YAMAMOTO KANAE was one of the pioneer artists in the Creative Print (*sōsaku hanga*) Movement in modern Japan. Though trained as a wood engraver beginning in 1893, Kanae aspired to paint, and from 1902 to 1906 he studied at the Western Painting department of the Tokyo School of Fine Arts. By 1907, Kanae and his friends Hakutei Ishii and Tsunetomo Morita had founded a monthly journal named *Ideas* (*Hōsun*), which became one of the most important magazines to promote creative prints. At the height of his reputation, Kanae left Japan to study in Paris from 1912 to 1916. Two prints from this period, *Bathers in Brittany* [FIG. 122] and *French Pastoral in Spring* [FIG. 123], with their uncommon subject matter and handling of colors, have a unique position in the history of the Creative Print Movement. This essay focuses on the first-mentioned print to illuminate its significance both in Kanae's career and in modern Japanese print history more broadly.

Bathers in Brittany dates from Kanae's six-week trip to that region in the summer of 1913. Brittany had been a popular destination for the Pont-Aven school and Nabi artists, such as Paul Gauguin, Émile Bernard, and Maurice Denis. Academic artists such as Pascal Adolphe Jean Dagnan-Bouveret also painted several works on Breton subjects, such as women and religious services, that were widely praised in Paris. In other words, Kanae's visit to Brittany was a conscious decision based on his familiarity with modern French art.

In Kanae's work, two female bathers relax by the seashore against a backdrop of blue ocean and slanted cliffs. A clothed woman on the left raises her hand, pointing to the right, apparently trying to connect with the two bathers. The cliff in the mid-ground is slightly tilted to add variety and movement to an otherwise balanced composition. Its unique shape is highlighted by the surrounding blue ocean, rather than by explicit, bold black contour outlines as often seen in *ukiyo-e* prints. Kanae may have borrowed this technique from painting manuals in China and Japan, print compendia that translated and transmitted earlier painting practices. On top of the cliff, Kanae used a few lines to suggest the rugged surface. Behind them, the sky is decorated with wavy lines. The landscape consists of three elements: land, water, and sky, which are structured without any sense of depth.

The whole picture does not suggest a specific season of the year or time of day, but the woman's clothing on the left explicitly situates the scene in Brittany. The ambiguous temporality may have been an effort to create a timeless quality, which is further enhanced by Kanae's careful manipulation of coloring. The blanched effect evokes a sense of dreaminess, or a detachment from reality. As Kanae wrote later for the magazine *Atelier* (*Atorie*) in January 1927, he intentionally diluted the pigments to achieve a pastel effect for this work.[1] His handling of color is reminiscent of the French painter Pierre Puvis de Chavannes; indeed, Kanae's work shares many similarities with Puvis's *Young Women by the Sea* [FIG. 124].

In Puvis's work, temporality is also suspended, an effect achieved partly by coloring and partly by lighting. The classicizing three women face different directions, guiding viewers' eyes to imagine beyond the painting. One woman is looking at the ocean, which is structured with rigorous

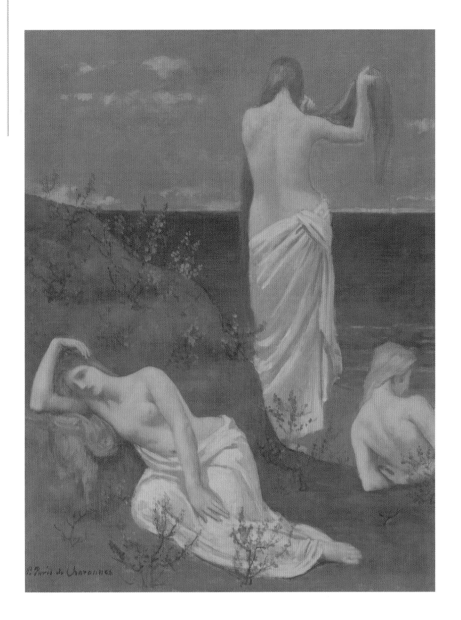

lines rejecting depth. According to Anke Spötter, this work signifies Puvis's effort to combine two traditional motifs: the seaside scene and the female nude, but in an unexpected manner.[2] While Puvis seemingly followed the rules of good composition such as pyramidal organization, he actually shifted one figure to the side, marginalizing and truncating it. The three women turn from one another in expressive gestures, yet Puvis closed off any clue of their purposes. This enigmatic image elicits a sense of estrangement and a mood of melancholy.[3]

Though Kanae was not copying Puvis's work directly, he certainly adopted several of its pictorial elements. Both works incorporate three women who do not interact with each other. Both landscapes constitute three flatly rendered elements—water, land, and sky—and both compositions use high horizon lines. On one hand, these similarities indicate Kanae's embrace of Puvis's art and his professed separation from the *ukiyo-e* tradition. On the other hand, despite its very Western subject matter, Kanae's print reveals his affinity with East Asian art tradition. For instance, the unmodulated coloring of the sea and sky is contrary to Puvis's treatment.

Even before going to France, Kanae had venerated Puvis and Paul Cézanne.[4] In 1913, the year he made *Bathers in Brittany*, Kanae finally saw a collection of Cézanne's works, which he praised in a letter to friends as being classical yet severely beautiful like a gem.[5] Kanae's choice of subject thus may have also been inspired by Cézanne, who explored the theme of bathers throughout his life [FIG. 125].[6] Kanae was certainly familiar with the importance of the bathing theme in the history of Western art, although the subject of nudes was controversial in Japan. In 1889, cultural administrators from the Ministry of the Interior prohibited the display of images of nudes in magazines. In 1901, this ban widened to include images displayed at public exhibitions. For instance, officials from the Fourth Domestic Industrial Exhibition had to cover the lower half of a nude image of a Western woman with a cloth.[7] Although the ban on showing nudes was lifted in 1907 when the national exhibition *Bunten* opened, the cultural authorities still hesitated to put nude paintings on view before the public.[8] This official policy generated a heated debate on the aesthetics of nudity and the notion of beauty among artists and intellectuals.[9] As Alicia Volk argues, "in early twentieth-century Japan the nude had become the most powerful and contested symbol of freedom in the arts."[10] Why did Kanae take up this subject and what was its relationship with the Creative Print Movement? To answer these questions, we must first examine the context of the modern Japanese prints with which Kanae was engaged before coming to France.

In 1904, Kanae published a print titled *Fisherman (Gyofu)* [FIG. 126] in the art journal *Morning Star (Myōjō)*, which marked the beginning of the Creative Print Movement. According to Helen Merritt, Kanae made two printing surfaces by carving on both sides of a single plank of wood. He printed from one side in ocher, which covered the entire picture surface except the water and areas of the towel around the fisherman's head, and printed the other side in black to provide details of the figure and background. Rather than cut away wood from lines in the traditional Japanese manner, he scooped out the unwanted wood, using a Western wood engraving

FIGURE 125
Paul Cézanne, *Three Bathers*, 1876–77, oil on canvas, The Barnes Foundation, BF96

technique.[11] Furthermore, he took charge of the whole process—conceptualizing, carving, and printing—unlike the *ukiyo-e* artists, who transmitted images of their ideas to wood engravers and printers who made the final products. Kanae's good friend Ishii Hakutei, also a renowned artist, called *Fisherman* a "knife picture" (*tōga*) and applauded Kanae's creative use of chisels in a direct and spontaneous way, as painters used their brushes.[12] This work broke with the Japanese woodblock tradition to claim an independent artistic quality for prints.

Artists involved in the Creative Print Movement sought to separate this new type of print, which they denoted with the neologism *hanga* ("printed picture"; "print"), from traditional *ukiyo-e* prints, whose production was supervised by a commercial publisher who coordinated the efforts of a print designer, carver, and publisher.[13] As articulated by Hakutei, creative prints brought out

the original characteristics of Japanese woodblock printing as "impractical, artistic printed pictures," instead of trying to copy original paintings, as the prints in painting manuals did.[14] Creative *hanga* accentuated rather than denied the woodblock medium, and possessed artistic qualities deserving as much attention as oil painting and watercolors.[15] Kanae's learning experience in Paris further deepened this belief. He noted that at the École des Beaux-Arts, students majoring in printmaking were eligible to compete with painting students for the highest award, the Prix de Rome, and argued that Japan should follow the international aesthetic standard to recognize the value of prints.[16]

In addition to its artistic innovation, *Fisherman* can be read as social commentary. Kanae romanticized the image of a fisherman by emphasizing the massive figure bathed in a magnificent sunset, his face half-turned away from the viewer. Here and in other prints, Kanae dignified members of the working class as if they were the true heroes in society, a liberal attitude that engaged with the larger social and political discourses of *jiyū minken* (freedom and people's rights) in the Meiji period. This Western-inspired concept of democracy motivated artists to represent "the people" in society as opposed to the elite class in pre-modern Japan.[17] After *Fisherman*, Kanae continued to represent the underprivileged lower classes. On his way to France, he stopped by Shanghai, where he made the print *Chinese Chicken* (1912), depicting three slightly overweight Chinese prostitutes. Their red, plump lips, bound feet, and exaggerated body shapes elicit sorrow and sympathy, a markedly different reaction from that sought by *ukiyo-e* images of beautiful and graceful women.

After settling down in France, Kanae was so attracted by the artistic atmosphere in Paris that he began exploring the artistic potential of woodblocks in urban themes and dreamlike landscapes. For instance, in *Young Chinese Girl* [FIG. 127], he depicted a stylish figure sitting by the window against the backdrop of bustling Parisian streets. The lines behind her body not only shape her silhouette but also echo the flow of crowds on the street, creating a sense of dynamism. The importance of expressive lines in Kanae's work gradually ceded to the use of color, revealing his growing interest in exploring the boundaries between prints and paintings. *French Pastoral in Spring* shows his free use of both Western art tradition and *ukiyo-e*. He represents the sky by means of a single band of blue, hand-wiped to create downward gradations, which recalls the *ukiyo-e* print technique used in landscapes by Katsushika Hokusai and others [FIG. 128]. Although the lines on the mountain are still vibrant, Kanae increased the relative importance of color to create a painterly surface. In *Bathers in Brittany*, Kanae's choice of theme and his application of Puvis's coloring techniques suggest a conscious effort to align himself with the history of Western art. But Kanae did not simply emulate paintings in his prints; the flat planes of color and the rough surface of the blue ocean explicitly highlight the qualities of woodcut.

French Pastoral in Spring and *Bathers in Brittany* reveal Kanae's explorations in using different techniques to raise prints to the status of fine art. *French Pastoral in Spring* shows Kanae's initial forays, freely adopting elements from *ukiyo-e* and paintings, while *Bathers in Brittany* pays homage to modern Western artists even as it maintains its printed flatness. After he returned to Japan, Kanae created more painterly prints with increasing emphasis on expressive colors, and later devoted himself entirely to the Children's Free Art Movement and the Farmer's Art Movement.[18] Kanae's effort in promoting the Creative Print Movement wrote a new page in the history of modern Japanese art.

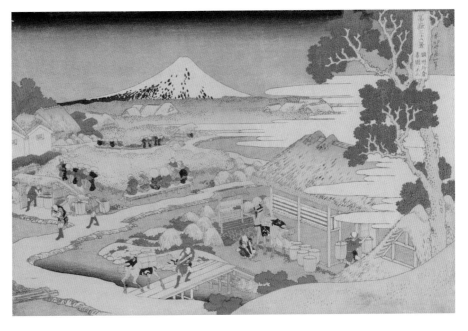

1. Helen Merritt, *Modern Japanese Woodblock Prints: The Early Years* (Honolulu: University of Hawaii Press, 1990), 161.

2. Anke Spötter, "Picasso's Bathers and the History of the Bathing Theme," in *Picasso: Bathers*, exh. cat., ed. Ina Cozen (Stuttgart: Staatsgalerie Stuttgart, 2005), 198.

3. Aimée Brown Price, *Pierre Puvis de Chavannes* (New Haven and London: Yale University Press, 2010), 95.

4. According to his travel journal, Kanae first saw Puvis's original paintings in Lyon in 1913, which further deepened an admiration that began with encountering reproductions of Puvis's work in Japan. He especially liked Puvis's orderly compositions and broad, smooth lines. Shūzō Yamakoshi, ed., *Yamamoto Kanae no tegami* (Ueda: Yamamoto Kanae Kinenkan, 1977 supplement), 4. Cited in Merritt, *Modern Japanese Woodblock Prints*, 299.

5. Merritt, *Modern Japanese Woodblock Prints*, 160.

6. Gottfried Boehm indicates that Cézanne created more than two hundred works on this subject from the end of the 1860s onward. Cézanne's aim was the pictorial relationship between body and nature, meaning that the bodies of the nudes did not allude to nakedness but contributed to the construction of a harmonious pictorial space. Gottfried Boehm, "A Paradise Created by Painting: Observations on Cézanne's Bathers," in *Paul Cézanne: The Bathers*, exh. cat., ed. Mary Louise Krumrine (New York: Harry N. Abrams, 1989), 13.

7. Satō Dōshin, "The Formation of Nude Painting: The 'Naked Body' and the Human Body," in *Modern Japanese Art and the Meiji State: The Politics of Beauty*, trans. Hiroshi Nara (Los Angeles: The Getty Research Institute, 2011), 264.

8. See Alicia Volk, *In Pursuit of Universalism: Yorozu Tetsugorō and Japanese Modern Art* (Berkeley and Los Angeles: University of California Press, 2010), 57–60.

9. For instance, upon seeing Kuroda Seiki's painting of the nude titled *Wisdom, Impression, Sentiment*, the writer Mori Ōgai remarked: "one may also doubt whether it is worthwhile painting nudes merely because Western masters do so." Another artist, Kume Keiichirō, criticized the ban on nude painting in his article, arguing that the nude should be the principal object of painting and sculpture. See Kume Keiichiro, "The Nude Is the Foundation of Fine Art," trans. Susanna Pavloska, *Doshisha Studies in Language and Culture* 11, no. 1 (August 2008): 107–17. Volk, *In Pursuit of Universalism*, 57–58.

10. Volk, *In Pursuit of Universalism*, 61.

11. Merritt, *Modern Japanese Woodblock Prints*, 111.

12. Mi Kawano, "Ha no e kara ega he no hōga: Katanaga 'Gyofu' wo megutte," in *Kindai nihon hanga no shosō*, ed. Shigeru Aoki (Tokyo: Chūō Kōron Bijutsu Shuppan, 1998), 270.

13. The Japanese term for print, *hanga*, was coined and used around 1905 in the magazine *Heitan*. This word is composed of two characters literally meaning "printed pictures." When read together, the sound "hanga" could also mean "half-painting." Before this term was coined, words referring to prints were diverse, but none of them denoted the concept of fine arts. For instance, one old term was *surimono*, meaning "printed thing," used for sheets of text or images with text that were published privately. Other terms included *mokuhan* for general woodblock, *dōban* for copperplate, and *sekihan* for lithograph. Merritt, *Modern Japanese Woodblock Prints*, 115.

14. Quote from Kawano, "Ha no e kara ega he no hōga," 281.

15. Yamamoto Kanae, "Hanga no dokuritsu to nihon no sōsaku hanga" (The Independence of Prints and Japanese Creative Prints), *Bijutsu Shinpo* (Art News) 2, no. 1 (1919): 118. Kawano, "Ha no e kara ega he no hōga," 282, and Tadashige Ono, *Kindai nihon no hanga* (Tokyo: Sansaisha, 1971), 11.

16. Yamamoto Kanae, "Hanga no dokuritsu to nihon no sōsaku hanga," 117.

17. Douglas R. Howland, *Translating the West: Language and Political Reason in Nineteenth-Century Japan* (Honolulu: University of Hawaii Press, 2002), 153–70.

18. On his way back to Japan in 1916, Kanae stopped by Moscow, just prior to the February Revolution. A friend there introduced him to proletarian literature and the arts of children and farmers. Imbued with humanitarian ideals, Kanae determined to promote the children's and farmers' art in Japan, which consumed his energy for years. See Merritt, *Modern Japanese Woodblock Prints*, 165–77.

EUROPE

1457 Woodcut initials in the Mainz Psalter are printed in red, which continues to be the most common ink used (besides black) in early examples of color woodcut printing.

1508 Invention, in Augsburg, of chiaroscuro (Italian for "light-dark") prints in two or three colors, each printed from a separate woodblock. The method rapidly spreads to Italy and gains popularity there.

1688 Dutch artist Johannes Teyler is granted a patent for a multi-color etching process that allows the printing of several colors applied to a single copperplate (the *à la poupée* method; see fig. 65).

CAT. 15

EAST ASIA

1341 The *Diamond Sutra* is printed in red and black ink (likely using a single impression from a single woodblock) in Yuan-dynasty China.

1606 In Ming-dynasty China, Ding Yunpeng's book *Ink Garden of the Cheng Family (Cheng shi mo yuan)* features *à la poupée* printed color.

1616 The *taoban* multi-block printing technique is employed in China using a special printing table.

1620–1644 Deluxe color-printed illustrated books appear in China, likely arriving in Japan by the 1680s.

1640 The Chinese publisher Min Qiji of Wuchang, Zhejiang province, releases an edition of *The Romance of the Western Chamber (Xixiang ji)* with color woodblock-printed illustrations (see fig. 7).

EUROPE

1720s German artist J. C. Le Blon invents a four-color process that superposes black, blue, red, and yellow inks from separate mezzotint plates, yielding full-spectrum color reproductions of paintings.

1729 In examples like the *Recueil Crozat* (see fig. 35), relief and intaglio methods begin to be used together, with woodcut tone-blocks supplying color to an etched design.

1760s–1770s Colored inks are incorporated into mezzotint, stipple engraving, and aquatint printing techniques.

1798 Bavarian artist Alois Senefelder invents lithography; different colors are soon printed from separate lithographic stones.

1818 Alois Senefelder announces plans for chromolithography in *A Complete Course of Lithography.*

1837 Godefroy Engelmann, in France, patents his chromolithographic process.

1850s–60s *Ukiyo-e* prints begin to circulate among French artists, collectors, and critics.

1880s–90s Lithographic posters flourish, encouraging bold experimentation in all forms of color printing.

1899 Society of French Artists officially overturns its previous statute banning color prints from the Salon.

EAST ASIA

1740s The first Japanese color prints: in *benizuri-e* (pink-printed pictures), *beni* (rose-red) and green are applied using multiple wood blocks; occasionally yellow and blue are added in small areas.

1765–66 Production of *egoyomi* (pictorial calendars) leads to an effective method for registering inks in separate printings, allowing color to be applied evenly across the entire surface of the print.

CAT. 107

1820s–30s Imported Berlin blue (*bero*) becomes available to *ukiyo-e* printmakers in Japan.

1860 Prussian diplomatic mission brings a lithographic press to Japan.

1860s Woodblock prints use bright aniline dyes recently imported from the West; these affordable synthetic dyes continue to be used in color woodblock prints during the 1870s and 1880s.

1882 Images of ancient temple treasures, published by the government printing bureau, are among Japan's first chromolithographs.

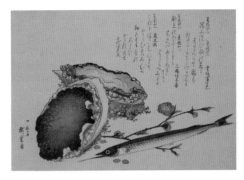

CAT. 41

CAT. 104

EUROPE

Early 1900s Color woodcut enjoys a revival, in part inspired by Paul Gauguin's and Edvard Munch's prints of the 1890s.

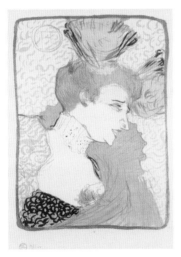

CAT. 48

EAST ASIA

1900 Color lithography becomes prominent in postcard production, after the latter is privatized by the Japanese government.

1904 The Creative Print (*sōsaku hanga*) Movement is born with the publication of Yamamoto Kanae's *Fisherman* (see fig. 126). In 1907, Ishii Hakutei, Yamamoto Kanae, and Morita Tsunetomo found *Hōsun*, a journal of the creative print.

1915–16 The publisher Watanabe Shōsaburō formally establishes the New Print (*shin hanga*) Movement, revitalizing interest in Edo-period woodblock prints.

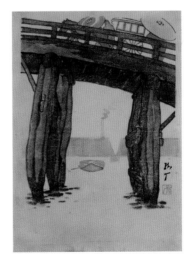

CAT. 92

Height precedes width in all measurements unless otherwise indicated.

French Prints

1

Anne Allen
English, active 1790s
After Jean Baptiste Pillement (French,
1728–1808)
Nouvelle suite de cahiers chinois no. 2, c. 1796–98
Five color etchings (printed *à la poupée* from two
copperplates)
7⅝ x 5½ in. (19.4 x 14 cm), plate; 10⅛ x 9⅛ in.
(25.7 x 23.2 cm), sheet (each, approx.)
Smart Museum of Art, Paul and Miriam Kirkley
Fund for Acquisitions, 2010.113a–e
Figs. 37, 64, 71

2

George Auriol
French, 1863–1938
Program for Le Théâtre Libre, 1889
Five-color lithograph
8½ x 12³⁄₁₆ in. (21.7 x 31 cm), image;
8⅞ x 12⅝ in. (22.7 x 32 cm), sheet
Spencer Museum of Art, Gift from the Virginia
and Ira Jackson Collection, Houston, 2004.0068
Fig. 114

3

Émile Bernard
French, 1868–1941
*Breton Women Hanging Their Wash (Bretonnes
étendant leur linge)*, 1886
Woodblock print with color stenciling
4⅛ x 15½ in. (10.6 x 39.3 cm), block;
14¹⁵⁄₁₆ x 22⁵⁄₁₆ in. (38 x 56.7 cm), sheet
Spencer Museum of Art, Museum purchase:
Letha Churchill Walker Memorial Art Fund,
1978.0089
Fig. 44

4

Émile Bernard
The Virgin with Saints (La vierge aux saintes), 1895
Hand-colored zincograph
17⁵⁄₁₆ x 11⅞ in. (44 x 30.1 cm), image;
24³⁄₁₆ x 16¼ in. (61.5 x 41.3 cm), sheet
Spencer Museum of Art, Museum purchase:
R. Charles and Mary Margaret Clevenger Fund,
1994.0031
Fig. 42

5

Pierre Bonnard
French, 1867–1947
Boating (Le canotage), 1897
Color lithograph on chine volant
10½ x 18½ in. (26.6 x 47.1 cm), image;
16⅞ x 22⅜ in. (42.9 x 56.8 cm), sheet
Smart Museum of Art, Paul and Miriam Kirkley
Fund for Acquisitions, 2007.130
Fig. 110

6

Félix Bracquemond
French, 1833–1914
*At the Zoological Gardens (Au Jardin
d'Acclimatation)*, 1873
Color etching and aquatint
8¹¹⁄₁₆ x 8⁹⁄₁₆ in. (22 x 21.7 cm), plate;
12½ x 10³⁄₁₆ in. (31.8 x 25.8 cm), sheet
Museum of Fine Arts, Boston, Frederick Keppel
Memorial, Gift of David Keppel, 13.5094
Fig. 55

7

Félix Bracquemond
Portrait of Edmond de Goncourt, 1882
Etching on heavy Japan paper
18 3/16 x 12 9/16 in. (46.2 x 31.9 cm), plate
Smart Museum of Art, Paul and Miriam Kirkley
Fund for Acquisitions, 2010.114
Fig. 57

8

Anne-Claude-Philippe, comte de Caylus, and
Nicolas Le Sueur
French, 1692–1765 and 1691–1764
After Giovanni Bonatti (Italian, c. 1635–1681)
Abbot Saint Restores a Blind Man's Sight, 1729–42
Etching and chiaroscuro woodcut
12 3/8 x 6 3/8 in. (31.4 x 16.2 cm), plate
Smart Museum of Art, University Transfer from
Max Epstein Archive, Gift of Max Epstein
1976.145.288
Fig. 35

CAT. 9

9

Alexandre-Louis-Marie Charpentier
French, 1856–1909
Mural Decoration for a Bathroom, 1898
Color lithograph with embossing
8 13/16 x 6 1/2 in. (22.4 x 16.6 cm), image;
11 7/16 x 8 1/16 in. (29.1 x 20.4 cm), sheet
Spencer Museum of Art, Gift from the Virginia
and Ira Jackson Collection, Houston, 2004.0071

10

François-Philippe Charpentier
French, 1734–1817
After Giovanni Bonatti (Italian, c. 1635–1681)
Abbot Saint Restores a Blind Man's Sight, 1763
Etching and aquatint
15 1/2 x 9 1/8 in. (39.4 x 23.2 cm)
Smart Museum of Art, University Transfer from
Max Epstein Archive, 1976.145.287
Fig. 36

11

Jules Chéret
French, 1836–1932
Casino de Paris, 1891
Color lithograph
31 1/4 x 22 7/16 in. (79.4 x 57 cm), image/sheet
Boston Public Library
Figs. 46, 109

12

Henri Edmond Cross
French, 1856–1910
Champs Élysées, 1898
Color lithograph
8 x 10 5/16 in. (20.3 x 26.2 cm), image;
10 5/8 x 14 1/4 in. (27 x 36.2 cm), sheet
Spencer Museum of Art, Museum purchase:
Helen Foresman Spencer Art Acquisition Fund,
1992.0120

13

Philibert Louis Debucourt
French, 1755–1832
*The Ascent, or The Morning Farewell (L'escalade,
ou les adieux du matin)*, 1787
Color aquatint
11 15/16 x 9 3/4 in. (30.4 x 24.8 cm), image;
13 5/8 x 9 15/16 in. (34.6 x 25.3 cm), sheet
National Gallery of Art, Washington, Widener
Collection, 1942.9.2258
Fig. 74

14

Philibert Louis Debucourt
La noce au château, 1789
Color aquatint and etching
11 13/16 x 8 7/8 in. (30 x 22.6 cm), image;
17 11/16 x 13 5/16 in. (45 x 33.8 cm), sheet
National Gallery of Art, Washington, Widener
Collection, 1942.9.2262

173

15

Charles-Melchior Descourtis
French, 1753–1820
After Caspar Wolf (Swiss, 1735–1783)
Chute de la Tritt dans la vallée de Muhlethal, 1776
Etching and wash manner printed in color
17 3/8 x 12 11/16 in. (44.2 x 32.2 cm), plate;
18 15/16 x 13 7/16 in. (48.1 x 34.1 cm), sheet
National Gallery of Art, Washington, Phillips
Family Fund, 2006.96.1
Illustrated on p. 169

16

Charles-Melchior Descourtis
After Jean-Frédéric Schall (French, 1752–1825)
The Shipwreck, plate 5 from *Paul and Virginia*, 1788
Intaglio color print
16 9/16 x 18 7/16 in. (42 x 46.8 cm), plate;
16 3/4 x 19 7/16 in. (42.6 x 49.3 cm), sheet
Museum of Fine Arts, Boston, Gift of Sylvester
Rosa Koehler, K210
Fig. 73

17

Georges-Olivier Desvallières
French, 1861–1950
Vase Bearer (Porteur d'amphore), 1898
Color lithograph
15 x 9 3/4 in. (38.1 x 24.8 cm), image;
16 x 12 1/8 in. (40.6 x 30.8 cm), sheet
Smart Museum of Art, Paul and Miriam Kirkley
Fund for Acquisitions, 2011.10
Fig. 54

18

Th. Dupuy
Chromolithographic show card displayed at the
Exposition Universelle of 1867
13 x 10 7/16 in. (33 x 26.5 cm), image;
19 5/8 x 13 in. (50 x 33 cm), sheet
National Museum of American History,
Smithsonian Institution, GA 01226
Fig. 108

19

Georges de Feure
French, 1868–1943
Evil Spring (La Source du Mal), 1894
Color lithograph on wove paper
13 3/4 x 10 in. (34.9 x 25.4 cm), image;
24 x 16 1/4 in. (61 x 41.3 cm), sheet
Smart Museum of Art, Paul and Miriam Kirkley
Fund for Acquisitions, 2011.108
Fig. 51

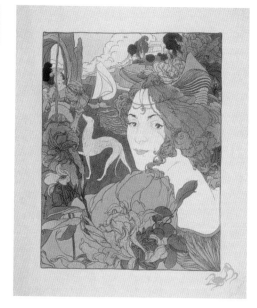

CAT. 20

20

Georges de Feure
Retour, 1897
Color lithograph
12 7/8 x 10 1/16 in. (32.7 x 25.5 cm), image;
21 1/8 x 15 7/8 in. (53.7 x 40.3 cm), sheet
Spencer Museum of Art, Gift of Pamela D.
Kingsbury in memory of Virginia Hartle Jackson,
2008.0312

21

Unknown artist
Printed by Gangel (French, 1756–1836)
The Prodigal Son, n.d.
Hand-colored woodblock print on thin wove
China paper
12 1/2 x 17 3/8 in. (31.8 x 44.1 cm), image;
16 1/8 x 25 5/8 in. (40.9 x 65 cm), sheet
The Art Institute of Chicago, Gift of the Print
and Drawing Club, 1953.1
Fig. 43

22

Charles Huard
French, 1874–1965
Anglers (Pêcheurs à la ligne), 1898
Color lithograph
8 5/8 x 12 5/8 in. (21.9 x 32.1 cm), image;
12 1/8 x 15 7/8 in. (30.8 x 40.3 cm), sheet
Smart Museum of Art, Paul and Miriam Kirkley
Fund for Acquisitions, 2011.9
Fig. 59

23

Henri-Gabriel Ibels
French, 1867–1936
At the Shore (Sur la plage), Program for Le Théâtre Libre, 1892
Color lithograph, proof before letters
11 7/16 x 15 15/16 in. (29 x 40.5 cm), sheet
Museum of Fine Arts, Boston, Lee M. Friedman Fund, 1981.452
Fig. 115

24

Jean-François Janinet
French, 1752–1814
After Adriaen van Ostade (Dutch, 1610–1684)
Le Nouvéliste, n.d.
Intaglio color print
10 7/16 x 8 9/16 in. (26.5 x 21.8 cm), plate/sheet
Museum of Fine Arts, Boston, Bequest of William Perkins Babcock, B4124

25

Jean-François Janinet
After Adriaen van Ostade
Le Nouvéliste, n.d.
Intaglio color print, trial proof, printed without yellow plate
9 5/8 x 8 in. (24.4 x 20.3 cm), image/sheet
Museum of Fine Arts, Boston, Gift of Sylvester Rosa Koehler, K184

26

Gaston de Latenay
French, 1859–1940
Huntresses, 1896
Color lithograph
18 1/4 x 13 in. (46.4 x 33 cm), image;
25 1/4 x 19 1/2 in. (64.1 x 49.5 cm), sheet
Smart Museum of Art, Paul and Miriam Kirkley Fund for Acquisitions, 2011.6

27

Gaston de Latenay
The Park (Le parc), 1897
Color lithograph
9 3/4 x 13 in. (24.8 x 33 cm), image;
12 x 16 in. (30.5 x 40.6 cm), sheet
Smart Museum of Art, Paul and Miriam Kirkley Fund for Acquisitions, 2011.7
Fig. 52

28

Louis Le Coeur and J.-F.-J. Swebach-Desfontaines
French, active c. 1784–1825 and 1769–1823
Bal de la Bastille, 1790
Etching and wash manner, printed in blue, red, and black inks
15 13/16 x 12 9/16 in. (40.2 x 31.9 cm), plate;
20 1/2 x 15 1/4 in. (52 x 38.8 cm), sheet
National Gallery of Art, Washington, Gift of Ivan E. and Winifred Phillips in memory of Neil Phillips, 1999.77.1

29

Auguste Lepère
French, 1849–1918
Convalescente, 1892
Color woodblock print
16 x 11 3/4 in. (40.8 x 29.8 cm), image;
21 11/16 x 14 1/4 in. (55.2 x 36 cm), sheet
Boston Public Library
Fig. 62

30

Auguste Lepère
The Breaking Waves, September Tide (Les lames déferlent, marée de septembre), 1901
Color woodblock print
11 x 15 9/16 in. (28 x 39.6 cm), image;
12 1/2 x 17 5/8 in. (31.9 x 44.9 cm), sheet
Boston Public Library
Fig. 63

31

Maximilien Luce
French, 1858–1941
Le Mee, 1897
Color lithograph with remarque on chine collé mounted on heavy wove paper
11 x 14 7/16 in. (28.2 x 36.8 cm), image without remarque; 19 3/4 x 25 9/16 in. (50.2 x 64.9 cm), sheet
Smart Museum of Art, Gift of the Estate of Philene Frevert, 1984.106

32

Édouard Manet
French, 1832–1883
Punch (Polichinelle), 1874
Color lithograph
21 x 13 3/4 in. (53.2 x 35 cm), sheet
National Museum of American History, Smithsonian Institution
Fig. 58

33

Luc Olivier Merson
French, 1846–1920
Salome, 1897
Color lithograph
13 ¾ x 7 ⅝ in. (34.9 x 19.4 cm), image;
15 ⅞ x 12 in. (40.3 x 30.5 cm), sheet
Smart Museum of Art, Paul and Miriam Kirkley
Fund for Acquisitions, 2011.8
Fig. 53

34

Paul Elie Ranson
French, 1862–1909
Tiger in the Jungle, 1893
Color lithograph
14 ⅜ x 11 ⅛ in. (36.5 x 28.3 cm), image
Smart Museum of Art, Bequest of Ruth
Philbrick, 2010.13
Fig. 113

35

After Pierre-Joseph Redouté
French, born in Flanders, 1759–1840
Anemone simple, from *Choix des plus belles fleurs
et des plus beaux fruits*, 1827
Color stipple engraving, finished by hand
10 ½ x 8 ½ in. (27.7 x 21.6 cm), plate
Minneapolis Institute of Arts, The Minnich
Collection, The Ethel Morrison Van Derlip Fund,
1966, P.18,347
Fig. 116

36

After Pierre-Joseph Redouté
Hortensia, from *Choix des plus belles fleurs et des
plus beaux fruits*, 1827
Color stipple engraving, finished by hand
10 ¾ x 8 ½ in. (27.3 x 21.6 cm), plate
Minneapolis Institute of Arts, The Minnich
Collection, The Ethel Morrison Van Derlip Fund,
1966, P.18,341

37

After Pierre-Joseph Redouté
Lychnide à grandes fleurs, from *Choix des plus
belles fleurs et des plus beaux fruits*, 1827
Color stipple engraving, finished by hand
11 x 8 ½ in. (27.9 x 21.6 cm), plate
Minneapolis Institute of Arts, The Minnich
Collection, The Ethel Morrison Van Derlip Fund,
1966, P.18,348

38

Henri Rivière
French, 1864–1951
Vegetable Garden at Ville-Hue (Saint-Briac), 1890
From the *Breton Landscapes*
Color woodblock print printed from eight blocks
on eighteenth-century Japanese laid paper
9 x 13 ¾ in. (22.9 x 34.9 cm), block;
13 3/16 x 19 9/16 in. (33.5 x 49.7 cm), sheet
Smart Museum of Art, Paul and Miriam Kirkley
Fund for Acquisitions, 2006.12
Fig. 49

39

Henri Rivière
*Lobster Boat at the Mouth of the Trieux River
(Loguivy)*, 1891
From the *Breton Landscapes*
Color woodblock print printed from nine blocks
on eighteenth-century Japanese laid paper
8 ¾ x 13 9/16 in. (22.2 x 34.5 cm), block;
13 11/16 x 20 ½ in. (34.8 x 52.1 cm), sheet
Smart Museum of Art, Paul and Miriam Kirkley
Fund for Acquisitions, 2006.11
Fig. 47

40

Henri Rivière
The Village of Perros-Guirec, 1891
From the *Breton Landscapes*
Color woodblock print printed from nine blocks
on eighteenth-century Japanese laid paper
8 ¾ x 13 9/16 in. (22.2 x 34.5 cm), block;
13 11/16 x 20 ½ in. (34.8 x 52.1 cm), sheet
Smart Museum of Art, Paul and Miriam Kirkley
Fund for Acquisitions, 2006.13
Fig. 48

41

Henri Rivière
*Small Wave Rising, Pointe de la Haye (Petite vague
montante, pointe de la Haye) (L'écume après la
vague)*, 1892
Color woodblock print
8 ⅞ x 13 9/16 in. (22.5 x 34.5 cm), image;
13 ⅝ x 20 ½ in. (34.7 x 52 cm), sheet
Spencer Museum of Art, Museum purchase:
Letha Churchill Walker Memorial Art Fund,
1988.0001
Illustrated on p. 171

42

Henri Rivière
The First Quarter [of the Moon], from La féerie des heures, 1901
Color lithograph
23 ½ x 9 ½ in. (59.8 x 24.1 cm), image;
25 ½ x 12 ³⁄₁₆ in. (64.8 x 31 cm), sheet
Spencer Museum of Art, Gift of Pamela D. Kingsbury, 2009.0135
Fig. 60

43

Paul Signac
French, 1863–1935
Boats (Les bateaux), 1897–98
Color lithograph on cream wove paper
9 ¼ x 15 ¹¹⁄₁₆ in. (23.5 x 39.8 cm), image;
15 ¹⁵⁄₁₆ x 20 ⅞ in. (40.5 x 53 cm), sheet
Museum of Fine Arts, Boston, Anonymous gift, 54.721
Fig. 39

44

Paul Signac
Boats (Les bateaux), 1897–98
Color lithograph on cream wove paper, trial proof, annotated in graphite by Signac, printed by Auguste Clot
15 x 21 ⁹⁄₁₆ in. (38.1 x 54.8 cm), sheet
Museum of Fine Arts, Boston, Gift of Peter A. Wick, 55.576
Fig. 41

45

Paul Signac
Boats (Les bateaux), 1897–98
Color lithograph, trial proof, color separation with yellow and pink stones only
12 ⅜ x 18 ³⁄₁₆ in. (31.4 x 46.2 cm), sheet
Museum of Fine Arts, Boston, Gift of Mr. and Mrs. Peter A. Wick, 57.773
Fig. 40

46

Henri de Toulouse-Lautrec
French, 1864–1901
Divan Japonais, 1892–93
Color lithograph
31 ¾ x 23 ½ in. (80.7 x 59.7 cm)
Smart Museum of Art, Bequest of Louise H. Landau, 2003.69
Fig. 112

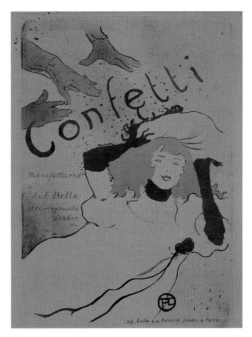

CAT. 47

47

Henri de Toulouse-Lautrec
Confetti, 1894
Color lithograph
22 ⅝ x 17 ¾ in. (57.5 x 45.1 cm), sheet
Smart Museum of Art, Bequest of Louise H. Landau, 2003.70

48

Henri de Toulouse-Lautrec
Mademoiselle Marcelle Lender en buste, 1895
Color lithograph
12 ¾ x 9 ½ in. (32.5 x 24.1 cm), image;
21 ½ x 15 ¹⁄₁₆ in. (54.7 x 38.3 cm), sheet
Spencer Museum of Art, Museum purchase: Elizabeth M. Watkins Fund, 1954.0113
Illustrated on p. 171

49

After Horace Vernet
French, 1789–1863
Aventure des Bosquets dans le Parc de Fontainebleau, #2 from The Life of Mlle de la Vallière, c. 1820
Intaglio color print
11 ¹⁄₁₆ x 15 ⁵⁄₁₆ in. (28 x 38.8 cm), plate;
14 ⁷⁄₁₆ x 17 ⅜ in. (36.6 x 44.2 cm), sheet
Smart Museum of Art, University Transfer from Max Epstein Archive, Gift of Mrs. C. Phillip Miller, 1963, 1967.116.160b
Fig. 56

50
Édouard Vuillard
French, 1868–1940
Interior with Pink Wallpaper II, 1899
From *Landscapes and Interiors (Paysages et intérieurs)*
Color lithograph
13 ¾ x 10 ¾ in. (34.5 x 27.5 cm), image;
15 ⁵⁄₁₆ x 12 ³⁄₁₆ in. (39 x 31 cm), sheet
Boston Public Library
Fig. 92

American Prints

51
Mary Cassatt
American, 1844–1926
The Letter, 1890/91
Color drypoint and aquatint, from three plates, on off-white laid paper
13 ⁵⁄₈ x 8 ⁵⁄₁₆ in. (34.5 x 21.1 cm), plate;
17 ¼ x 11 ¹¹⁄₁₆ in. (43.7 x 29.7 cm), sheet
The Art Institute of Chicago, Mr. and Mrs. Martin A. Ryerson Collection, 1932.1282
Fig. 99

52
Mary Cassatt
Woman Bathing, 1890/91
Color drypoint and aquatint
14 ³⁄₈ x 10 ½ in. (36.5 x 26.6 cm), plate;
18 ⁷⁄₈ x 12 ⁵⁄₁₆ in. (47.9 x 31.2 cm), sheet
National Gallery of Art, Washington, Gift of Mrs. Lessing J. Rosenwald, 1989.28.5
Fig. 38

53
Mary Cassatt
Feeding the Ducks, c. 1895
Drypoint and aquatint with monotype inking, in color on cream laid paper
11 ¹¹⁄₁₆ x 15 ½ in. (29.7 x 39.5 cm), plate;
15 ¼ x 19 ½ in. (38.6 x 49.5 cm), sheet
The Art Institute of Chicago, Gift of Laura May Ripley, 1992.159
Fig. 50

54
Arthur Wesley Dow
American, 1857–1922
Ipswich Bridge/The Old Bridge, c. 1893–95
Color woodblock print
4 ¾ x 2 ⅛ in. (12 x 5.5 cm), image;
5 ⁷⁄₈ x 3 ¼ in. (15 x 8.3 cm), sheet
Spencer Museum of Art, Museum purchase: Helen Foresman Spencer Art Acquisition Fund, 1999.0207
Fig. 118

55
Arthur Wesley Dow
Ipswich Bridge/The Old Bridge, c. 1893–95
Color woodblock print
4 ¾ x 2 ⅛ in. (12.1 x 5.5 cm), image;
5 ⁷⁄₈ x 3 ¼ in. (15 x 8.2 cm), sheet
Spencer Museum of Art, Museum purchase: Helen Foresman Spencer Art Acquisition Fund, 1999.0208
Fig. 119

56
Arthur Wesley Dow
Ipswich Bridge/The Old Bridge, c. 1893–95
Color woodblock print
4 ¾ x 2 ⅛ in. (12.1 x 5.5 cm), image;
5 ¾ x 3 ⅜ in. (14.7 x 8.5 cm), sheet
Spencer Museum of Art, Museum purchase: Helen Foresman Spencer Art Acquisition Fund, 1999.0209
Figs. 91, 120

57
Arthur Wesley Dow
Ipswich Bridge/The Old Bridge, c. 1893–95
Color woodblock print
4 ¾ x 2 ⅛ in. (12 x 5.5 cm), image;
5 ⁷⁄₈ x 3 ¼ in. (15 x 8.3 cm), sheet
Spencer Museum of Art, Museum purchase: Helen Foresman Spencer Art Acquisition Fund, 1999.0210
Fig. 121

58
Helen Hyde
American, 1868–1919
Going to the Fair, 1910
Color woodblock print
7 ¾ x 19 in. (19.7 x 48.3 cm), block;
10 ⁹⁄₁₆ x 22 in. (26.8 x 55.9 cm), sheet
Smart Museum of Art, Gift of Brenda F. and Joseph V. Smith, 2004.142
Fig. 117

Japanese Prints

59

Hasegawa Sadanobu II
Japanese, 1848–1940
A Record of Saigō in Kagoshima, 1877 (Meiji jūnen Kagoshima Saigō ki)
Color woodblock print
9 ¹³/₁₆ x 7 ½ in. (24.9 x 19.1 cm)
Brooklyn Museum, Brooklyn Museum
Collection, X864.4
Fig. 24

60

Hishikawa Moronobu, #7 from A Comparison of Beauties by Famous Masters of the Past (Chūko shomeika bijin kurabe), 1887
Color woodblock print
9 x 6 ¾ in. (22.9 x 17.2 cm), image;
10 ¾ x 8 ¼ in. (27.3 x 21.1 cm), sheet
Publisher: Aoki Tsunesaburō
Spencer Museum of Art, 2002.0099

61

Iwasa Katsushige, #4 from A Comparison of Beauties by Famous Masters of the Past (Chūko shomeika bijin kurabe), 1887
Color woodblock print
9 ³/₁₆ x 6 ⅞ in. (23.4 x 17.4 cm), image;
10 ¾ x 8 ⅜ in. (27.3 x 21.2 cm), sheet
Publisher: Aoki Tsunesaburō
Spencer Museum of Art, 2002.0096
Fig. 27

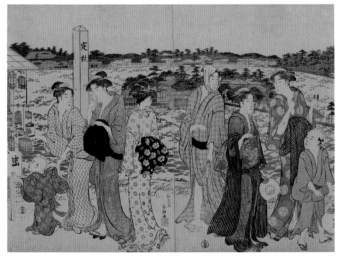

CAT. 63

62

Katsukawa Shun'ei
Japanese, 1762–1819
The Actor Ichikawa Komazō III before a Bamboo Blind, late 1780s
Color woodblock print
12 ⁹/₁₆ x 5 ¾ in. (31.9 x 14.6 cm), sheet
Smart Museum of Art, University Transfer
from Max Epstein Archive, Gift of Harold Swift,
1967.116.157

63

Katsukawa Shunchō
Japanese, active c. 1780–1801
Enjoying the Cool off Shinobazu Pond, n.d.
Color woodblock print, diptych
14 ⅜ x 9 ⅝ in. (36.1 x 24.5 cm), each
Collection of Mr. and Mrs. Harlow Niles
Higinbotham

64

Katsukawa Shunchō
Figures Caught in a Sudden Shower, n.d.
Color woodblock print, triptych
15 x 10 in. (37.9 x 25.5 cm), each
Collection of Mr. and Mrs. Harlow Niles
Higinbotham

65

Katsushika Hokusai
Japanese, 1760–1849
Fuji from beneath Mannen Bridge at Fukagawa (Fukagawa mannen bashi shita), early 1830s
From the *Thirty-six Views of Mt. Fuji*
Color woodblock print
10 ⅛ x 14 ¹³/₁₆ in. (25.7 x 37.7 cm), image/sheet
Spencer Museum of Art, 0000.2903
Fig. 13

66

Katsushika Hokusai
Fuji from the Tea Plantation of Katakura in Suruga Province (Sunshū Katakura chaen no Fuji),
early 1830s
From the *Thirty-six Views of Mt. Fuji*
Color woodblock print
9 ⅞ x 14 ¾ in. (25.1 x 37.5 cm), sheet
Smart Museum of Art, Gift of Mr. and Mrs.
Gaylord Donnelley, from the Frances Gaylord
Smith Collection, 1972.13
Fig. 128

67

Katsushika Hokusai
Mishima Pass in Kai Province (Kōshū Mishima-goe), early 1830s
From the *Thirty-six Views of Mt. Fuji*
Color woodblock print
9 ⁷⁄₈ x 14 ¹³⁄₁₆ in. (25.1 x 37.6 cm), sheet
Smart Museum of Art, Gift of Mr. and Mrs.
Gaylord Donnelley, from the Frances Gaylord
Smith Collection, 1972.12
Fig. 12

68

Katsushika Hokusai
Hydrangea and Swallow, c. 1833–34
Color woodblock print
10 ¼ x 15 in. (26.1 x 38.5 cm)
The Art Institute of Chicago, Clarence
Buckingham Collection, 1925.3376
Fig. 4

69

Katsushika Hokusai
Morning Glories and Tree Frog, c. 1833–34
Color woodblock print
10 ⁷⁄₁₆ x 14 ⁵⁄₈ in. (26.4 x 37.2 cm)
The Art Institute of Chicago, Clarence
Buckingham Collection, 1925.3369
Fig. 3

70

Katsushika Hokusai
Poppies, c. 1833–34
Color woodblock print
10 x 14 ³⁄₈ in. (25.4 x 36.5 cm)
The Art Institute of Chicago, Clarence
Buckingham Collection, 1925.3372
Fig. 2

71

Katsushika Hokusai
Sangi Takamura, Abalone Divers
From the *One Hundred Poems by One Hundred
Poets as Explained by the Wet Nurse (Hyakunin
isshu uba ga etoki)*, 1835–36
Color woodblock print
14 ¹³⁄₁₆ x 10 ¼ in. (37.5 x 25.9 cm)
Collection of Mr. and Mrs. Harlow Niles
Higinbotham

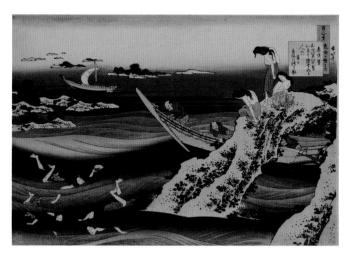

CAT. 71

72

Kawanabe Kyōsai
Japanese, 1831–1889
Hell Courtesan (Jigoku Tayū), #9 from *Kyosai's
Drawings for Pleasure (Kyōsai raku ga)*, 1874
Color woodblock print
13 ³⁄₁₆ x 8 ⁷⁄₈ in. (33.5 x 22.7 cm), image;
14 x 9 ½ in. (35.5 x 24.1 cm), sheet
Spencer Museum of Art, Lucy Shaw Schultz
Fund, 2001.0012

73

Kitagawa Utamaro
Japanese, 1753?–1806
Mosquito-net (Kaya), c. 1794–95
From the *Model Young Women Woven in Mist
(Kasumi-ori musume hinagata)*
Color woodblock print
15 ¼ x 10 in. (38.6 x 25.5 cm)
The Art Institute of Chicago, Clarence
Buckingham Collection, 1930.412
Fig. 1

74

Kitagawa Utamaro
*Taking Shelter from a Sudden Summer Shower
under a Huge Tree*, early 1790s
Color woodblock print, triptych
14 ⁷⁄₈ x 10 in. (37.8 x 25.4 cm), each
Smart Museum of Art, Gift of Mr. and Mrs.
Gaylord Donnelley, from the Frances Gaylord
Smith Collection, 1972.14
Fig. 93

75

Kobayashi Kiyochika
Japanese, 1847–1915
Pomegranates and Grapes, c. 1879–81
Color woodblock print
9 ³⁄₈ x 13 ¹³⁄₁₆ in. (23.8 x 35.1 cm), image;
9 ⁷⁄₁₆ x 14 in. (24 x 35.5 cm), sheet
The Minneapolis Institute of Arts, Gift of Louis
W. Hill, Jr., P.70.158
Fig. 25

76

Kobayashi Kiyochika
*Departure of the Warrior Kusunoki Masashige at
Sakurai Station (Nankō Sakurai eki ketsubetsu
no zu)*, c. 1880–99
Color woodblock print
11 ½ x 16 ¾ in. (29.2 x 42.6 cm), image;
11 ⁵⁄₈ x 16 ¹⁵⁄₁₆ in. (29.5 x 43 cm), sheet
Publisher: Daikokuya (Matsuki Heikichi)
The Minneapolis Institute of Arts, Bequest
of Louis W. Hill, Jr., 96.146.120
Fig. 26

77

Miyagawa Shuntei
Japanese, 1873–1914
Origami (Paper folding), 1896
From *Children's Pastimes (Kodomo fūzoku)*
Color woodblock print
12 x 8 ¼ in. (30.5 x 21.1 cm), image;
14 ⁵⁄₈ x 9 ⁷⁄₈ in. (37.1 x 25.1 cm), sheet
Spencer Museum of Art, William Bridges Thayer
Memorial, 0000.1639
Fig. 31

78

Ochiai Yoshiiku
Japanese, 1833–1904
*Night Parade of One Hundred Demons at Sōma
Palace (Sōma dairi hyakki yagyō zu)*, 1893
Color woodblock print, triptych
13 ¾ x 9 ¼ in. (35 x 23.5 cm), image/sheet (each)
Publisher: Fukuda Kumajirō
Spencer Museum of Art, 1983.0115
Fig. 21

79

Okumura Masanobu
Japanese, 1686–1764
*Daikoku and Ebisu Performing a Manzai Dance
at New Year*, late 1710s
Hand-colored woodblock print
22 x 12 ³⁄₈ in. (56 x 31.4 cm)
Collection of Mr. and Mrs. Harlow Niles
Higinbotham
Fig. 78

80

Okumura Masanobu
*Entertainment of "Buying and Selling" at the Ebisu
Festival in the Tenth Month (Jūgatsu Ebisu kō uri
kai no tei)*, 1720s
Hand-colored woodblock print
11 ⁵⁄₁₆ x 15 ³⁄₁₆ in. (28.5 x 38.5 cm)
Collection of Mr. and Mrs. Harlow Niles
Higinbotham
Fig. 79

81

Okumura Masanobu
*Large Perspective Picture of a Second-Floor Parlor
in the New Yoshiwara (Shin Yoshiwara nikai zashiki
dote o mitōsu ōukie)*, late 1730s
Hand-colored woodblock print
16 ½ x 25 ⁷⁄₈ in. (41.9 x 65.6 cm)
Publisher: Okumuraya Genroku
The Mann Collection, Highland Park, IL
Fig. 81

82

Okumura Masanobu
*A Floating World Monkey Trainer on the Sumida
River (Sumidagawa ukiyo saru mawashi)*, late
1740s–early 1750s
Color woodblock print, benizuri-e
12 ⁵⁄₈ x 17 ½ in. (32.1 x 44.6 cm)
The Mann Collection, Highland Park, IL
Fig. 82

83

Suzuki Harunobu
Japanese, 1725–1770
*Young Woman Jumping from the Kiyomizu Temple
Balcony with an Umbrella as a Parachute*, 1765
Color woodblock print
10 ¾ x 7 ⁵⁄₈ in. (27.2 x 19.3 cm)
Collection of Mr. and Mrs. Harlow Niles
Higinbotham
Fig. 84

84

Suzuki Harunobu
Autumn Moon in the Mirror Stand (Kyōdai no shūgetsu), c. 1766
From the *Eight Parlor Views (Zashiki hakkei)*
Color woodblock print
11 3/16 x 8 1/16 in. (28.4 x 20.5 cm), sheet
Smart Museum of Art, Gift of Mr. and Mrs.
Gaylord Donnelley, from the Frances Gaylord
Smith Collection, 1972.5
Fig. 85

85

Suzuki Harunobu
Evening Snow on the Floss Shaper (Nurioke no bosetsu), c. 1766
From the *Eight Parlor Views (Zashiki hakkei)*
Color woodblock print, nishiki-e
11 5/16 x 8 3/16 in. (28.7 x 20.8 cm)
The Mann Collection, Highland Park, IL
Fig. 86

86

Suzuki Harunobu
Couple beside a Well, 1766/67
Color woodblock print
11 1/16 x 8 3/16 in. (28.1 x 20.8 cm)
Smart Museum of Art, Gift of Mr. and Mrs.
Gaylord Donnelley, from the Frances Gaylord
Smith Collection, 1972.6
Figs. 5, 87

87

Suzuki Harunobu
A Young Woman Visiting a Shrine on a Stormy Night, c. 1768
Color woodblock print, nishiki-e
11 1/4 x 8 5/16 in. (28.6 x 21.1 cm)
The Mann Collection, Highland Park, IL
Fig. 88

88

Suzuki Harunobu
Two Women Seated by a Stream, 1768–69
Color woodblock print
10 7/8 x 8 1/4 in. (27.6 x 20.9 cm)
Collection of Mr. and Mrs. Harlow Niles
Higinbotham
Fig. 89

89

Suzuki Shōnen
Japanese, 1848–1918
Plum Blossoms and Running Water (Baika ryūsui no zu), #2 from the *Album of Landscapes by Shōnen (Shōnen sansui gafu)*, 1893
Color woodblock print
9 1/4 x 6 11/16 in. (23.5 x 17 cm), image;
10 11/16 x 8 1/16 in. (27.2 x 20.5 cm), sheet
Spencer Museum of Art, 0000.2036.c

90

Tanaka Masunobu
Japanese, active c. 1736–1748
The Gate of the Yoshiwara, late 1730s
Hand-colored woodblock print
11 5/16 x 16 1/8 in. (28.6 x 41.2 cm)
Collection of Mr. and Mrs. Harlow Niles
Higinbotham
Fig. 80

91

Terasaki Kōgyō
Japanese, 1866–1919
Rice at Sunset, c. 1890–95
Color woodblock print
9 1/16 x 8 5/8 in. (23 x 21.9 cm)
Brooklyn Museum, Gift of the estate of
Dr. Eleanor Z. Wallace, 2007.32.24

92

Tobari Kogan
Japanese, 1882–1927
The Bridge, 1913
Color woodblock print
19 3/8 x 14 in. (49.2 x 35.6 cm), image/sheet
Collection of Charles H. Mottier
Illustrated on p. 171

93

Torii Kiyohiro
Japanese, 1737–1776
The Actor Onoe Kikugorō I, called Baikō, as Issun Tokubei, 1760
Color woodblock print, benizuri-e
15 5/8 x 6 3/4 in. (39.6 x 17.2 cm)
Publisher: Maruya Kohei
The Mann Collection, Highland Park, IL
Fig. 83

94

Torii Kiyomasu I
Japanese, 1694?–1716?
*Ichikawa Danjūrō I as Yamagami Gennaisaemon
and Yamanaka Heikurō as Soga no Iruka in the play
Keisei Ōshōkun*, 1701
Hand-colored woodblock print
24 7/8 x 12 11/16 in. (63.1 x 32.2 cm)
Publisher: Emiya Kichiemon
The Mann Collection, Highland Park, IL
Fig. 76

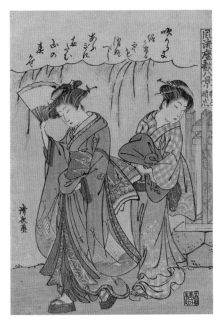

CAT. 95

95

Torii Kiyonaga
Japanese, 1752–1815
*A Fan Suggesting a Dispersed Storm (Sensu
no seiran)*, 1777
Color woodblock print
8 11/16 x 5 7/8 in. (22.1 x 15 cm)
The Art Institute of Chicago, Frederick W.
Gookin Collection, 1939.949

96

Torii Kiyonaga
*Girl in a Blue Robe Whispering to a Man outside
through a Latticed Window*, 1784
Color woodblock print, pillar print
27 x 4 11/16 in. (68.8 x 11.8 cm)
Collection of Mr. and Mrs. Harlow Niles
Higinbotham
Figs. 14, 90

97

Torii Kiyonaga
In a Public Bathhouse, c. 1783–84
Color woodblock print
14 5/8 x 9 11/16 in. (37.3 x 24.6 cm)
The Art Institute of Chicago, Clarence
Buckingham Collection, 1925.2610
Fig. 15

98

Torii Kiyonaga
A Party in the Shinagawa Pleasure Quarters, n.d.
Color woodblock print, triptych
Left: 14 1/2 x 9 7/8 in. (36.8 x 25.1 cm);
center: 15 1/4 x 9 15/16 in. (38.6 x 25.2 cm);
right: 15 1/4 x 10 in. (38.6 x 25.4 cm)
Publisher: Tsutaya Jūzaburō
The Mann Collection, Highland Park, IL

99

Torii Kiyonaga
Washday, c. 1788
Color woodblock print, triptych
Left: 15 x 10 in. (38.1 x 25.4 cm);
center: 15 3/8 x 10 1/8 in. (39 x 25.7 cm);
right: 15 1/4 x 10 1/8 in. (38.7 x 25.8 cm)
The Art Institute of Chicago, Clarence
Buckingham Collection, 1925.2335

100

Totoya Hokkei
Japanese, 1780–1850
Crane with Setting Sun, c. 1820
Color woodblock print, shikishiban format
deluxe printing
8 3/16 x 7 3/16 in. (20.8 x 18.2 cm)
Brooklyn Museum, Gift of Dr. Eleanor Z. Wallace
in memory of Dr. Stanley Wallace, 2002.121.2

101

Tsubaki Chinzan
Japanese, 1801–1854
Nandina domestica, 1869 (posthumous printing)
Color woodblock print
9 7/8 x 5 7/8 in. (25 x 15 cm), sheet
Block carver: Kido Kōtarō; printer: Yamamoto
Iwakichi
National Museum of American History,
Smithsonian Institution
Fig. 100

102

Tsukioka Yoshitoshi
Japanese, 1839–1892
*Pine, Bamboo, Plum: A Plaque Hung at Yushima
(Shōchikubai Yushima no kakegaku)*, 1885
Color woodblock print, vertical diptych
26 ¾ × 9 ¼ in. (67.8 × 23.5 cm), image/sheet
Spencer Museum of Art, R. Charles and Mary
Margaret Clevenger Fund, 1999.0150

103

Tsukioka Yoshitoshi
The Moon at Kuruwa (Kuruwa no tsuki), 1886
From the *One Hundred Aspects of the Moon*
(*Tsuki hyaku shi*)
Color woodblock print
14 × 9 ½ in. (35.6 × 24.1 cm), sheet
Brooklyn Museum, Bequest of Dr. Eleanor Z.
Wallace, 2007.31.7

104

Utagawa (Andō) Hiroshige
Japanese, 1797–1858
Abalone and Japanese Halfbeak, 1832–33
From the *Collection of Fish (Uozukushi)*
Color woodblock print
10 × 14 ½ in. (25.5 × 37 cm)
Publisher: Nishimuraya Yohachi
The Mann Collection, Highland Park, IL
Illustrated on p. 171

105

Utagawa (Andō) Hiroshige
*A Long-tailed Blue Bird on a Branch of Flowering
Plum*, early 1830s
Color woodblock print
15 × 6 ¹⁵⁄₁₆ in. (38.1 × 17.6 cm)
Publisher: Jukurindō (Wakasaya Yoichi)
The Mann Collection, Highland Park, IL

106

Utagawa (Andō) Hiroshige
*Narumi: Shop With Famous Arimatsu Tie-Dyed
Cloth (Narumi, meisan Arimatsu shibori mise)*, #41
from the *Fifty-three Stations of the Tōkaidō*, also
known as the *Vertical Tōkaidō*, 1855
Color woodblock print
13 ½ × 8 ⅞ in. (34.3 × 22.7 cm)
Publisher: Tsutaya Kichizō (Kōeidō)
Collection of Mr. and Mrs. Harlow Niles
Higinbotham

CAT. 106

107

Utagawa (Andō) Hiroshige
Moon-Viewing Point, #82 from the *One Hundred
Views of Famous Places in Edo*, 8th month of 1857
Color woodblock print
14 ⅛ × 9 ⅝ in. (35.9 × 24.4 cm)
Collection of Mr. and Mrs. Harlow Niles
Higinbotham
Illustrated on p. 170

108

Utagawa (Andō) Hiroshige and
Utagawa Kunisada
Japanese, 1797–1858 and 1786–1865
An Elegant Genji: Tsukuda (Fūryū Genji Tsukuda),
1853
Color woodblock print, triptych
Left: 14 ½ × 10 ⅛ in. (37 × 25.8 cm);
center: 14 ⅝ × 10 ⅛ in. (37.2 × 25.8 cm);
right: 14 ¹¹⁄₁₆ × 10 in. (37.2 × 25.4 cm)
Brooklyn Museum, Gift of Mrs. H. S. Chapman,
53.196.1a–c
Fig. 18

109

Utagawa Kunichika
Japanese, 1835–1900
A Stylish Genji: Amusements with Fireflies in Purple Silk (Imayō Genji Yukari kinu hotaru asobi), 1861
Color woodblock print; central print from a triptych
14 x 9 ½ in. (35.6 x 24.1 cm)
Publisher: Moriya Jihei
Brooklyn Museum, Anonymous Gift, 76.151.25

110

Utagawa Kunisada
Japanese, 1786–1865
The Actor Ichikawa Kodanji IV as Subashiri no Kumagorō, 1859
From *Thieves in Designs of the Times*
Color woodblock print
14 ½ x 9 ⅞ in. (36.8 x 25.1 cm)
Brooklyn Museum, Anonymous Gift, 76.151.26
Fig. 19

111

Utagawa Kunisada
The Young Yoshitsune Playing the Flute in the play Onzōshi ushiwakamaru, 1860
Color woodblock print
13 ¹¹⁄₁₆ x 9 ½ in. (34.8 x 24.1 cm)
Smart Museum of Art, The Mary and Earle Ludgin Collection, 1981.140

112

Utagawa Kunisada and others
Album of Prints, 1847–51
Color woodblock prints
14 ¼ x 9 ¼ in. (36.2 x 23.5 cm), sheet (each bound, approx.)
Smart Museum of Art, Gift of Alice and Barry Karl in memory of Marguerite Woodward-Clarke, 2005.77
Figs. 102, 103, 104

113

Utagawa Kunisada II
Japanese, 1823–1880
The Actor Bando Hikosaburō V as Ono no Tōfū, 1863
Color woodblock print
13 ¹⁵⁄₁₆ x 8 ½ in. (35.4 x 21.6 cm), sheet
Smart Museum of Art, Gift of Mrs. Gregory Orloff in honor of Norman McQuown, 2002.8

114

Utagawa Kunisada II
The Actor Onoe Kikujirō II as Funadama Osai in the play Koharu nagi okitsu shiranami, 1864
Color woodblock print
13 ¹³⁄₁₆ x 9 ¾ in. (35.1 x 24.8 cm)
Smart Museum of Art, The Mary and Earle Ludgin Collection, 1981.139
Fig. 17

115

Utagawa Kuniteru II
Japanese, 1830–1874
Farmers, from *The Four Occupations: A Rustic Genji*, 1869
Color woodblock print, triptych
14 ½ x 29 ½ in. (37 x 75 cm), overall
National Museum of American History, Smithsonian Institution
Fig. 101

116

Utagawa Kuniyoshi
Japanese, 1797–1861
The Actor Ichikawa Ebizō as Arajirō Yoshizumi in the play Shibaraku, c. 1847–1852
Color woodblock print
9 ¾ x 14 ¼ in (24.8 x 36.2 cm), sheet
Spencer Museum of Art, Gift of Rose K. Auerbach, 1967.0021

117

Utagawa Yoshikazu
Japanese, active 1850–1870
Meeting of Minamoto no Yoshitsune and the Ghost of Taira no Tomomori (Minamoto no Yoshitsune Taira no Tomomori no rei ni au zu), c. 1851–53
Color woodblock print, triptych
14 ¼ x 30 ⅛ in. (36.3 x 76.6 cm), overall
Spencer Museum of Art, R. Charles and Mary Margaret Clevenger Fund, 1999.0203.a,b,c
Fig. 20

118

Various artists
Collector's Album of Prints, late 19th century
Color woodblock prints
14 x 19 ¼ in. (35.6 x 48.9 cm), sheet (each bound, approx.)
Smart Museum of Art, Gift of Dr. and Mrs. Herman Pines, 1989.14
Figs. 22, 23

119

Yamamoto Kanae
Japanese, 1882–1946
French Pastoral in Spring, 1912–13
Color woodblock print
9 ⅝ x 13 ⅛ in. (24.5 x 33.3 cm), image;
11 ½ x 15 in. (29.2 x 38.1 cm), sheet
Collection of Charles H. Mottier
Fig. 123

120

Yamamoto Kanae
Bathers in Brittany, 1913
Color woodblock print
6 x 8 ½ in. (15.2 x 21.6 cm), image
Collection of Charles H. Mottier
Fig. 122

121

Yōshū (Hashimoto) Chikanobu
Japanese, 1838–1912
Spring Felicitations in Japanese Brocade
(*Wakin haru no kotobuki*), 1885
Color woodblock print, triptych
14 ⅛ x 9 ¼ in. (35.9 x 23.6 cm), image;
14 ⅝ x 10 in. (37.3 x 25.4 cm), sheet (each)
Spencer Museum of Art, Lucy Shaw Schultz
Fund, 2007.0066.a,b,c
Fig. 30

122

Yōshū (Hashimoto) Chikanobu
The Illustrious Nobility of the Empire, 1887
Color woodblock print, triptych
14 ⅜ x 9 ¼ in. (36.5 x 23.6 cm), image;
14 ¾ x 9 ¾ in. (37.4 x 24.9 cm), sheet (each)
Spencer Museum of Art, Lucy Shaw Schultz
Fund, 2006.0034.a,b,c
Fig. 28

123

Yōshū (Hashimoto) Chikanobu
The First Month (Ichigatsu), 1890
From the *Calendar of Eastern Customs*
(*Azuma fūzoku nenjū gyōji*)
Color woodblock print
14 ⅛ x 9 3⁄16 in. (36 x 23.4 cm), image/sheet
Spencer Museum of Art, Lucy Shaw Schultz
Fund, 2007.0062.01

CAT. 124

124

Yōshū (Hashimoto) Chikanobu
The Ninth Month (Kugatsu), 1890
From the *Calendar of Eastern Customs*
(*Azuma fūzoku nenjū gyōji*)
Color woodblock print
14 ⅛ x 9 ¼ in. (36 x 23.5 cm), image/sheet
Spencer Museum of Art, Lucy Shaw Schultz
Fund, 2007.0062.09

Books

125

The Romance of the Western Chamber (Xixiang ji),
1977 facsimile of an album of color woodblock
prints originally published by Min Qiji, Wucheng,
Zhejiang, 1640
East Asian Art Collection, University of
Chicago Library, fPL2694.H878H87
Fig. 7

126

Nakamura Hōchū et al., *Kōrin gafu* (*The Kōrin
picture album*), Edo, 1802
New York Public Library, Spencer Collection

127

Sō Geppō, after Ike no Taiga, *Taigadō gafu* (*The
Taigadō picture album*), Kyoto, undated, probably
1803
New York Public Library, Spencer Collection

128

Wang Gai, *The Mustard Seed Garden Manual*
(*Jie zi yuan hua zhuan*), original imprint of 1818
Chinese edition
East Asian Art Collection, University of Chicago
Library, 6170 1179
Fig. 10

129

Noritané Ninagawa, *Kwan-ko-dzu-setsu: tōki no
bu* [=Notice historique et descriptive sur les arts
et industries japonais—art céramique], 5 vols.,
Tokyo, 1876–78
Ryerson and Burnham Libraries, The Art
Institute of Chicago

130

Louis Gonse, *L'art japonais*, 2 vols., Paris, 1883
University of Chicago Library, fN7350.G6

131

Siegfried Bing, *Artistic Japan*, 6 vols., London, 1891
University of Chicago Library, fN7350.B58

132

Reproduction of *Miracles of the Kasuga Shrine
Deity (Kasuga gongen genki-e)* in *Kokka*, no. 31
(April 1892)
Block carver: Iiyama Ryōnosuke; printer: Tamura
Tetsunosuke
East Asian Art Collection, University of Chicago
Library, fN8.K8
Fig. 29

133

S. W. Bushell, *Oriental Ceramic Art from the
Collection of W. T. Walters*, New York, 1899
Boston Public Library
Fig. 61

134

Progressive proof book associated with
Oriental Ceramic Art
Boston Public Library

135

Watanabe Seitei, *Kacho gafu (Album of Birds and
Flowers)*, Tokyo, 1903
Field Museum, Boone Collection

Ceramics

136

China, Qing dynasty
*Lidded Box Painted with Scenes of Europeans in
China*, late 18th century
Guangdong ware, enamel colors on tin
Height: 5 in. (12.7 cm); diameter: 13 ¾ in.
(34.9 cm)
Trammell and Margaret Crow Collection of
Asian Art, 1960.21
Fig. 9

137

China, late Qing dynasty
Bowl, 19th century
Porcelain with overglaze polychrome enamel
decoration
Height: 6 ¼ in. (15.9 cm); diameter: 14 ½ in.
(36.8 cm)
Smart Museum of Art, University Transfer,
1991.266
Fig. 8

Other Materials

A variety of woodblocks, tools, and colorants
from the Department of Graphic Arts of
the National Museum of American History,
Smithsonian Institution, Washington, DC

Aitken, Geneviève, and Marianne Delafond. *La collection d'estampes japonaises de Claude Monet à Giverny.* Paris: La Bibliothèque des arts, 1983.

Aoki Shigeru, ed. *Kindai nihon hanga no shosō* (Aspects of Modern Japanese Prints). Tokyo: Chūō Kōron Bijutsu Shuppan, 1998.

Baas, Jacquelyn, and Richard S. Field. *The Artistic Revival of the Woodcut in France 1850–1900.* Exh. cat. Ann Arbor: University of Michigan Museum of Art, 1984.

Bakumatsu Meiji no dōhanga: Gengendō to Shuntōsai o chūshin ni (Bakumatsu Meiji Copperplate Engraving). Exh. cat. Tokyo: Tenri Gyararī, 2006.

Bargiel, Réjane, and Ségolène Le Men. *La Belle Époque de Jules Chéret: De l'affiche au décor.* Exh. cat. Paris: Les Arts Décoratifs/ Bibliothèque nationale de France, 2010.

Bogel, Cynthea J., et al. *Hiroshige: Birds and Flowers.* New York: G. Braziller, 1988.

Burch, R. M. *Colour printing and colour printers.* London: I. Pitman, 1910.

Carey, Frances, and Antony Griffiths. *From Manet to Toulouse-Lautrec: French Lithographs, 1860–1900.* Exh. cat. London: British Museum Publications, 1978.

Carlson, Victor I., and John W. Ittmann. *Regency to Empire: French Printmaking, 1715–1814.* Exh. cat. Minneapolis: The Minneapolis Institute of Arts, 1984.

Carpenter, John, ed. *Hokusai and His Age: Ukiyo-e Painting, Printmaking, and Book Illustration in Late Edo Japan.* Amsterdam: Hotei, 2005.

Cate, Phillip Dennis, and Sinclair Hamilton Hitchings. *The Color Revolution: Color Lithography in France 1890–1900.* Exh. cat. Santa Barbara and Salt Lake City: Peregrine Smith, 1978.

Cate, Phillip Dennis, and Marianne Grivel, eds. *From Pissarro to Picasso: Color Etching in France; Works from the Bibliothèque Nationale and the Zimmerli Art Museum.* Exh. cat. New Brunswick, NJ: Zimmerli Art Museum, 1992.

Chiba City Museum of Art. *Torii Kiyonaga: Edo no Bīnasu Tanjō* (Torii Kiyonaga: The Birth of Venus in Edo). Exh. cat. Chiba-shi: Chiba City Museum of Art, 2007.

Clark, Timothy, ed. *The Actor's Image: Print Makers of the Katsukawa School.* Chicago: The Art Institute of Chicago, 1994.

——. *Kuniyoshi: From the Arthur R. Miller Collection.* London: Royal Academy of Arts, 2009.

——, et al. *The Dawn of the Floating World, 1650–1765: Early Ukiyo-e Treasures from the Museum of Fine Arts, Boston.* London: Thames & Hudson, 2001.

Clergue, Yolande, ed. *Le regard de Vincent Van Gogh sur les estampes japonaises du XIXe siècle.* Exh. cat. Arles: Association pour la création de la Fondation Vincent van Gogh, 1999.

Coats, Bruce A., ed. *Chikanobu: Modernity and Nostalgia in Japanese Prints.* Exh. cat. Leiden: Hotei, 2006.

Davis, Julie Nelson. *Utamaro and the Spectacle of Beauty.* Honolulu: University of Hawaii Press, 2007.

Edgren, Sören. *Chinese Rare Books in American Collections*. New York: China Institute in America, 1984.

Focillon, Henri. *Maîtres de l'estampe: Peintres graveurs*. Paris: Librairie Renouard, 1930.

Forrer, Matthi. *Hokusai*. New York: Rizzoli, 1988.

———. *Hokusai*. New York: Prestel, 2010.

Fossier, François. *Auguste Lepère, ou le renouveau du bois gravé*. Exh. cat. Paris: Réunion des musées nationaux, 1992.

Franklin, Colin, and Charlotte Franklin. *A Catalogue of Early Colour Printing from Chiaroscuro to Aquatint*. Oxford: The authors, 1977.

Gage, John. *Colour and Culture: Practice and Meaning from Antiquity to Abstraction*. London: Thames & Hudson, 1993.

Gookin, Frederick William. *Rare and Valuable Japanese Color Prints: The Noted Collection Formed by a Distinguished French Connoisseur of Paris*. New York: Howard Strickland, 1921.

Gordon-Smith, Maria. *Pillement*. Cracow: IRSA, 2006.

Grasselli, Margaret Morgan. *Colorful Impressions: The Printmaking Revolution in Eighteenth-Century France*. Exh. cat. Washington: National Gallery of Art, 2003.

La gravure impressionniste: De l'école de Barbizon aux Nabis. Exh. cat. Paris: Somogy, 2001.

Graybill, Maribeth, ed. *The Artist's Touch, the Craftsman's Hand: Three Centuries of Japanese Prints from the Portland Art Museum*. Exh. cat. Portland, OR: Portland Art Museum, 2011.

Gulik, Robert H. van. *Erotic Color Prints of the Ming Period*. Leiden: Brill, 2004.

Harootunian, H. D., and Sarah Thompson. *Undercurrents in the Floating World: Censorship and Japanese Prints*. Exh. cat. New York: Asia Society Galleries, 1991.

Haverkamp-Begemann, Egbert. *Color in Prints*. Exh. cat. New Haven: Yale University Art Gallery, 1962.

Hayakawa, Monta. *The Shunga of Suzuki Harunobu: Mitate-e and Sexuality in Edo*. Translated by Patricia J. Fister. Kyoto: International Research Center for Japanese Studies, 2001.

Hockley, Allen. *The Prints of Isoda Koryūsai: Floating World Culture and its Consumers in Eighteenth-Century Japan*. Seattle and London: University of Washington Press, 2003.

Imahashi Riko. *Edo no kachōga: hakubutsugaku o meguru bunka to sono hyōshō* (Birds and Flowers: The Representation of Natural History During the Edo Period). Tokyo: Sukaidoa, 1996.

Ives, Colta Feller. *The Great Wave: The Influence of Japanese Woodcuts on French Prints*. Exh. cat. New York: The Metropolitan Museum of Art, 1974.

Izzard, Sebastian, with J. Thomas Rimer and John T. Carpenter. *Kunisada's World*. New York: Japan Society, in collaboration with the Ukiyo-e Society of America, 1993.

Junod, Philippe, and Michel Pastoreau, eds. *La couleur: Regards croisés sur la couleur du Moyen Age au XXe siècle: Actes du colloque à l'Université de Lausanne, les 25–27 juin 1992*. Paris: Léopard d'or, 1994.

Keyes, Roger. *Ehon: The Artist and the Book in Japan*. Exh. cat. New York: New York Public Library, 2006.

———. *The Bizarre Imagery of Yoshitoshi: The Herbert R. Cole Collection*. Exh. cat. Los Angeles: Los Angeles County Museum of Art, 1980.

Klompmakers, Inge. *Of Brigands and Bravery: Kuniyoshi's Heroes of the Suikoden*. Amsterdam: Hotei, 2003.

Kobayashi Hiromitsu. "Chen Hongshou's Graphic Arts: A Study of Late Ming Pictorial Woodblock Prints." *Kokka*, no. 1061 (1983): 25–39.

Kobayashi Kiyochika ten: Hikari to kage no ukiyoeshi (Kobayashi Kiyochika: Ukiyo-e Artist of Light and Shadow). Exh. cat. Tokyo: Itabashi Kuritsu Bijutsukan, 1982.

Kobayashi Tadao. *Edo Tokyo wa donna iro: Shikisai Hyōgen o yomu* (What Color is Edo Tokyo?: Reading Color Expression). Tokyo: Kyōiku Shuppan, 2000.

Kobayashi Tadashi. *Ukiyo-e: An Introduction to Japanese Woodblock Prints*. Translated by Mark A. Harbison. Tokyo and New York: Kodansha International, 1997.

Kuwagata Keisai. Tsuyama: Tsuyama Kyōiku Iinkai and Ōta Kinen Bijutsukan, 2004.

Link, Howard A. *The Theatrical Prints of the Torii Masters: A Selection of Seventeenth- and Eighteenth-Century Ukiyo-e*. Exh. cat. Honolulu: Honolulu Academy of Arts, 1977.

Ma Meng-ching. "Learning from Prints and Painting: The Multiple Characteristics of the Ten Bamboo Studio Collection of Calligraphy and Painting." *Gugong xueshu jikan* 18, no. 1 (2000): 109–49.

———. "A Study of How Late-Ming Publishers Emphasized Visuality within Book Illustrations through the Romance of the Western Chamber." *Meishushi yanjiu ji kan*, no. 13 (2002): 201–77.

Marks, Andreas. *Japanese Woodblock Prints: Artists, Publishers, and Masterworks, 1680–1900*. Tokyo and Singapore: Tuttle Publishing, 2010.

Mathews, Nancy Mowll, and Barbara Stern Shapiro. *Mary Cassatt: The Color Prints*. Exh. cat. Williamstown: Williams College Museum of Art, 1989.

Meech, Julia, and Jane Oliver, eds. *Designed for Pleasure: The World of Edo Japan in Prints and Paintings, 1680–1860*. Exh. cat. New York: Asia Society and Japanese Art Society of America, 2008.

Meiji no hanga: Oka Korekushon o chūshin ni (Meiji Prints: Centering on the Oka Collection). Kawasaki: Kawasaki-shi Shimin Myūjiamu, 2002.

Merritt, Helen, and Nanako Yamada. *Woodblock Kuchi-e Prints: Reflections of Meiji Culture*. Honolulu: University of Hawaii Press, 2000.

Monet & Japan. Exh. cat. Canberra: National Gallery of Australia, 2001.

Mutō Junko. *Shoki ukiyoe to kabuki: Yakushae ni Chūmoku shite* (Early Ukiyo-e and Kabuki). Tokyo: Kasama Shoin, 2005.

Newland, Amy Reigle, ed. *The Commercial and Cultural Climate of Japanese Printmaking*. Amsterdam: Hotei, 2004.

Nishiki-e no tanjō: Edo shomin bunka no kaika (The Birth of Nishiki-e: The Flowering of Edo Commoner Culture). Exh. cat. Tokyo: Tokyo Metropolitan Edo-Tokyo Museum, 1996.

Nishikie to chūgoku hanga ten: Nishikie wa kōshite umareta (Nishiki-e and Chinese Prints: How Nishiki-e Were Born). Exh. cat. Tokyo: Ota Kinen Bijutsukan, 2000.

Okada Yoshirō. *Edo no egoyomi* (Edo Picture Calendars). Tokyo: Taishūkan Shoten, 2006.

Ono Tadashige. *Nihon no sekibanga* (Japanese Lithography). Tokyo: Bijutsu Shuppansha, 1967.

Orientations 40, no. 3 (2009). Special issue on Chinese color printing. With articles by Christer von der Burg, Hiromitsu Kobayashi, James Cahill, Craig Clunas, Sören Edgren, Song Pingshen, Sebastian Izzard, and Wang Chao.

Reed, Marcia, and Paola Demattè. *China on Paper: European and Chinese Works from the Late Sixteenth to the Early Nineteenth Century*. Exh. cat. Los Angeles: Getty Research Institute, 2007.

Rodari, Florian, ed. *Anatomie de la couleur: L'invention de l'estampe en couleurs*. Exh. cat. Paris: Bibliothèque nationale de France; Lausanne: Musée Olympique, 1996.

Roger-Marx, Claude. *The Graphic Work of Edouard Vuillard*. Translated by Susan Fargo Gilchrist. San Francisco: Alan Wofsy Fine Arts, 1990.

Russell, Charles E. *French Colour-prints of the XVIIIth Century: The Art of Debucourt, Janinet & Descourtis*. London and New York: Halton, 1949.

Smith, Henry D. II. *Kiyochika: Artist of Meiji Japan*. Exh. cat. Santa Barbara: Santa Barbara Museum of Art, 1988.

Spee, Clarissa von, ed. *The Printed Image in China: From the 8th to the 21st Centuries*. Exh. cat. London: British Museum Press, 2010.

Stevenson, John. *Yoshitoshi's Strange Tales*. Amsterdam: Hotei Publishing, 2005.

Sueur-Hermel, Valérie. *Henri Rivière: Entre impressionnisme et japonisme*. Exh. cat. Paris: Bibliothèque nationale de France, 2009.

Suzuki Jūzō. *Ehon to ukiyoe: Edo shuppan bunka no kōsatsu*. Tokyo: Bijutsu Shuppansha, 1979.

Tanita Hiroyuki, ed. *Hanga ni miru Japonisumu ten* (Seeking the Floating World: The Japanese Spirit in Turn-of-the-Century French Art). Exh. cat. Yokohama: Taniguchi Jimusho, 1989.

Tinios, Ellis. *Mirror of the Stage: The Actor Prints of Kunisada.* Exh. cat. Leeds: University Gallery Leeds, 1996.

Tsuruta Takeyoshi. "Painting Manual of the Mustard Seed Garden and Its Influence on Japan." *Bijutsu Kenkyu* 283 (1972): 1–12.

Twyman, Michael. *Images en couleur: Godefroy Engelmann, Charles Hullmandel et les débuts de la chromolithographie.* Exh. cat. Lyon: Musée de l'imprimerie, 2007.

Waterhouse, David B. *Harunobu and His Age: The Development of Colour Printing in Japan.* London: Trustees of the British Museum, 1964.

Watrous, James. *American Color Woodcuts: Bounty from the Block, 1890s–1990s: A Century of Color Woodcuts.* Exh. cat. Milwaukee: Elvehjem Museum of Art, University of Wisconsin–Madison, 1993.

Weisberg, Gabriel P., et al. *Japonisme: Japanese Influence on French Art, 1854–1910.* Exh. cat. Cleveland: Cleveland Museum of Art, 1975.

Wright, Suzanne E. " 'Luoxuan Biangu Jianpu' and 'Shizhuzhai Jianpu': Two Late-Ming Catalogues of Letter Paper Designs." *Artibus Asiae* 63, no. 1 (2003): 69–122.

Catalogue published in conjunction with
the exhibition
Awash in Color: French and Japanese Prints
Smart Museum of Art
University of Chicago
4 October 2012–20 January 2013

Copyright © 2012
Smart Museum of Art
University of Chicago
5550 South Greenwood Avenue
Chicago, Illinois 60637
(773) 702-0200
smartmuseum.uchicago.edu

Awash in Color: French and Japanese Prints is one
in a series of projects at the Smart Museum
of Art supported by an endowment from the
Andrew W. Mellon Foundation. Major funding
has been provided by the University of Chicago
Women's Board and The Samuel H. Kress
Foundation, with additional support generously
provided by Ariel Investments, The Elizabeth
F. Cheney Foundation, The IFPDA Foundation,
and Thomas McCormick and Janis Kanter.
Related programming has been made possible
by the University of Chicago's France Chicago
Center, Department of Music, and Department
of Art History, as well as Mrs. Betty Guttman.
Additional support for the exhibition catalogue
was provided by Furthermore: a program of the
J. M. Kaplan Fund.

Chelsea Foxwell and Anne Leonard, with David
Acton, David Waterhouse, Drew Stevens,
Andreas Marks, Laura Kalba, and Stephanie Su

Project Editor: Anne Leonard
Copy Editor: Katherine E. Reilly
Design and typesetting: Joan Sommers Design,
Chicago
Color separations: Professional Graphics,
Rockford, IL
Printed in China through Asia Pacific Offset

Library of Congress Cataloging-in-Publication Data

Foxwell, Chelsea.
Awash in color : French and Japanese prints / Chelsea
Foxwell and Anne Leonard ; with David Acton . . . [et al.].
 p. cm.
Catalog of an exhibition held at Smart Museum of Art,
University of Chicago, Oct. 4, 2012–Jan. 20, 2013.
Includes bibliographical references.
ISBN 978-0-935573-51-0
1. Color prints, French—Exhibitions. 2. Color prints,
Japanese—Exhibitions. I. Leonard, Anne (Anne
Rachel) II. Acton, David, 1953- III. David and Alfred
Smart Museum of Art. IV. Title.
NE1300.8.F8F68 2012
769.944074'77311—dc23

 2012022679

Cover: Henri de Toulouse-Lautrec, *Divan
Japonais* (detail), 1892–93 (cat. 46); Kitagawa
Utamaro, *Taking Shelter from a Sudden Summer
Shower under a Huge Tree* (detail), early 1790s
(cat. 74)
Reverse cover: Louis Le Coeur and J.-F.-J.
Swebach-Desfontaines, *Bal de la Bastille* (detail),
1790 (cat. 28); Henri Rivière, *Small Wave Rising,
Pointe de la Haye* (detail), 1892 (cat. 41)
Front flap: Utagawa Kunisada, *The Young
Yoshitsune Playing the Flute* (detail), 1860 (cat. 111)
Back flap: Utagawa (Andō) Hiroshige, *A Long-
tailed Blue Bird on a Branch of Flowering Plum*,
early 1830s (cat. 105)